IMAGES
of America

LAKESIDE
CALIFORNIA

Richard S. White

ARCADIA
PUBLISHING

Published by Arcadia Publishing
Charleston, South Carolina

Library of Congress Catalog Card Number: 2002110150

For all general information contact Arcadia Publishing at:
Telephone 843-853-2070
Fax 843-853-0044
E-mail sales@arcadiapublishing.com
For customer service and orders:
Toll-Free 1-888-313-2665

Visit us on the Internet at www.arcadiapublishing.com

*This book is dedicated to my parents, Carl and Harriet White. They so loved
San Diego County and our beautiful town nestled in the hills.*

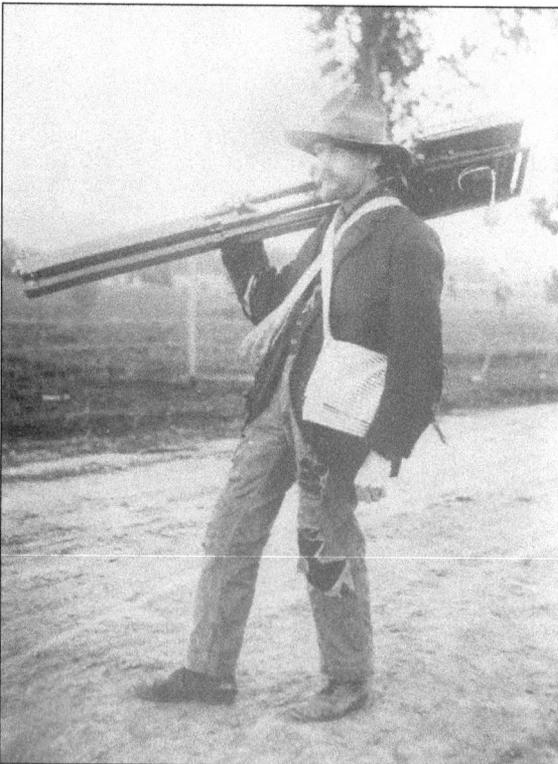

On May 10, 1909, Charles F. Petty, "The Tramp Photographer," started his long journey from San Diego to New York on foot. With him is a husky team of horses and a covered wagon with all the necessary paraphernalia for such a trip. But, he had vowed not to ride a moment in the vehicle unless he absolutely had to for some unforeseen reason.

Petty came to San Diego in 1894 and was pronounced incurably afflicted with tuberculosis. But he recovered after a life entirely out of doors in San Diego. At the time of his departure, he was suffering from "nervous paralysis" and it was because of this trouble that he took his walk from coast to coast. Petty captured most of the 1909 images of Lakeside in this book during his stop in Lakeside.

CONTENTS

ACKNOWLEDGMENTS

Legends of Lakeside; Lakeside Historical Society, 1985

011 = Union Title Insurance and Trust Co., Historic Collection
012 = San Diego Historical Society, Photograph Collection
020 = San Diego Historical Society, Ticor Collection
035 = Historic Collection, Title Insurance and Trust Company, San Diego, CA
038 = Historic Collection, Title Insurance and Trust Company, San Diego, CA
041 = Union Title Insurance and Trust Co., Historic Collection
042 = Historic Collection, Title Insurance and Trust Company, San Diego, CA
043 = Historic Collection, Title Insurance and Trust Company, San Diego, CA
086 = Historic Collection, Title Insurance and Trust Company, San Diego, CA
087 = Historic Collection, Title Insurance and Trust Company, San Diego, CA
090 = Historic Collection, Title Insurance and Trust Company, San Diego, CA
131 = Union Title Insurance and Trust Co., Historic Collection
143 = Union Title Insurance and Trust Co., Historic Collection
147 = San Diego Historical Society, Ticor Collection
158 = Helix Water District
159 = Helix Water District
168 = Helix Water District
176 = Union Title Insurance and Trust Co., Historic Collection
191 = San Diego Historical Society, Ticor Collection
192 = San Diego Historical Society, Ticor Collection
206 = San Diego Historical Society, Ticor Collection
223 = San Diego Historical Society, Ticor Collection

INTRODUCTION

For thousands of years, people have been coming to Lakeside to enjoy its moderate climate and take advantage of the abundant supply of water in Lindo Lake—San Diego County's only natural lagoon. The first inhabitants were a group of Indians who called themselves the Kumeyaay. They lived a peaceful life, hunting, fishing, gathering acorns, mesquite beans, pinon seeds, and berries. They were also skilled in making pottery, weaving baskets, and making jewelry from shells, seeds, hollow bones, and small stones. During the cold months of winter, the Kumeyaay lived on the desert side of the mountains for the warmth from their sacred "Great Rocks." As soon as the cold weather ended, they moved west, back towards the coast.

Soon after the San Diego Mission was established in 1769, the Padres began to explore the country to the east, seeking grazing lands for their cattle, sheep, and other livestock. Naturally they followed the San Diego River upstream. About ten miles from the mission, they discovered a broad valley with a luxuriant sea of wild grasses. True to the Spanish custom of giving descriptive place-names, they called this valley El Cajon, "the box." They named it so because the valley is truly boxed in by high hills and mountains. This name appears on maps as early as 1800. Here, hundreds of head of cattle and sheep grazed, and in the low hills on the east side of the valley (Lakeside) large numbers of swine were raised. This section became known as Canada de Los Coches, "Glen of the Pigs."

Around 1820, when the land was still Mission property, Jose Maria Estrudillo of San Diego built his summer home. It was the first known in Lakeside and was located near what is now Maine Avenue and Parkside Street.

With land grants, many ranchos were created under the Mexican flag between 1831 and 1848. In 1843, Apolinaria Lorenza was granted 28.39 acres, which were named Canada de los Coches, in order to preserve the Mission hog ranch for the Padres. And in 1845, the 48,799.85 acre land grant titled El Cajon Rancho was made to Maria Antonio Estudillo de Pedrorena. The Los Coches Rancho was completely surrounded by the El Cajon Rancho, but the two grants were at all times separate. Los Coches was the smallest San Diego County land grant, and El Cajon was the largest. In 1859, the little Los Coches Rancho was purchased from the Catholic Church by Jessie Julian Ames. Then in 1869, the El Cajon Rancho was sold and opened for settlement.

In the fall of 1870, Benjamin P. Hill came to the El Cajon Valley and purchased 10,000 acres from the Pedrorena's estate to start a ranch. He built his first home in Lakeside at what is now Wildcat Canyon and Willow Roads. There he raised thoroughbreds and had a training racetrack. This ranch was described as being "twenty miles from the county seat and post office . . . and from school and church seven miles."

Mr. Joseph Foster, after his marriage to Martha Swycaffer in 1880, bought the John B. Rea homestead at the foot of what is now San Vicente Dam. "Uncle Joe," as he was affectionately known, and Jim Frary started a stage coach line from San Diego to Julian. For 23 years Mr. Foster was a County Supervisor for the 3rd District, and served as chairman of the Board of Supervisors for 14 years.

In 1886, Ben Hill sold 6,600 acres to the newly formed El Cajon Land Company. The land company immediately began to promote Lakeside as a town site. To attract people to the new

township, the El Cajon Land Company erected a large 80-room Victorian-style inn with a resort next to Lindo Lake. The construction was completed in 1887 at the cost of $50,000.

When the railroad came to Lakeside in 1889, families from throughout the country came on the San Diego Cuyamaca Eastern Railroad with all the joyous crowding and paraphernalia appropriate for a school or church picnic. Not much lake was apparent, and the decorations consisted mostly of sand and eucalyptus trees, but the picnics were always highly exciting.

Small businesses began to spring up—Beamer's Stable and Blacksmith's shop, a boarding house that became a general store, a butcher shop, and a school was started. And to take care of the spiritual needs of the new town, a church was built in 1896. By the turn of the century, Lakeside had become a thriving community.

John H. Gay bought the Lakeside Inn in 1904. He fenced off the park and claimed it as part of the estate. Then he laid out a 60-foot wide racetrack that circled the lake. It was especially adapted for automobile and horse racing. On this track in April of 1907, Barney Oldfield, driving his "Green Dragon," set a new land speed record of 70.3 mph. The beautiful grounds of the Inn continued to be the scene of many parties where celebrities and millionaires met for golf, boating, duck hunting, or to attend the races. Sadly, in 1920, the Lakeside Inn was dismantled at the wish of the disgruntled Gay following his death.

In 1920, newcomers could hardly believe that Lakeside had such a good rail connection from San Diego. There were excellent passenger and freight services with many daily runs, as well as a Saturday Night Special to bring home the crowds who had enjoyed a day in the country. Each time the tracks had been destroyed by floods, they were immediately repaired to Lakeside. But the line to Foster was not replaced after the Flood of 1916. The tracks to Lakeside were repaired after the Flood of 1927, but by that time the line was no longer profitable. By 1938, the link from Santee to Lakeside had been removed, and the Santee to El Cajon portion was removed in 1942 when Gillepsie Field ws completed. This marked the end of the railroad era in the Lakeside area.

On Juy 5, 1920, the first Lakeside Rodeo ws organized by Bill Kuhner and held on the Emil Klicka property south of Lindo Lake. In 1933, the Lakeside Rodeo Association was formed and the arena was moved to an area east of Channel Road. A grandstand ws built, and chutes and fences were installed. Today, the annual rodeos are organized by the Lakeside Stadium Association and are held at the new rodeo grounds on Mapleview Avenue.

As we begin the 21st century, Lakeside has far exceeded its founder's visions of population and commerce. But, it still maintains a friendly, small town atmosphere. By taking a leisurely stroll down Lakeside's revitalized historic Maine Avenue, you will experience a piece of the past and sense the pride that has been taken in our rich and diverse history.

Benjamin P. Hill was born in Monroe County, Missouri in 1843. He left Missouri for California in 1852, traveling the overland emigrant route. He arrived in Suscal Valley, Napa County, the same year and began ranching and farming. In the fall of 1870, he came to Lakeside, then only part of El Cajon Valley, and built his home.

One

THE BEGINNING

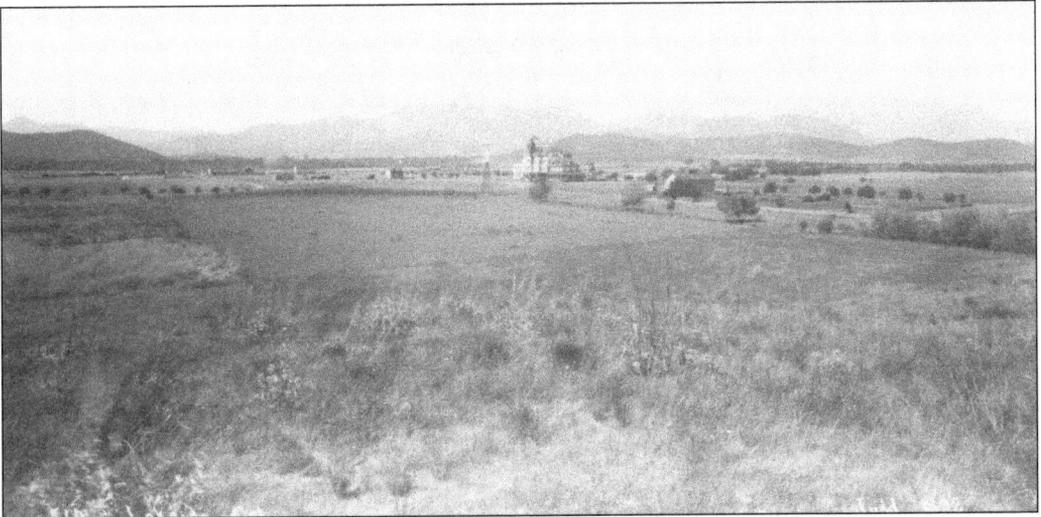

At the time the El Cajon Valley Land Company began to promote Lakeside as a town site, there were few inhabitants in the area. This is Lakeside looking northeast with the Lakeside Inn and its farm in the center in 1892.

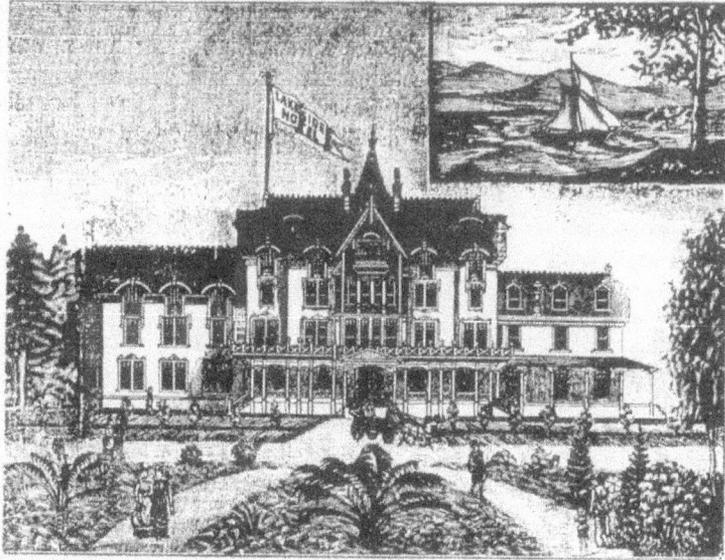

In 1886, this advertisement appeared in many magazines luring people to purchase land and move to the new town of Lakeside that was being developed and promoted by the El Cajon Land Company.

Lakeside is the "garden of San Diego County" according to this 1888 advertising folder on the advantages of El Cajon Valley.

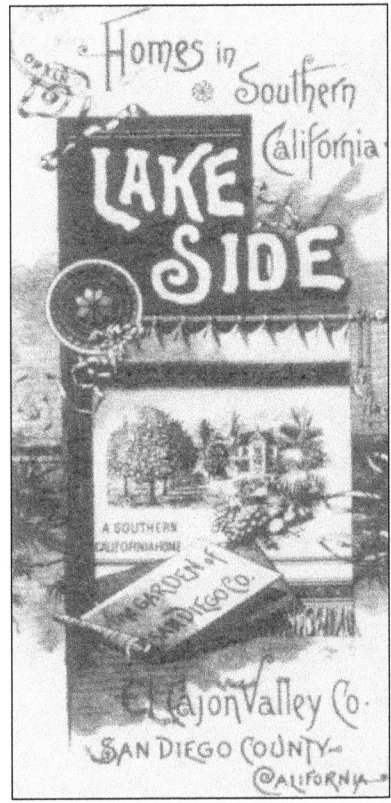

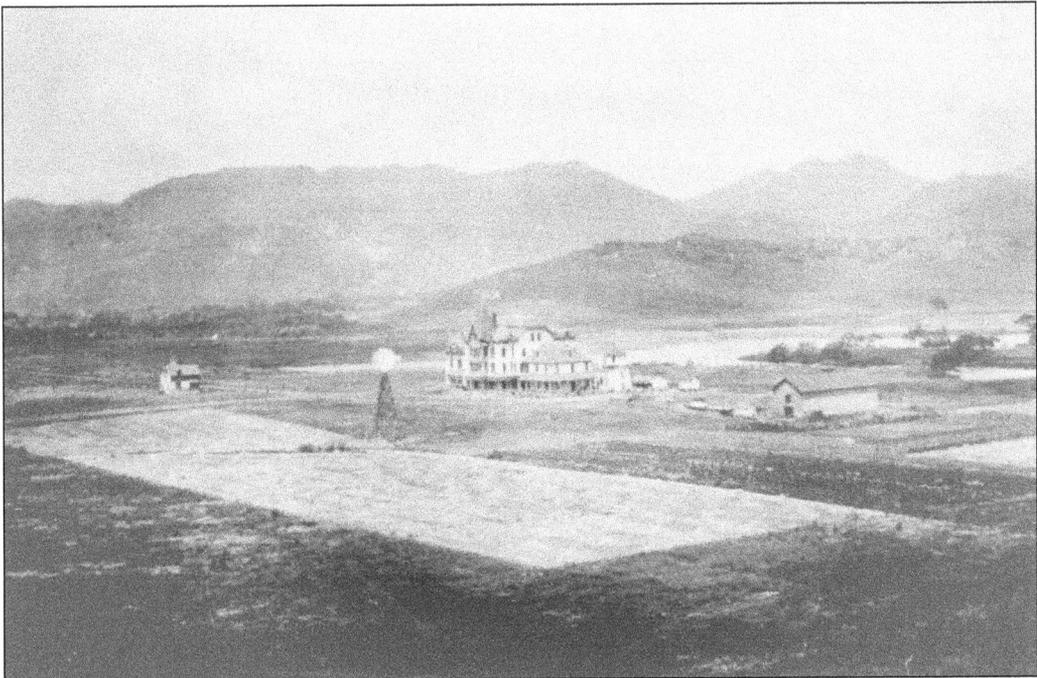

This image is looking north at Lakeside and the Lakeside Inn on Lindo Lake. The El Cajon Land Company completed construction of the Inn in 1887.

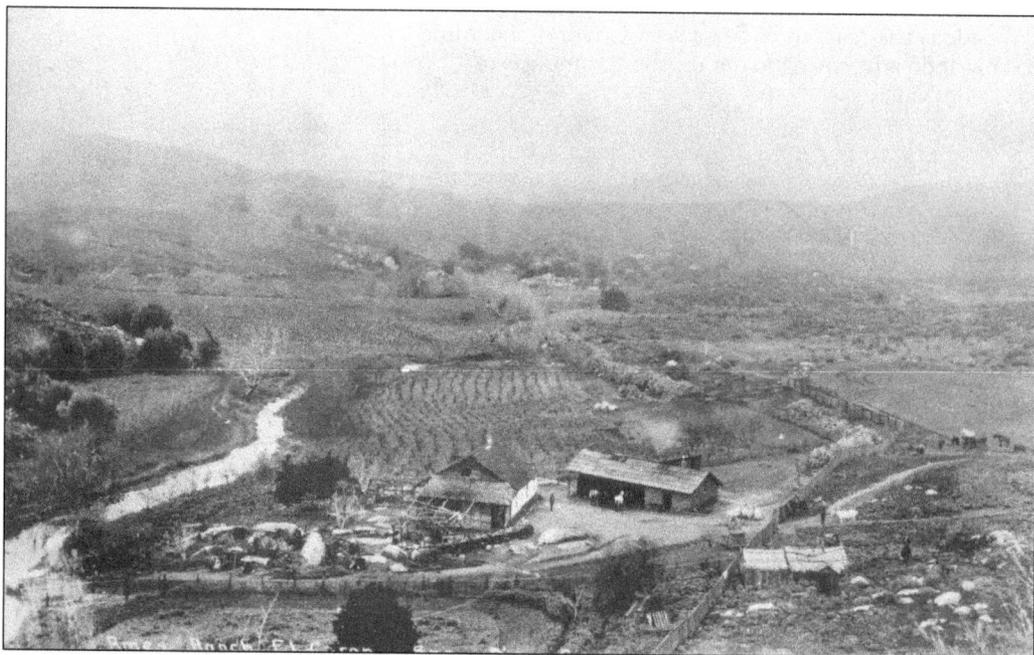

Ames Ranch (1859–1888) is pictured above. Jessie Julian Ames built the adobe ranch house and stable on de la Canada de Los Coches Rancho, California's smallest Spanish land grant (California Historical Landmark No. 425). The original grantee, Apolinaria Lorenzana, raised hogs for the San Diego Mission de Alcala until 1843 when it was abandoned. This was also the site of the old Grist Mill located at Los Coches Road and Old Highway 80.

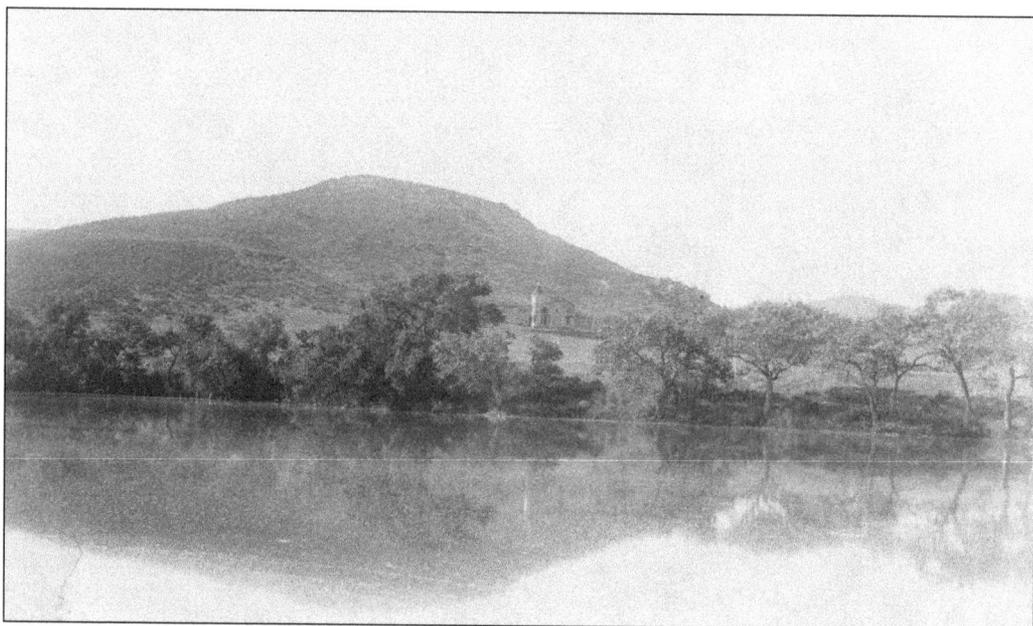

This 1887 picture features Lindo Lake with Lakeside's first home, the "Castle House," on the hillside in the background.

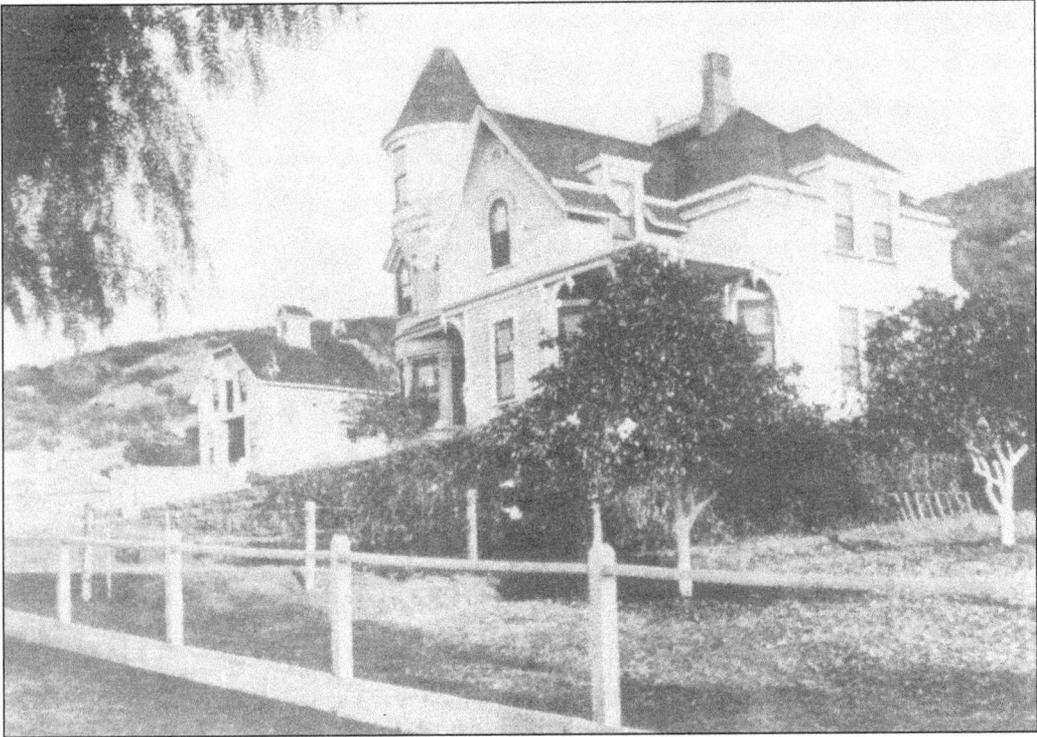

Once the show place of Lakeside, there is still an air of grandeur surrounding the Castle House. The first home in Lakeside, which cost $9,000 in gold, was built of Redwood from Oregon with double floors of pine. The shingles on the second story and the tower were diamond-shaped. All of the original windows in the house have a border of small panes of various-colored glass, typical of Colonial days. On the first floor is a large pantry. The staircase leads to the second floor with its five bedrooms, two large hall closets, and second tower room. A narrow circular stairway leads to the top tower room, which makes an excellent observatory for viewing the valley.

George H. Mansfield, vice-president of the El Cajon Valley Land Company, was a bachelor from New York. The El Cajon Land Company built the Castle House in 1887 for him as a show place in the style popular in New England at that time.

13

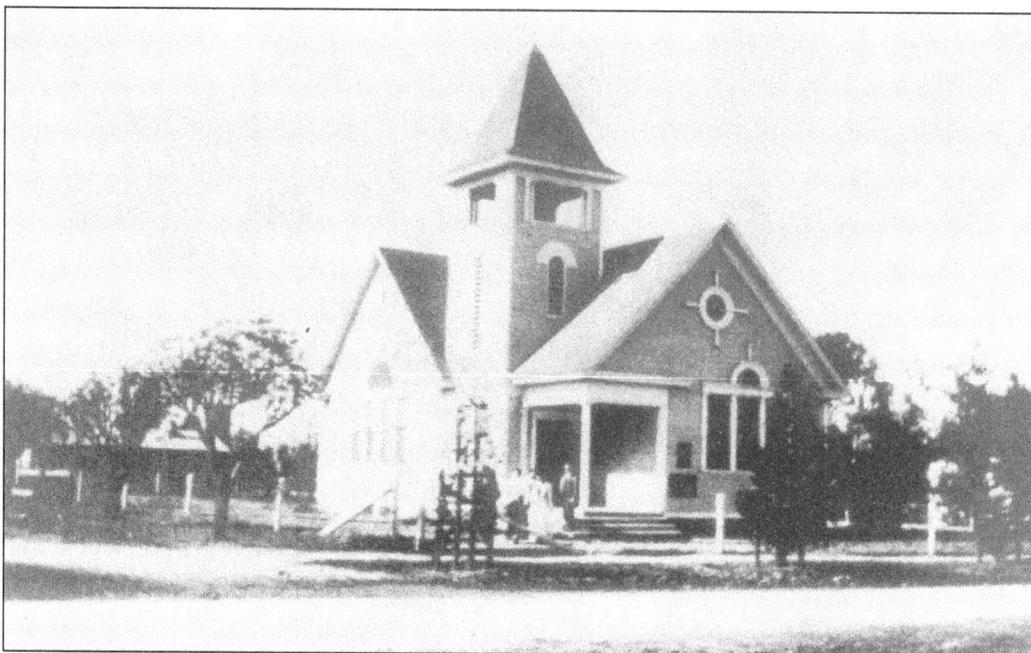

Lakeside's first church was organized in 1883 with 13 charter members. Worship services were conducted on the porch of the old Lakeside Inn, which was located approximately where the Lakeside Post Office now stands.

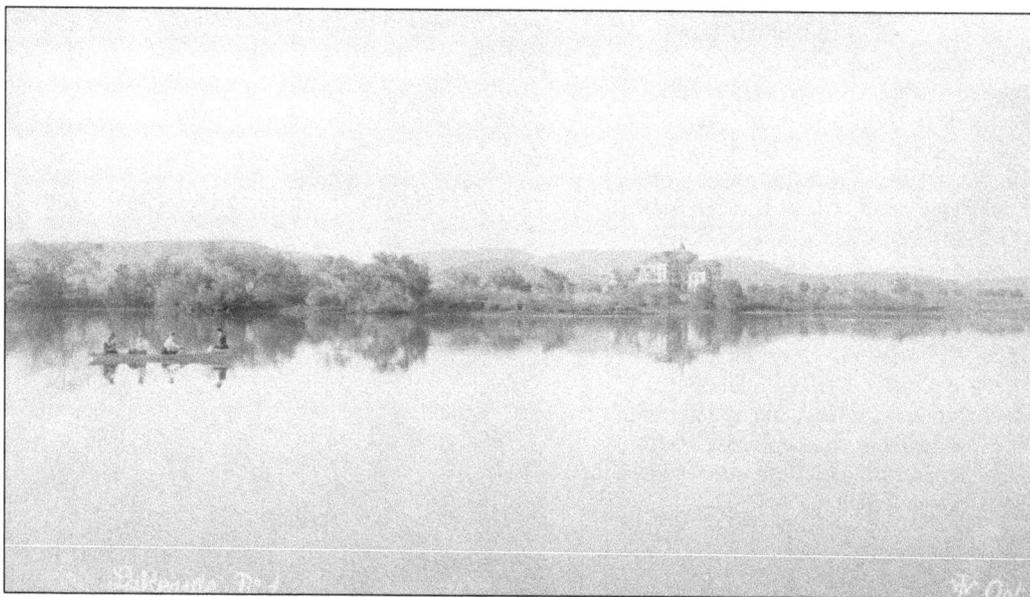

In 1895, construction began on the sanctuary which still stands as a familiar landmark at the corner of Parkside Street and Maine Avenue. The first service in the new sanctuary was held on February 9, 1896, and formal dedication was held on March 29, 1896. It is now designated as an historical site within the Presbyterian Church and is now owned and occupied by the Lakeside Historical Society. Pictured above, boaters enjoy Lindo Lake with the newly completed Lakeside Inn in the background.

14

Two

THE LAKESIDE INN
AND RACETRACK

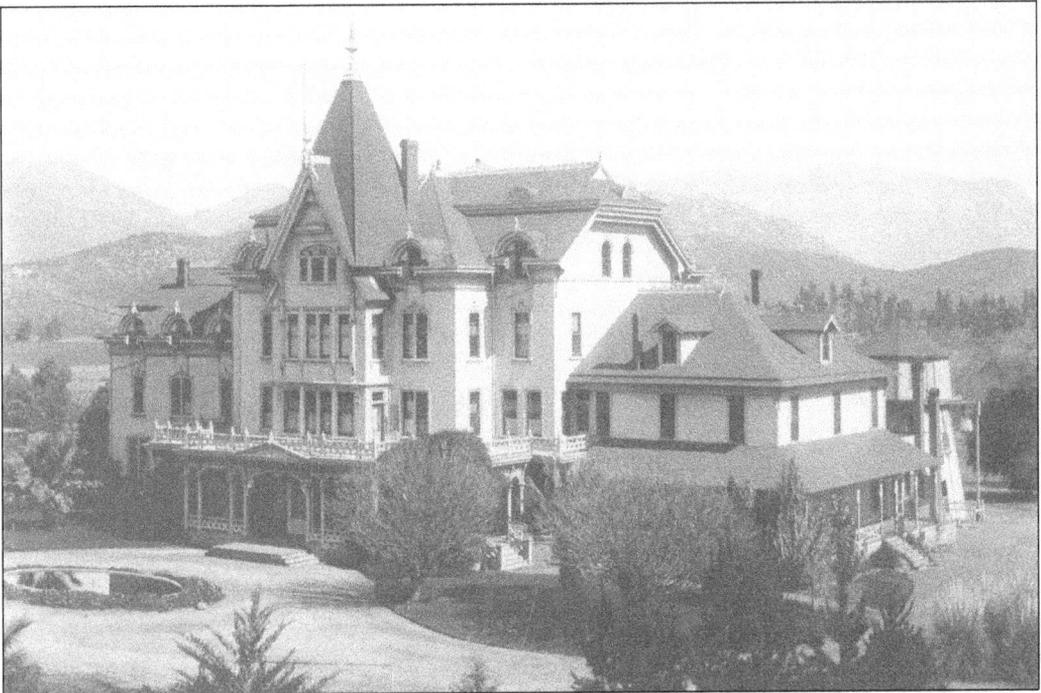

The El Cajon Land Company built the Lakeside Inn in 1887. This was the company that subdivided and laid out Lakeside's town site, dedicating 45 acres of land, which included Lindo Lake, as a public park. Captain Joseph Smith managed the Inn for the Land Company for a number of years.

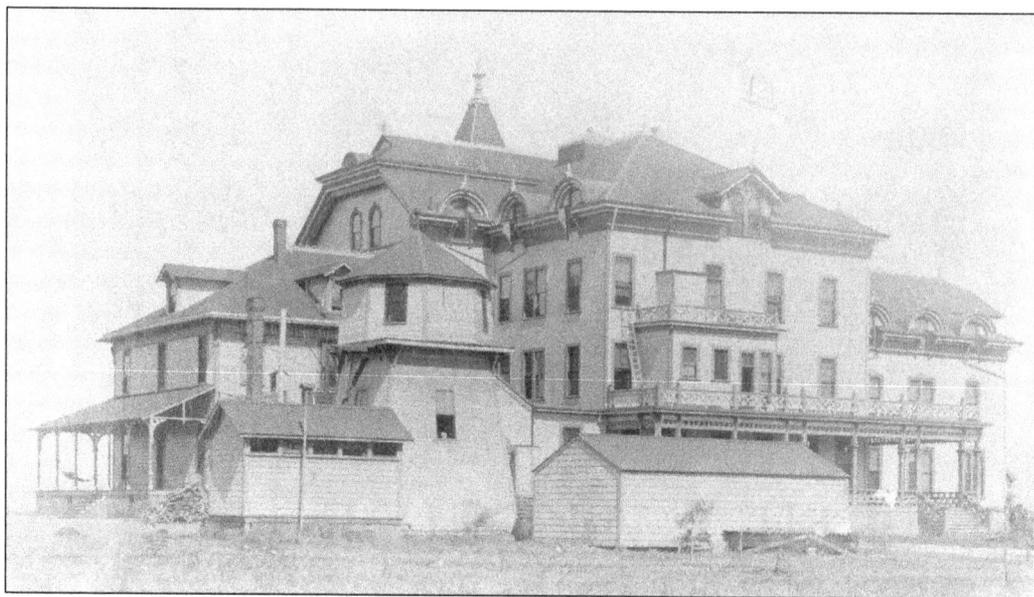

This photo reveals the rear of the newly-constructed Lakeside Inn with the American flag proudly flying above. The water tower stands in the foreground.

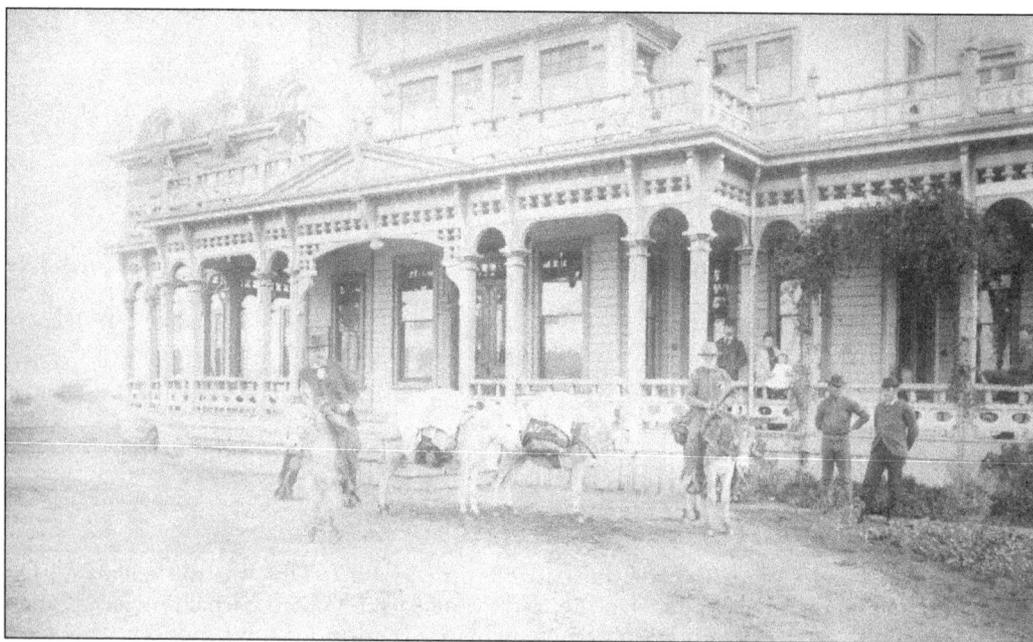

Some of the Inn's first visitors were two traveling men with their pack mules.

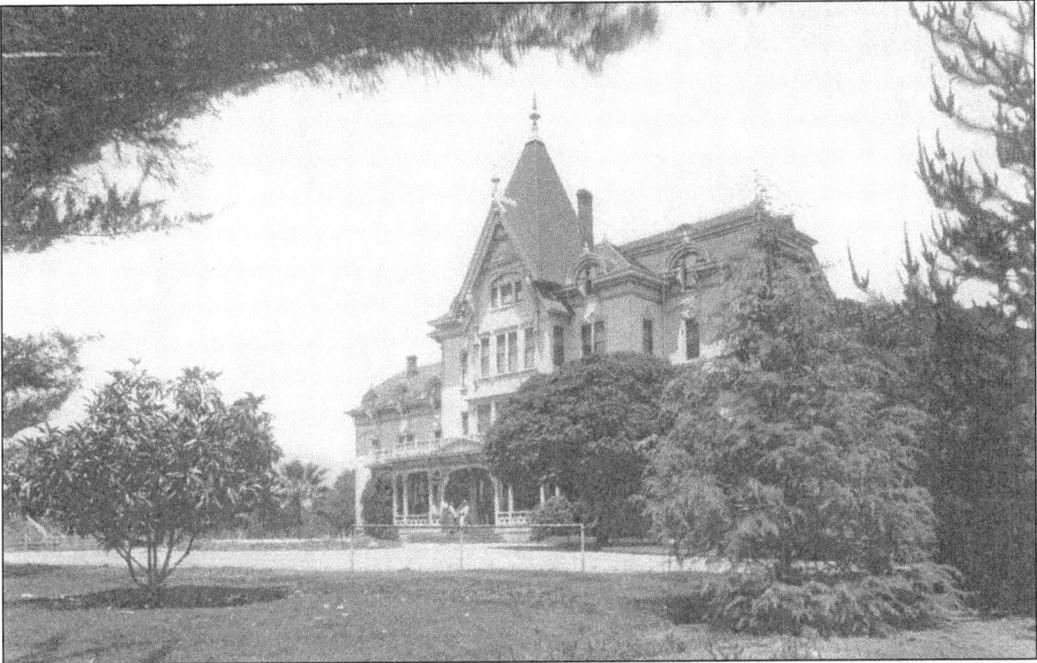

The 80 rooms in the Lakeside Inn were spacious, single or suite, with large windows that afforded plenty of sunlight and a view of the beautiful surrounding mountains. There were electric bells, gaslights, telephones and a spacious and warmly decorated lobby. A system of gas and sewerage, including the baths, was complete. The architecture was similar to the Hotel del Coronado, so the Inn was frequently referred to as "The Coronado of the Hills." (Photo: 1910.)

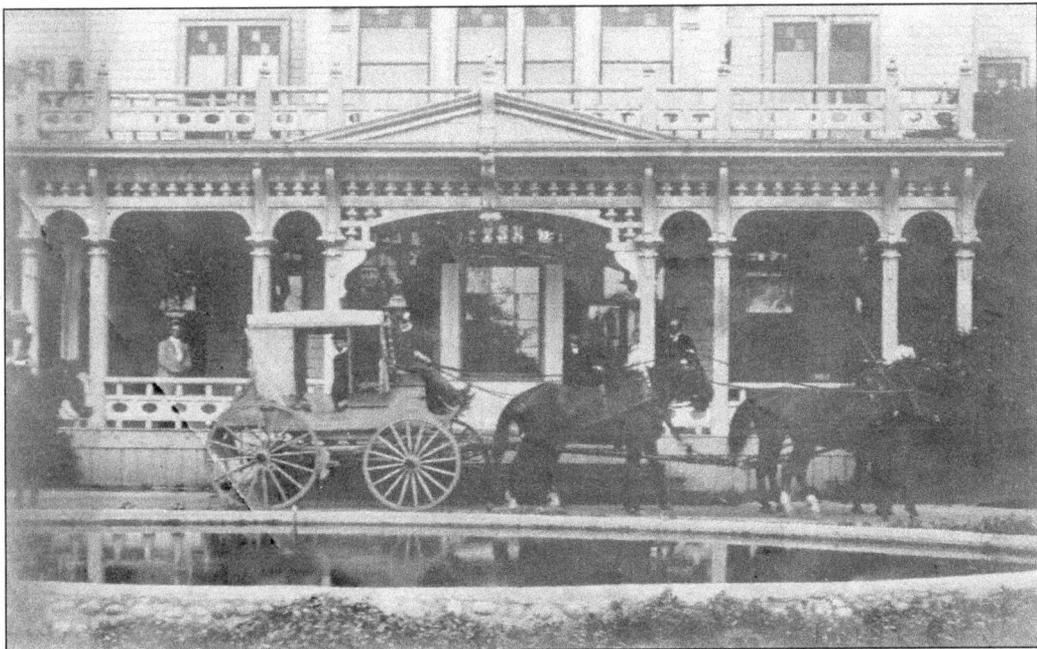

The stagecoach made frequent stops at the Inn. In this image, the stage driver waits patiently while visitors prepare to depart in 1900.

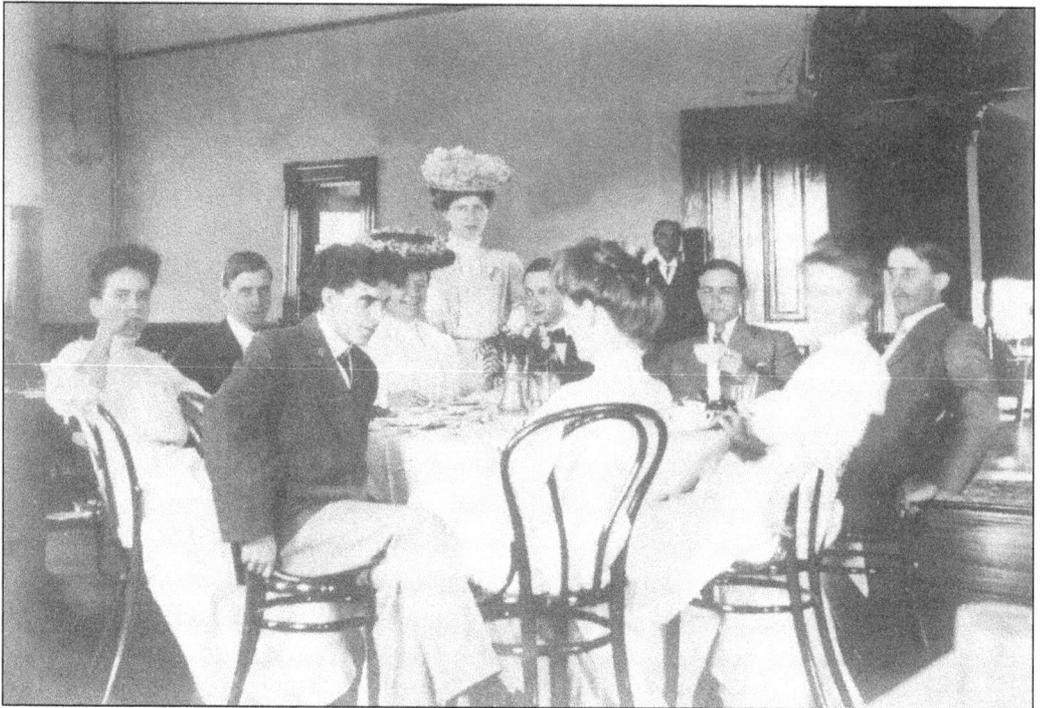

Cuisine at the Inn was considered outstanding, as the 300-acre farm owned by the Inn furnished garden fresh vegetables. Eggs were fresh from the hennery with Jersey milk and butter provided by their dairy and the squabs from the loft. This photo was taken in 1906.

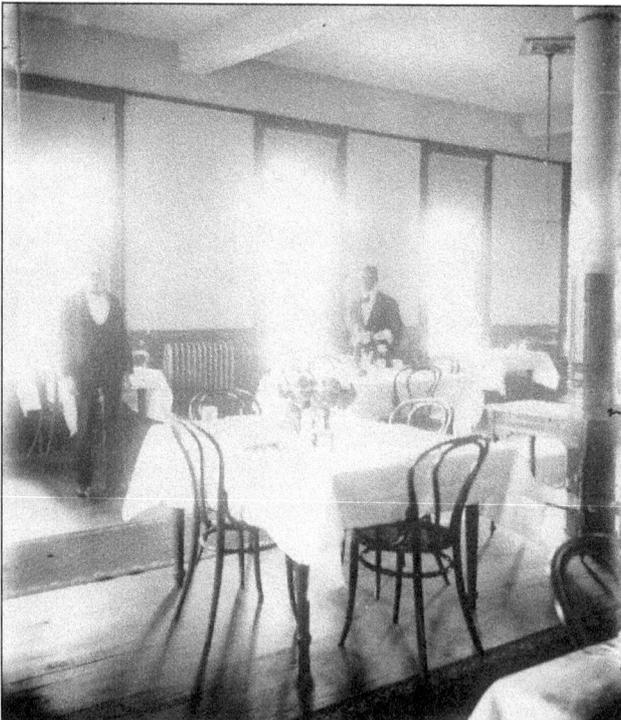

This photo shows the Inn's dining room.

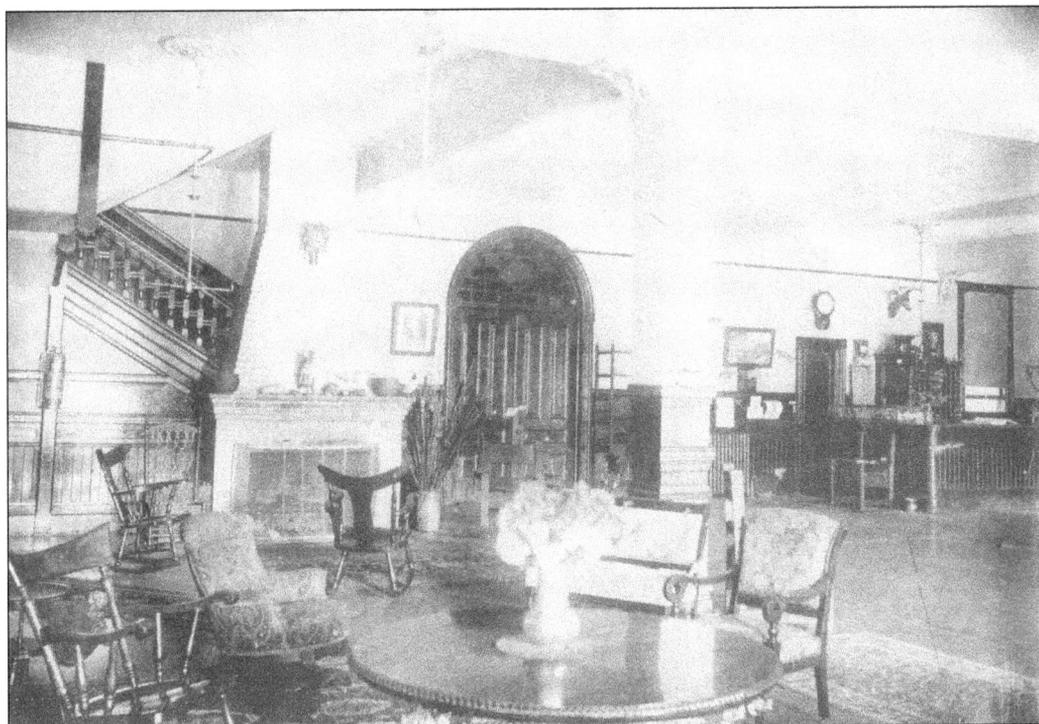

Visitors to the Inn had their first impression of the luxurious furnishings as they entered the spacious and warmly decorated lobby. Rates at the Inn were $10 per week or $2 a day, with special rates for nurses and children.

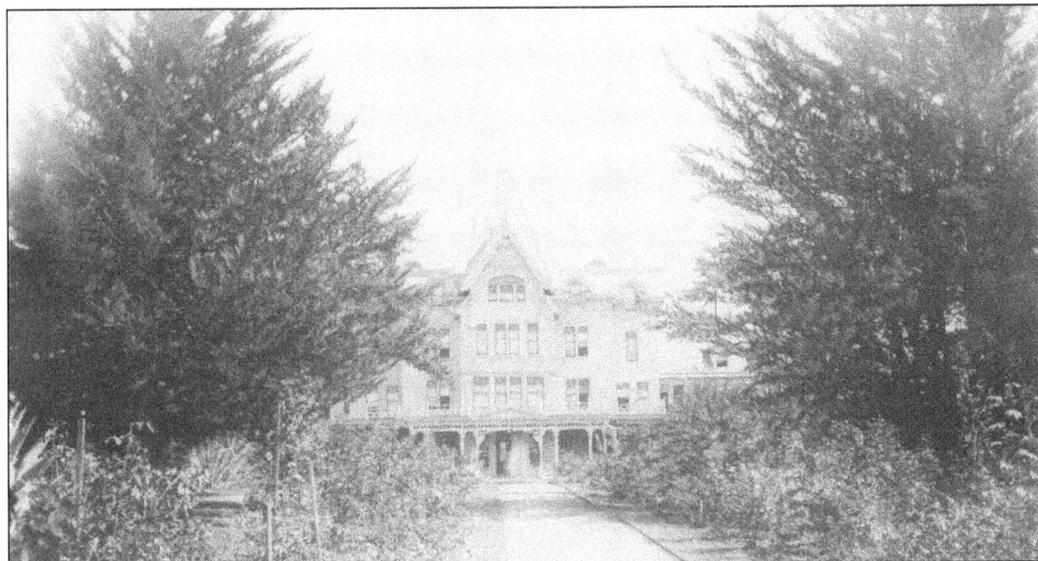

In about 1900, the Inn was sold to Father Henry Eummelen and Tom Fisher. Father Eummelen, a Catholic priest, was also a noted doctor and established the Kneipp Sanitarium in connection with the Inn. His Kneipp Water Cure for rheumatism and paraplegics was similar to the now famous Sister Kenney Cure. The sanitarium consisted of hot baths and water exercise and was located in back of the Inn in a number of wooden buildings.

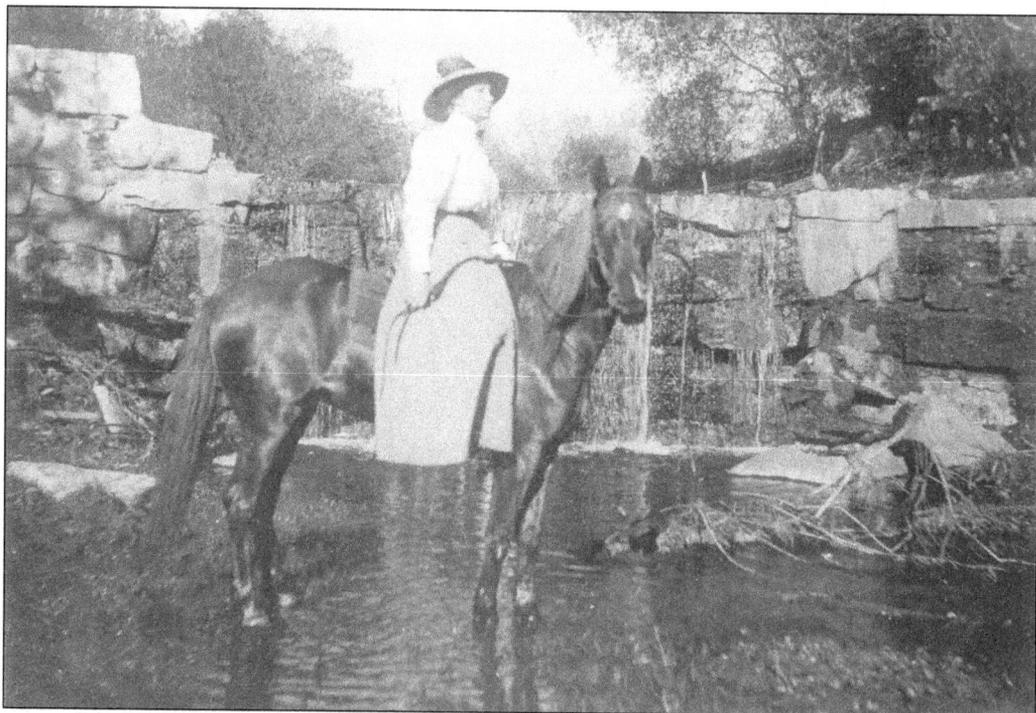

Livery service was complete with carriages of all descriptions. There were a variety of saddle horses, many of which were suited for children, ladies, and sportsmen. A guest of the Lakeside Inn in 1900 sits on her horse in front of the Los Coches Dam. This dam was built for the purpose of supplying water to the Inn.

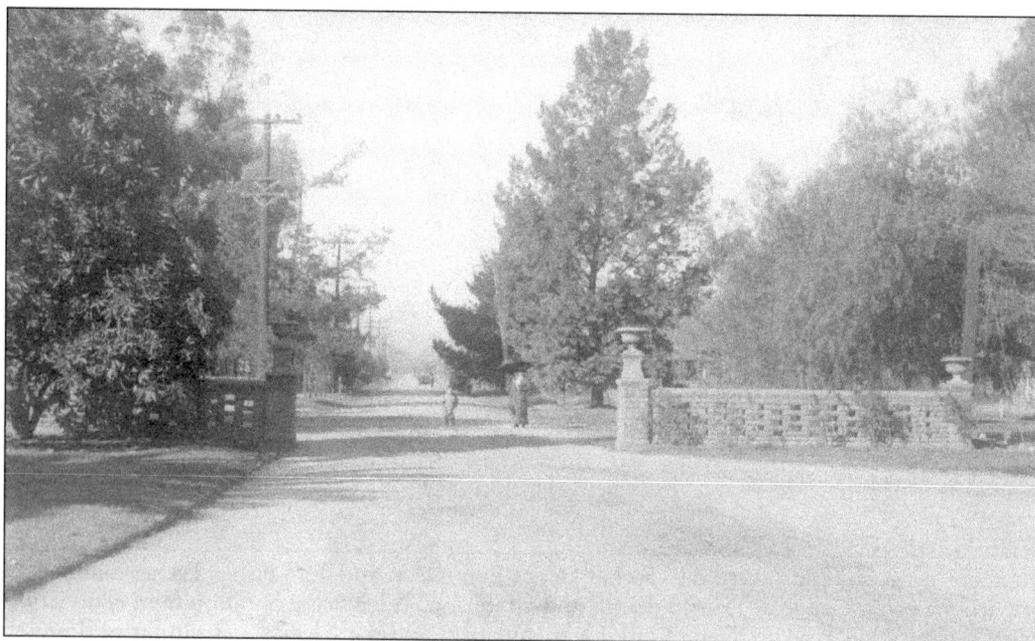

This photo shows the recently completed block wall at the entrance to the Lakeside Inn. This picture is looking west down Woodside Avenue in 1908.

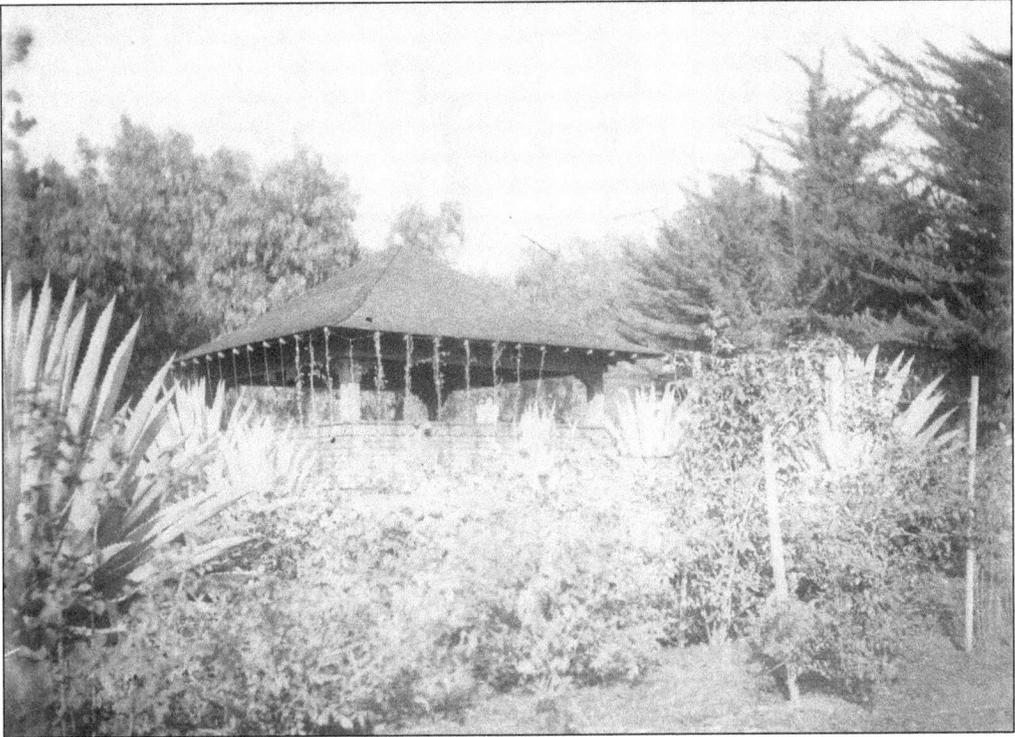

On hot summer days, the cool Spring House (Cabana) and gardens were a welcomed relief. Today, the roof of this building is all that remains of the Inn. It is part of the old Cecil's Restaurant near the corner of Woodside and Maine Avenues.

The lush gardens began at the back steps of the Inn.

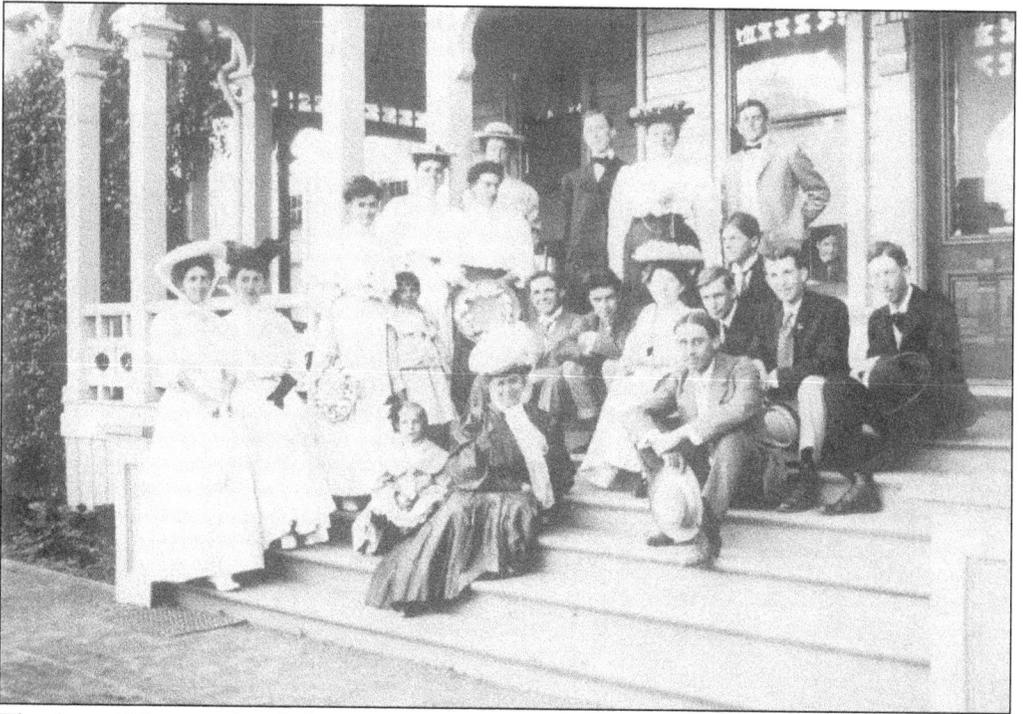

The beautiful grounds of the Inn were the scene of many parties where celebrities and millionaires met for golf, boating, duck hunting, or to attend the races. The ballroom of the Inn was the scene of many social festivities.

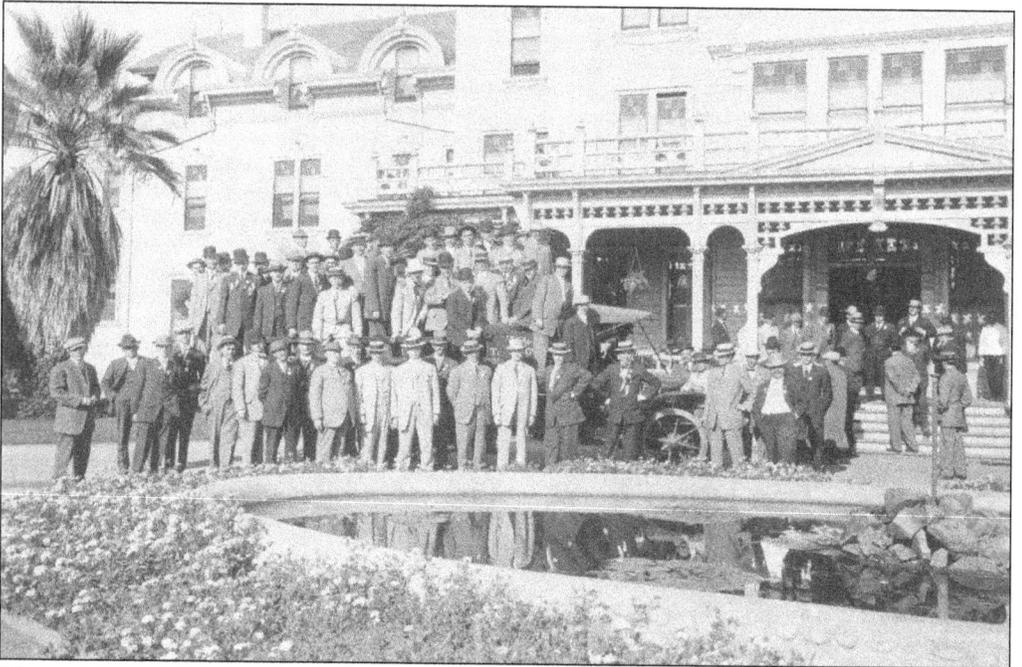

This event at the Inn was no doubt a gala celebration with much "whoopee." Notice that all of the men were wearing hats—something unheard of today.

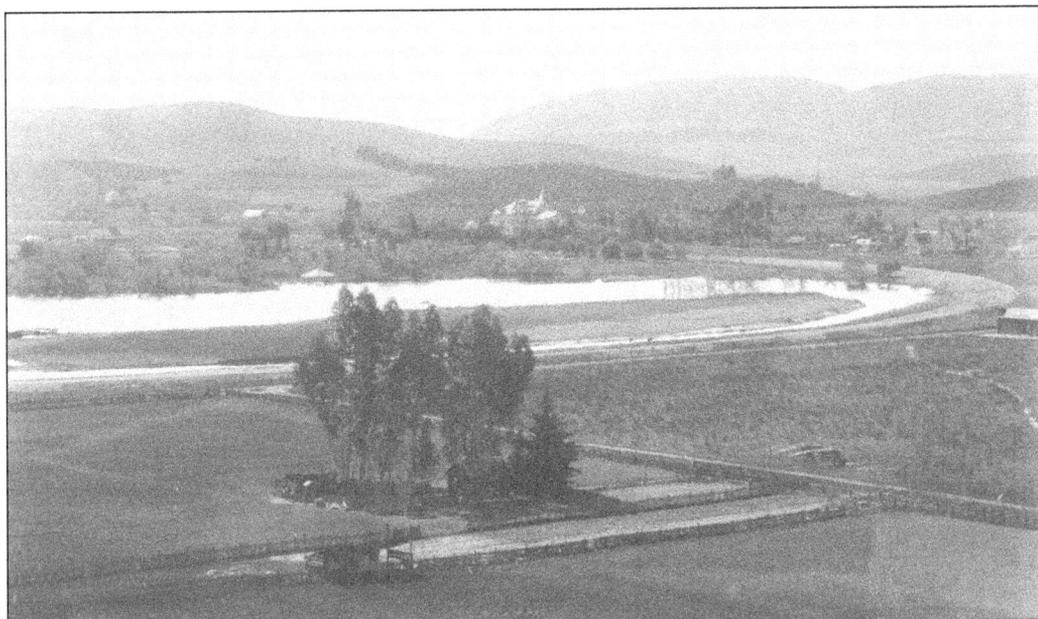

John H. Gay bought the Inn in 1904. He fenced off the park and claimed it as part of the estate. He laid out a 60-foot wide racetrack that was especially adapted for automobile and horse racing. The track circled the lake. W.A. Crow ran the Inn for his uncle, John Gay, until about 1908.

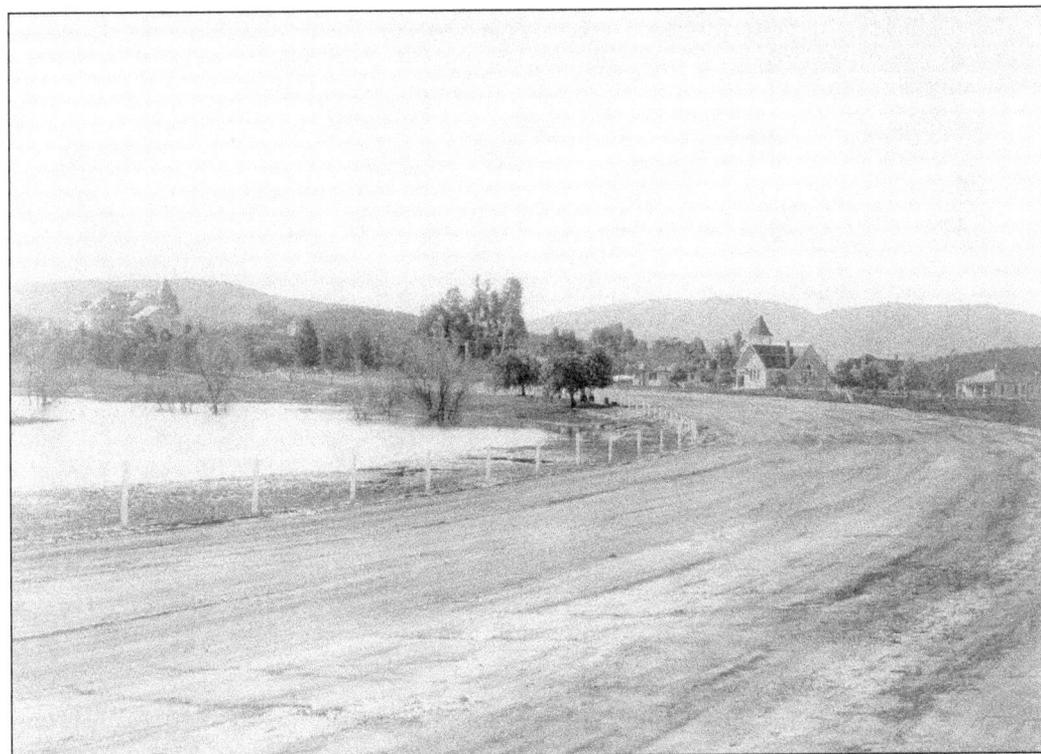

The newly constructed racetrack with the Inn (left) and the Lakeside Community Church (right) in the background is pictured above.

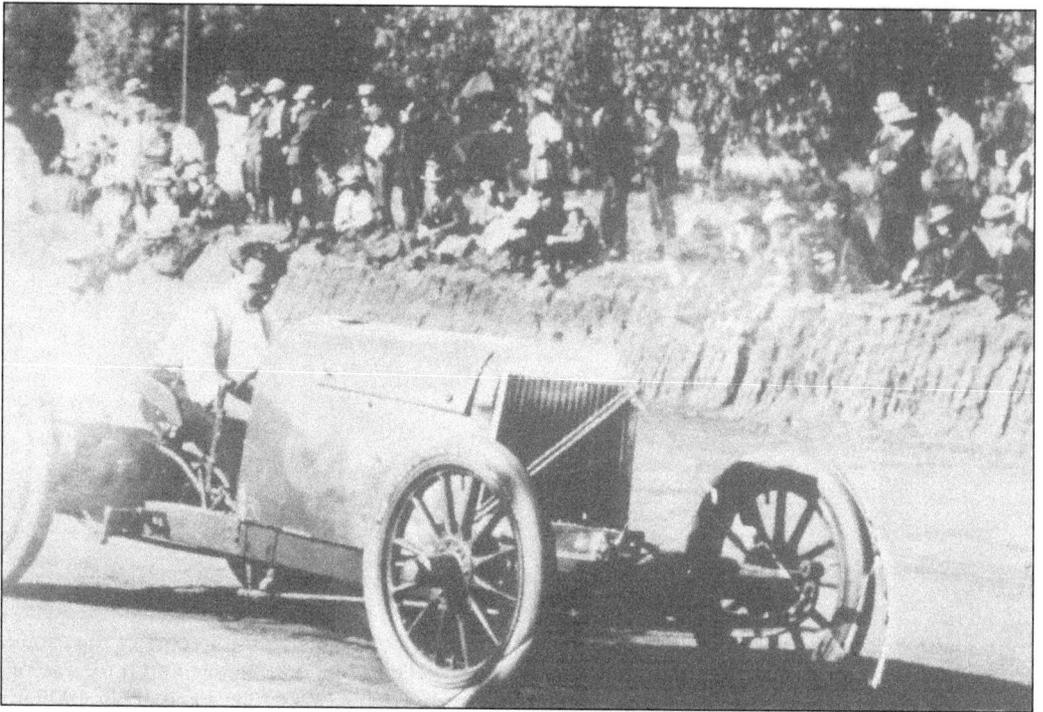

On April 7, 1907, The *San Diego Union* announced the first event to open the new racetrack. Barney Oldfield in his "Green Dragon" (pictured above) was to be featured in a match against Bruno Seibel in the "Red Devil" on Saturday, April 20 and Sunday, April 21, 1907. Special excursion trains ran from San Diego to Lakeside and returned after the races.

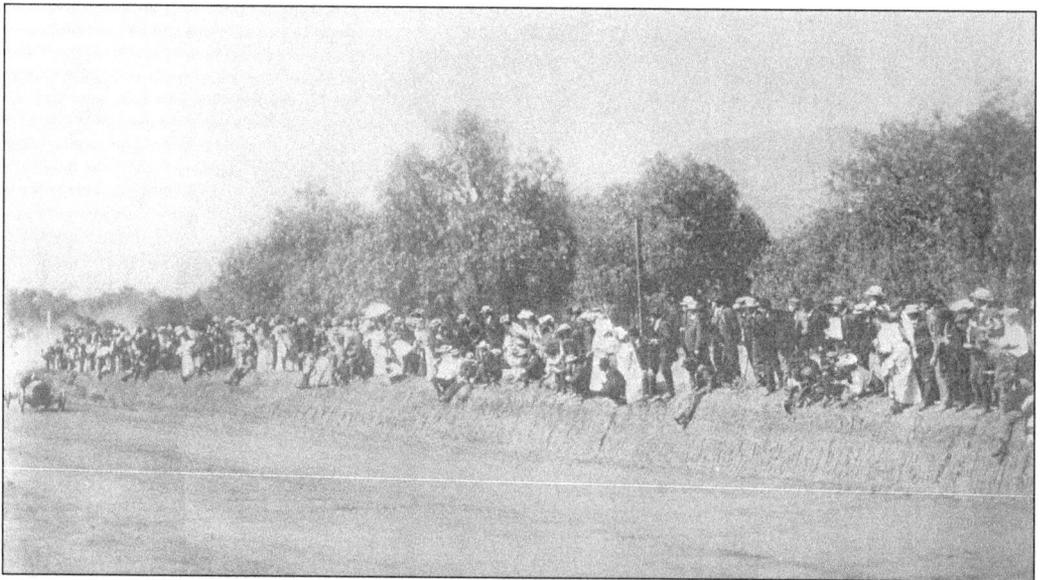

The *Union* stated that the largest crowd in Lakeside's history was expected. Both Oldfield and Seibel pronounced the track as excellent and without a peer anywhere in the world. According to the April 22, 1907 issue of the Union, Oldfield had set a new record of 51.8 seconds for the mile (a death defying 70.3 mph).

24

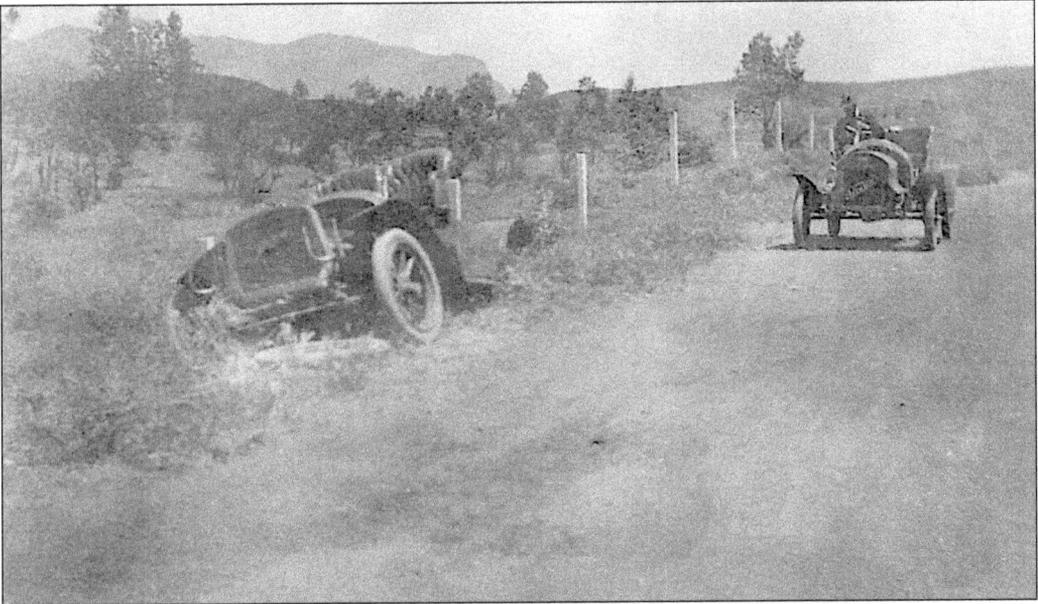

On June 12, 1908, at the Lakeside Speedway track, Roy just missed running into this "smash-up" at 50 mph. It is said that he stopped his car and brought the men back to the Inn.

Mrs. Wormington stands in front of the cement block wall of the Lakeside Inn in 1909. The Wormington's were one of the owners of the "Castle House" on Orange Avenue (Castle Court). (Photo by Charles Petty, "the Tramp Photographer.")

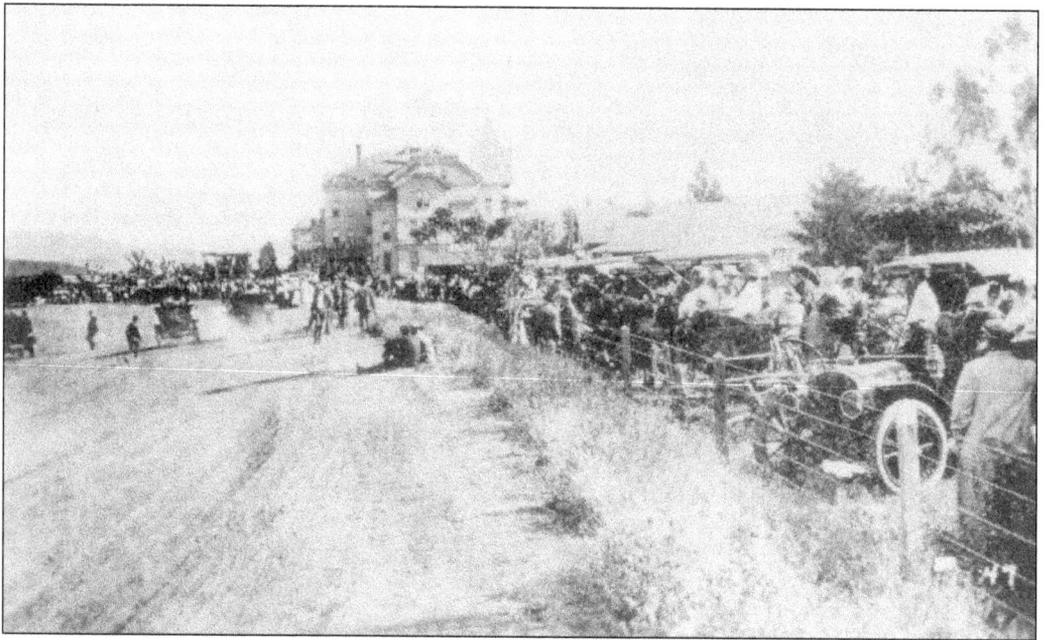

Hundreds of people enjoy a Sunday afternoon at the races in this 1912 photo with the Victorian-style Lakeside Inn as a backdrop.

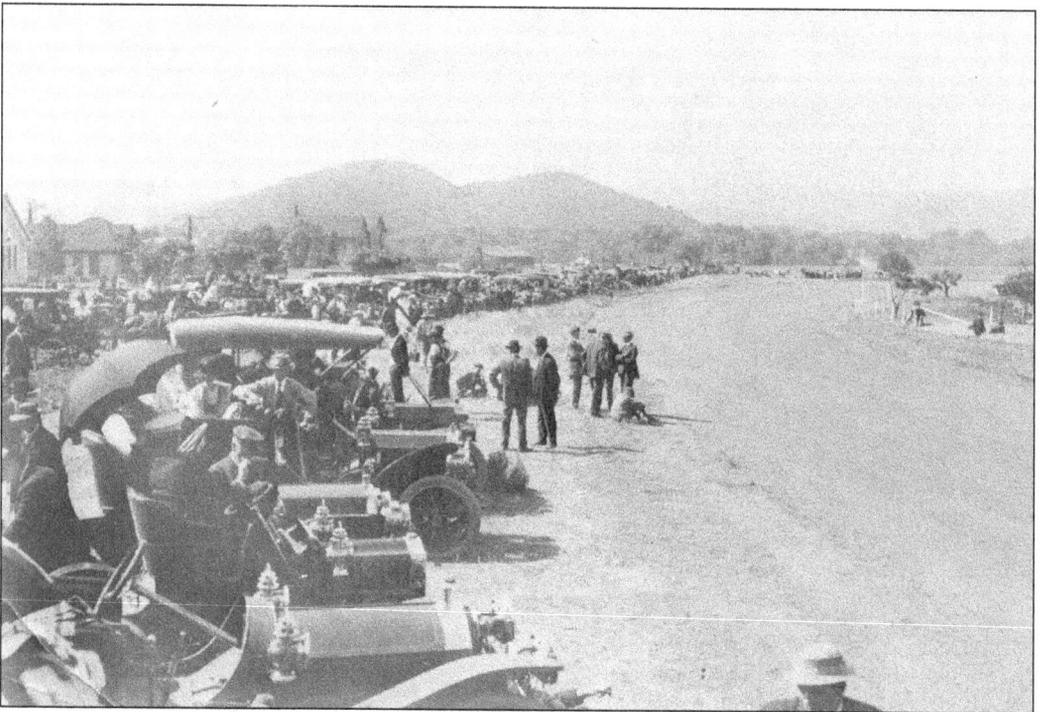

For about 10 years, regular weekly auto and motorcycle races were held at the dirt circular track. Many old-timers recalled spending Sunday afternoons at the track, even testing their own driving and mechanical skills. This picture is looking north with Maine Avenue to the left behind the row of cars.

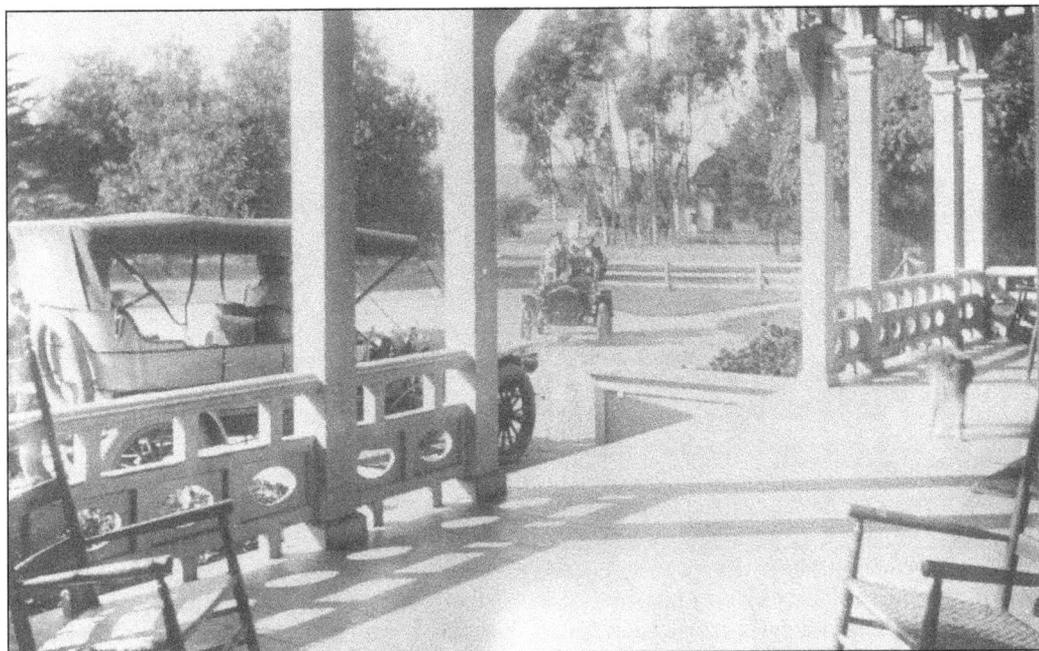

In 1914, the Inn was still a popular resort and sitting on the front porch was a wonderful way to spend a lazy afternoon.

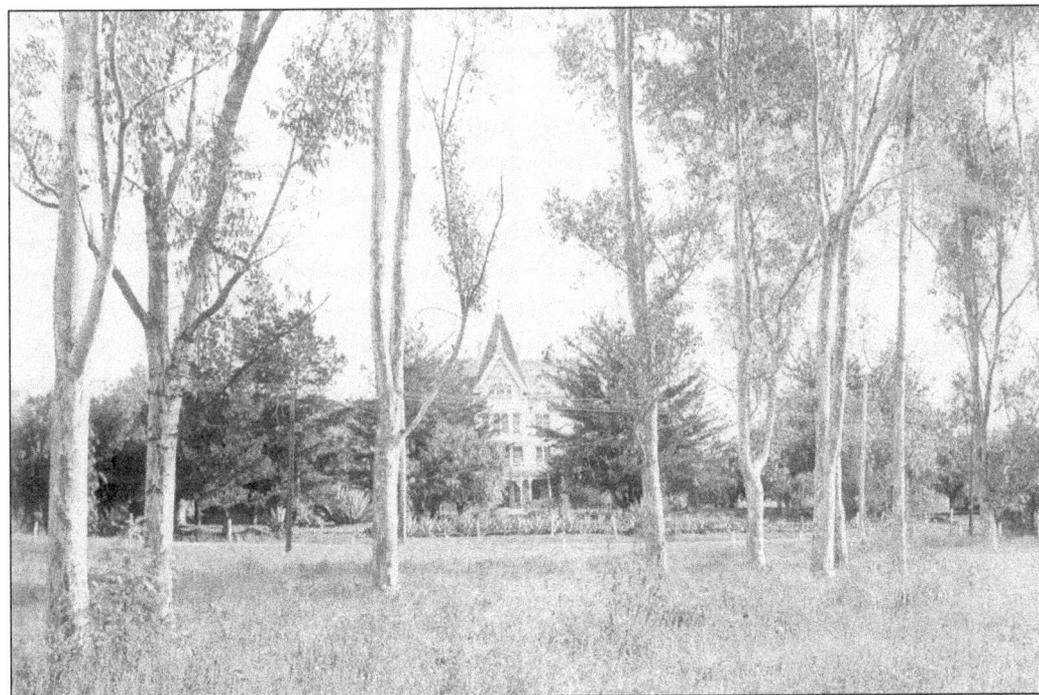

Some of the area old-timers remembered that the land and lake had been dedicated as a park. They proceeded to bring suit for its return. After many long court battles, the County of San Diego regained possession of the park on May 11, 1919, and it was again open to the public and no longer for the exclusive use of the Inn's patrons.

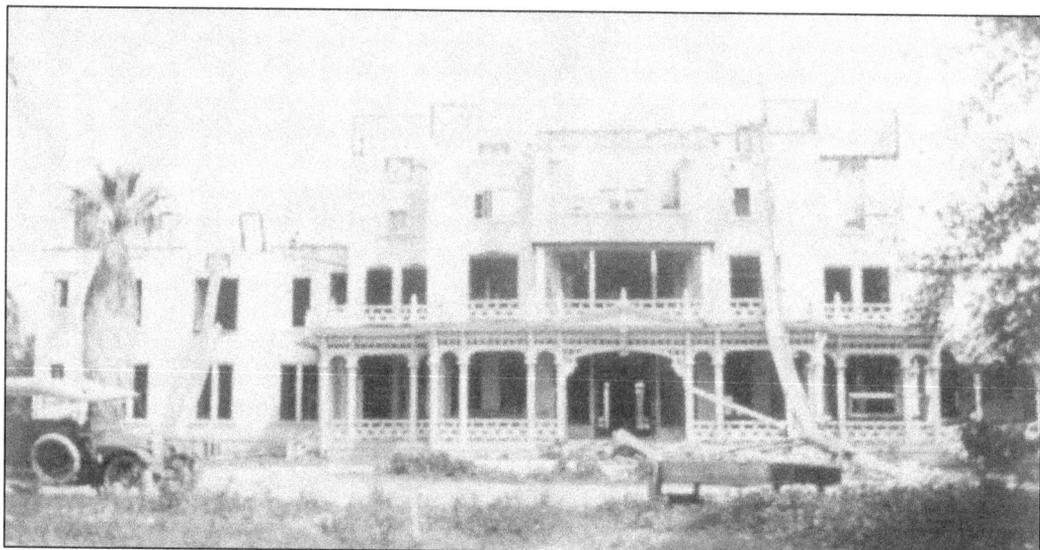

While the park and lake (its principal assets) were in litigation, the mammoth four-story structure lost its value as a resort hotel. So in February of 1920, the Lakeside Inn was torn down after many years of idleness. It has been stated that Gay became so embittered over the loss of the lake and surrounding property that he placed in his will the desire that upon his death the Inn be demolished.

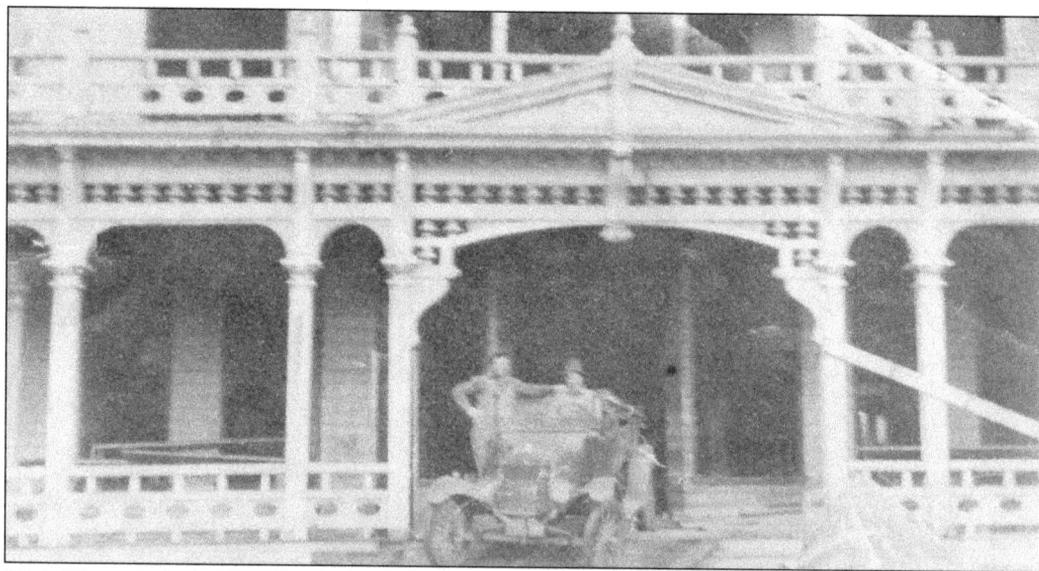

Walt Hartung helped with the demolition of the Lakeside Inn. Following World War I, building materials had soared in price so that the lumber from the Inn brought more cash than the original cost of the building, which was about $50,000. Much of the lumber went into homes that were being built at the time. Tom La Madrid, Lakeside's blacksmith, claims to have gotten the prize bargain. He bought 18 heavy doors, 10 feet high, for $1.50 each, which included rollers. They had been used between the dinning room and the lobby when the doors were rolled back, making it one large room.

Another historical building whose beauty could now enhance our area is gone. How nice it would have been to hold onto this part of Lakeside's heritage.

Three

LINDO LAKE

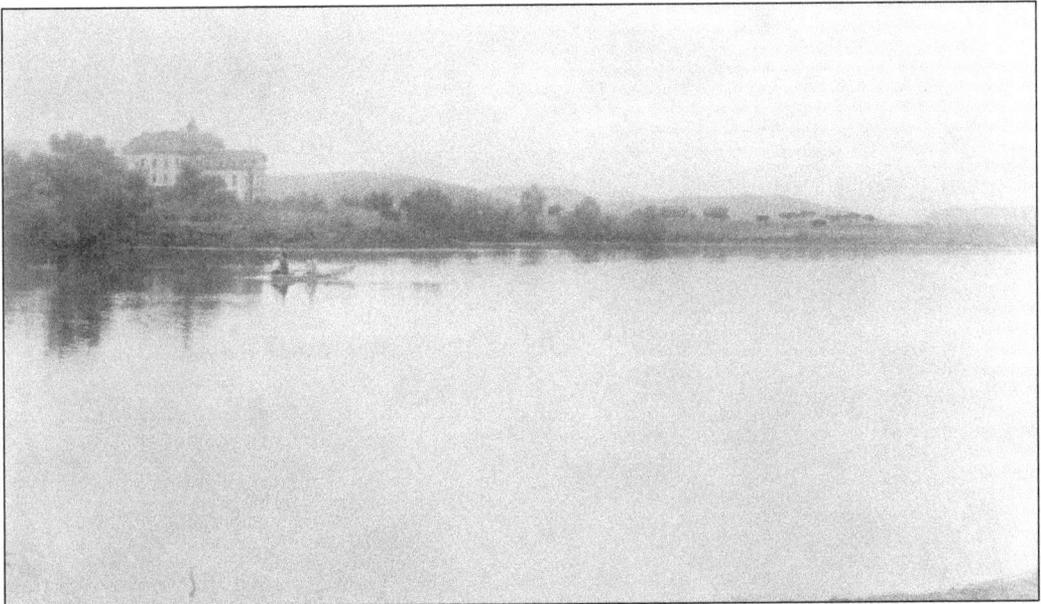

Boating and fishing were a favorite pastime on Lindo Lake. This image shows boaters enjoying the lake in 1887 with the new inn in the background.

Claimed to be the only natural freshwater lake in San Diego County, it was originally fed by mountain streams. When subdividing land in 1886 for the 3,000 acre Lakeside Town site, the

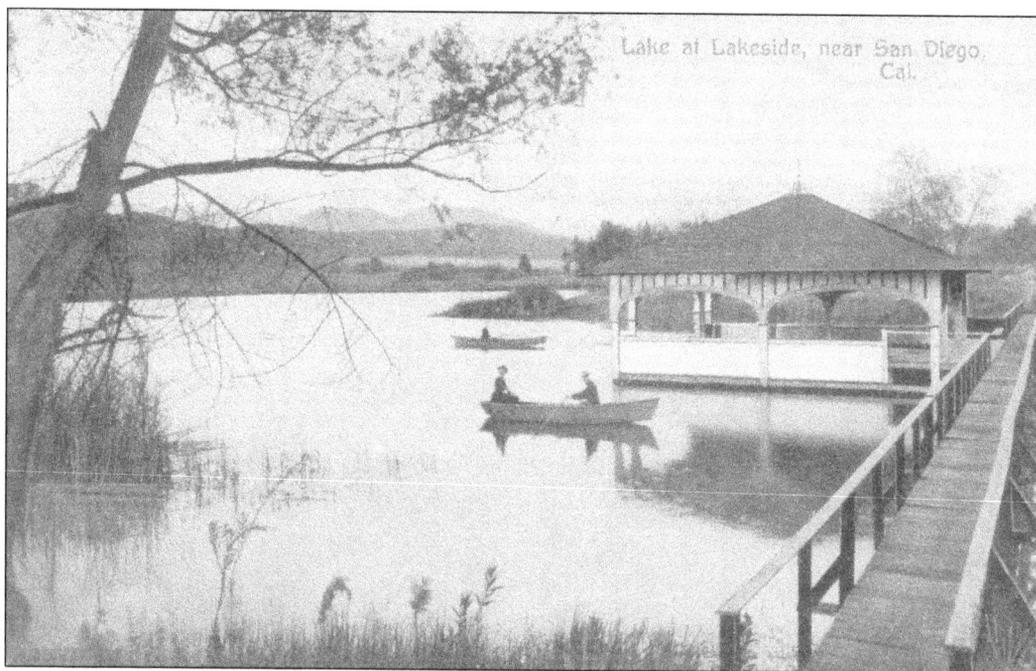

Lake at Lakeside, near San Diego, Cal.

This postcard from around 1910 shows the boathouse and boaters enjoying the lake.

El Cajon Valley Land Company dedicated 45 acres as a public park. The park was landscaped and a boathouse was built. This natural lagoon became known as Lindo Lake.

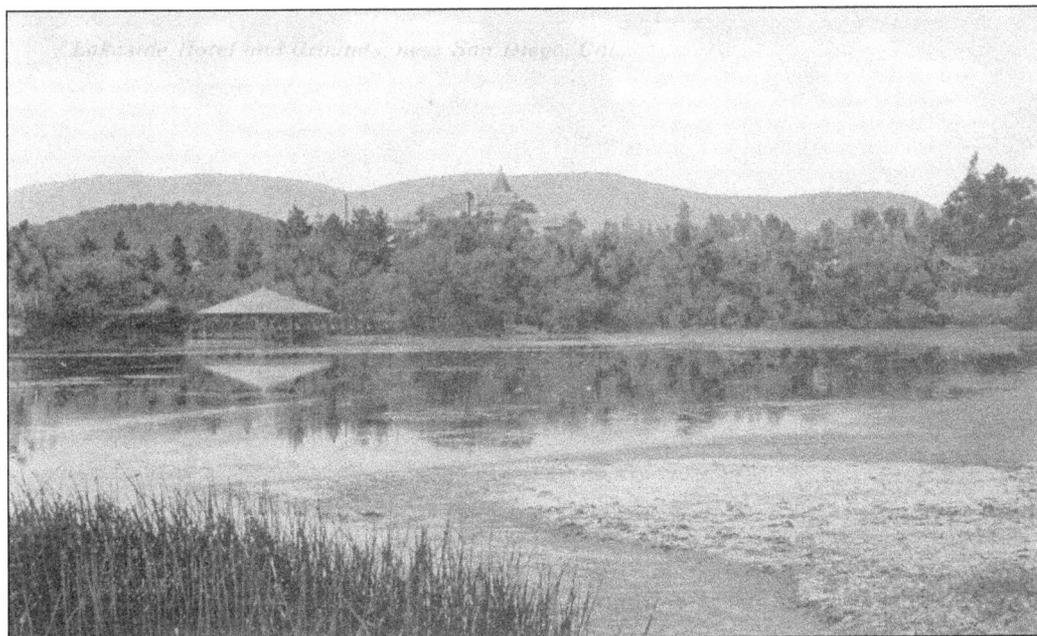

This postcard of Lindo Lake, the boathouse, and the Inn were on sale at the 1913 Panama-California Exposition held in San Diego at Balboa Park. The Exposition was to commemorate the completion of the Panama Canal.

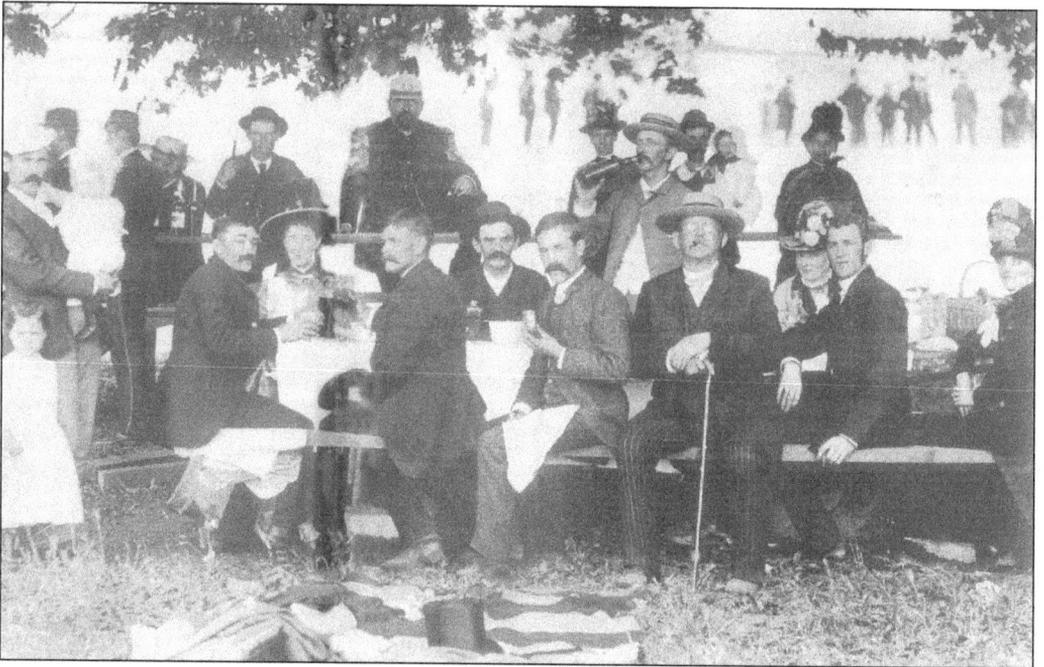

When the railroad came to Lakeside, families from throughout the country would proceed to Lakeside on the San Diego & Cuyamaca Eastern Railroad. Not much lake was apparent, and the decorations consisted mostly of sand and eucalyptus trees, but the picnics were always very exciting. Note the man with the bottle; there is one in every crowd. (Photographer, J.A. Sherriff: 1887.)

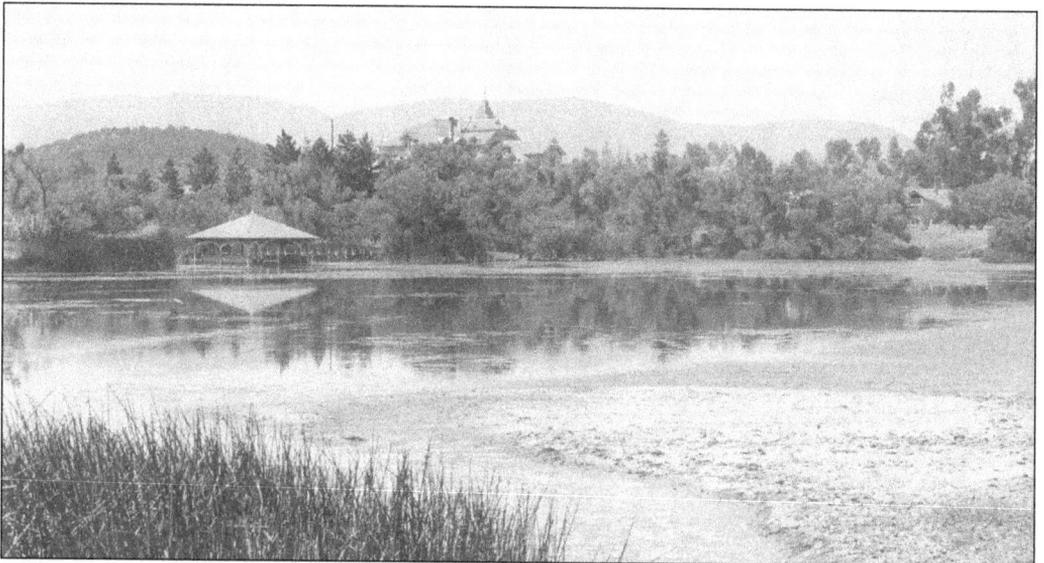

The boathouse sits on Lindo Lake with the Lakeside Inn in the background in 1907. According to old-timer William S. Doty, " . . . the sack races, three-legged races, and potato races were both exhausting and dramatic, and the food, naturally, was superb." There are accounts of the train being so over-crowded that the boys would justifiably sit on the steps of the open platforms of the little cars and feel that this was, indeed, life in the raw.

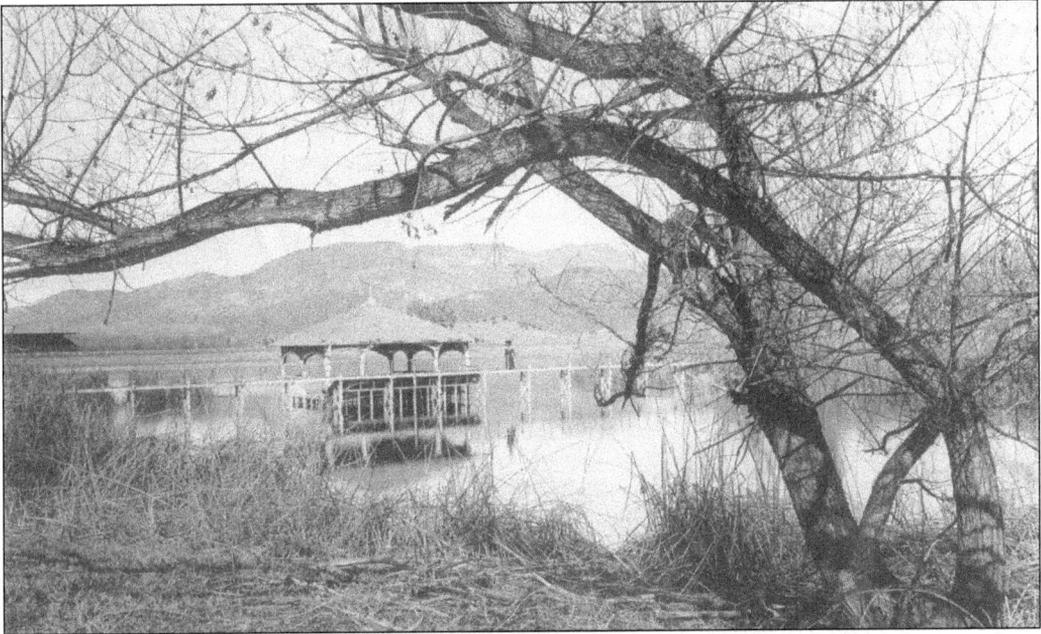

This is a view of the boathouse and walkway with the racetrack bleachers on the left in the distance.

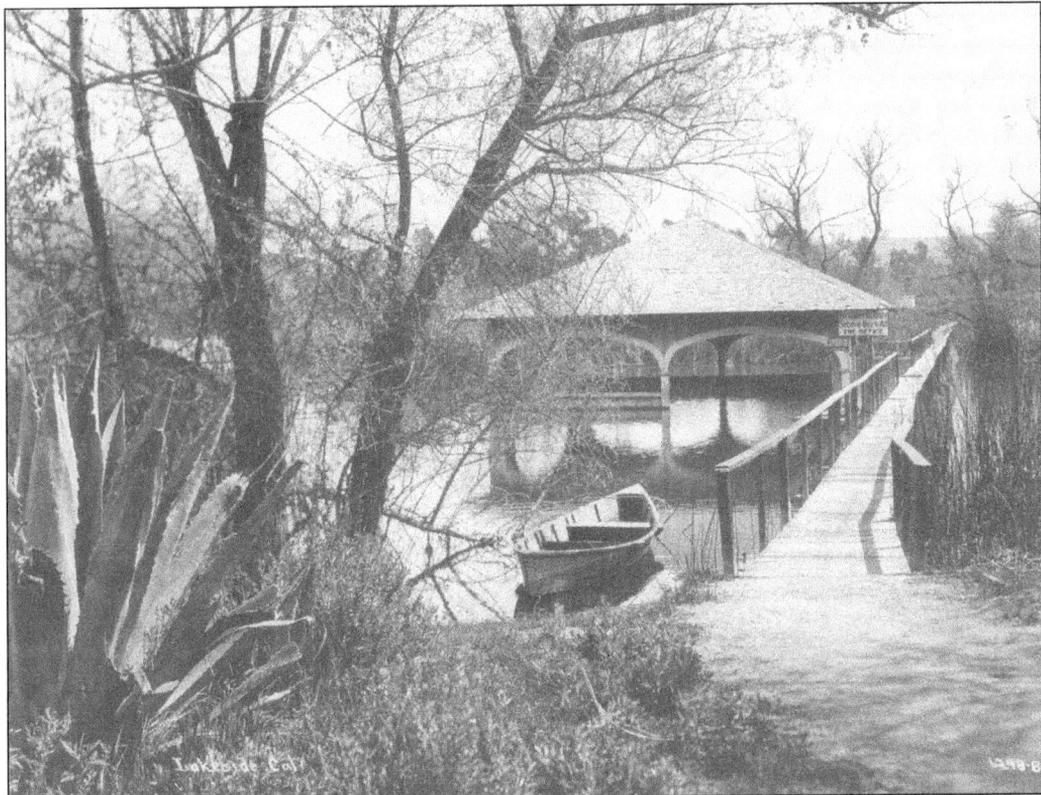

This is a view looking north of the boathouse and walkway in 1907.

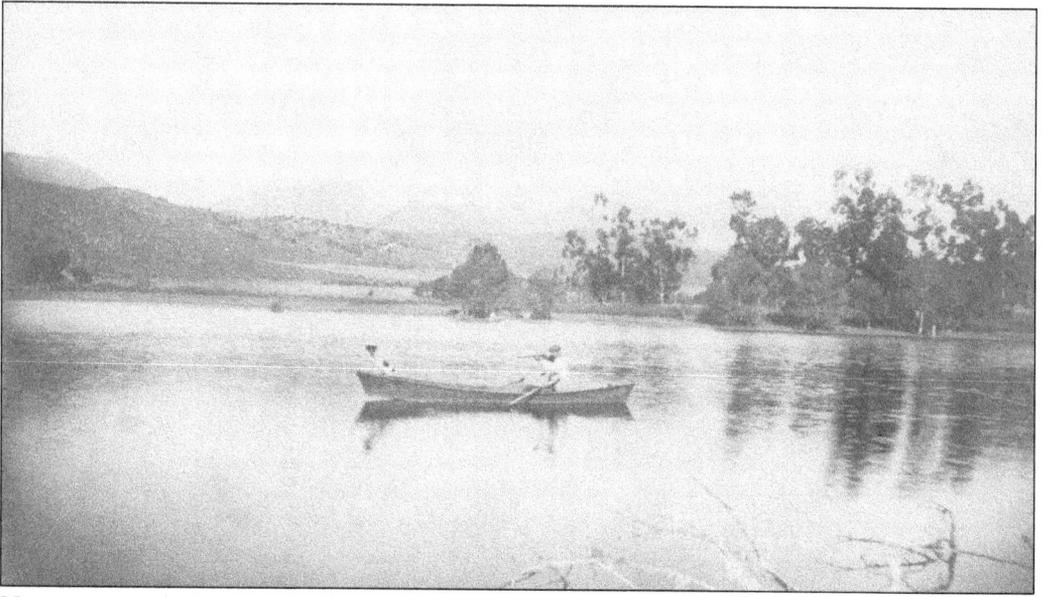

Hunting waterfowl was a popular sport on Lindo Lake in 1909. This gentleman is hunting from a boat with his bird dog. (Photo by Charles Petty, "the Tramp Photographer.")

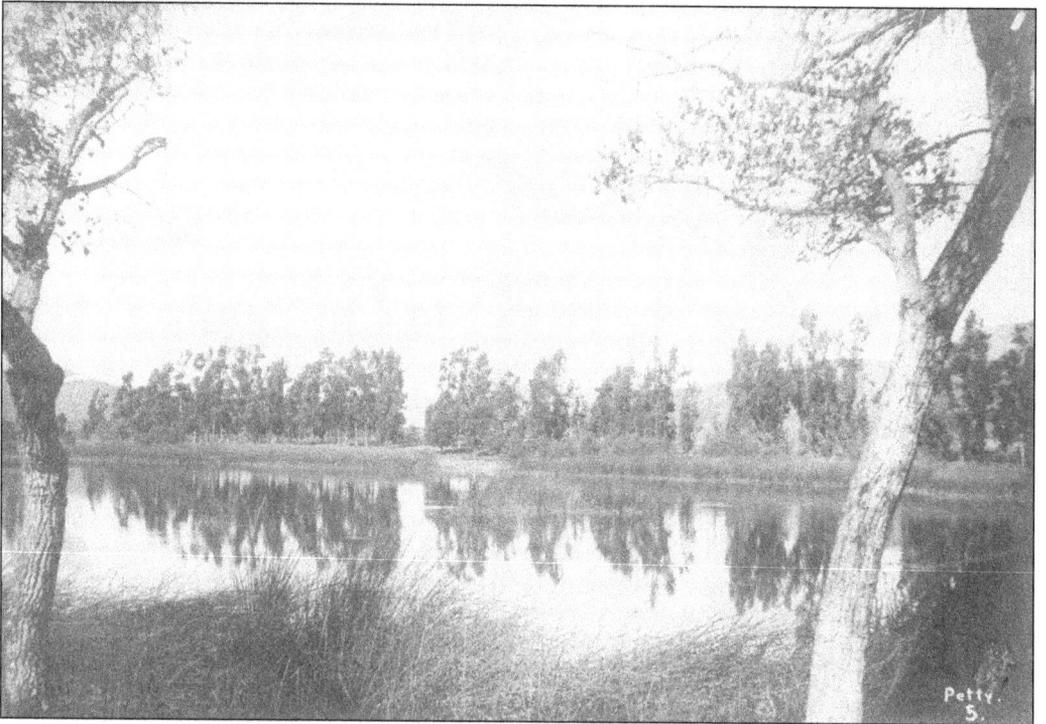

The beautiful scenery surrounding the lake in 1909 offered Charles Petty a wonderful subject for his photography.

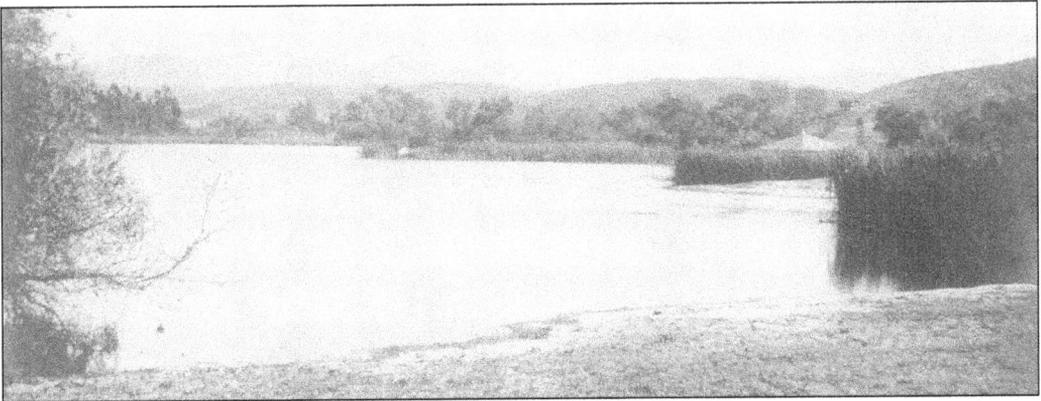

This photo shows Lindo Lake looking towards the southeast in 1909. (Photo by Charles Petty, "the Tramp Photographer.")

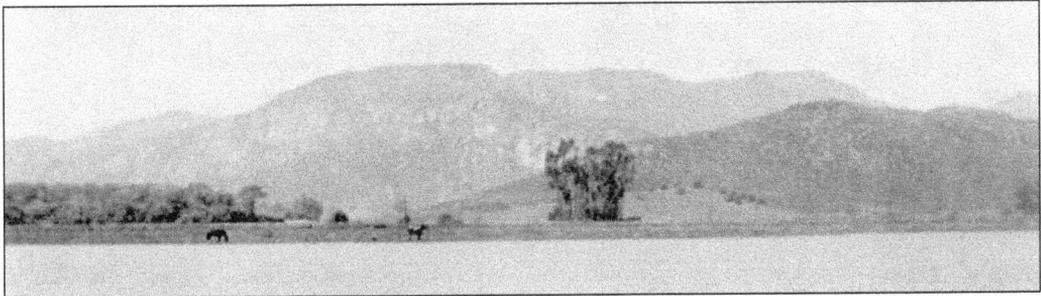

Looking across the lake to the north in 1918, Lindo Lake is still at maximum capacity after the Flood of 1916.

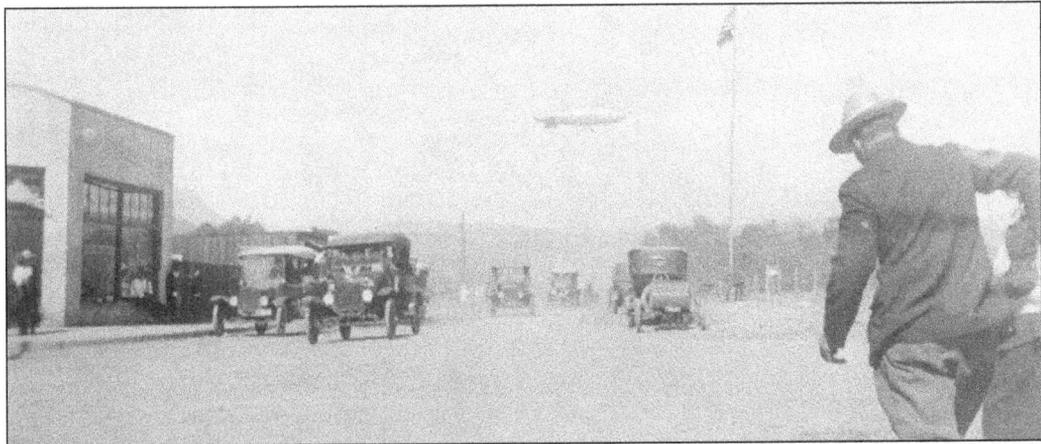

John H. Gay bought the Inn in 1904 and he fenced the park and claimed it as part of the estate. Some of the area old-timers remembered that the land and lake had been dedicated as a park, so they proceeded to bring suit for its return. After many long court battles, the County of San Diego regained possession of the park on May 11, 1919. It was again open to the public rather than for the exclusive use of the Inn's patrons. On July 4, 1920, a dedication celebration was held at the reopened park and the main attraction was a Navy airship from the San Diego Navy instillation. This image of the incoming blimp was taken looking east from the corner of Sycamore Street (Lakeshore Drive) and Maine Avenue.

35

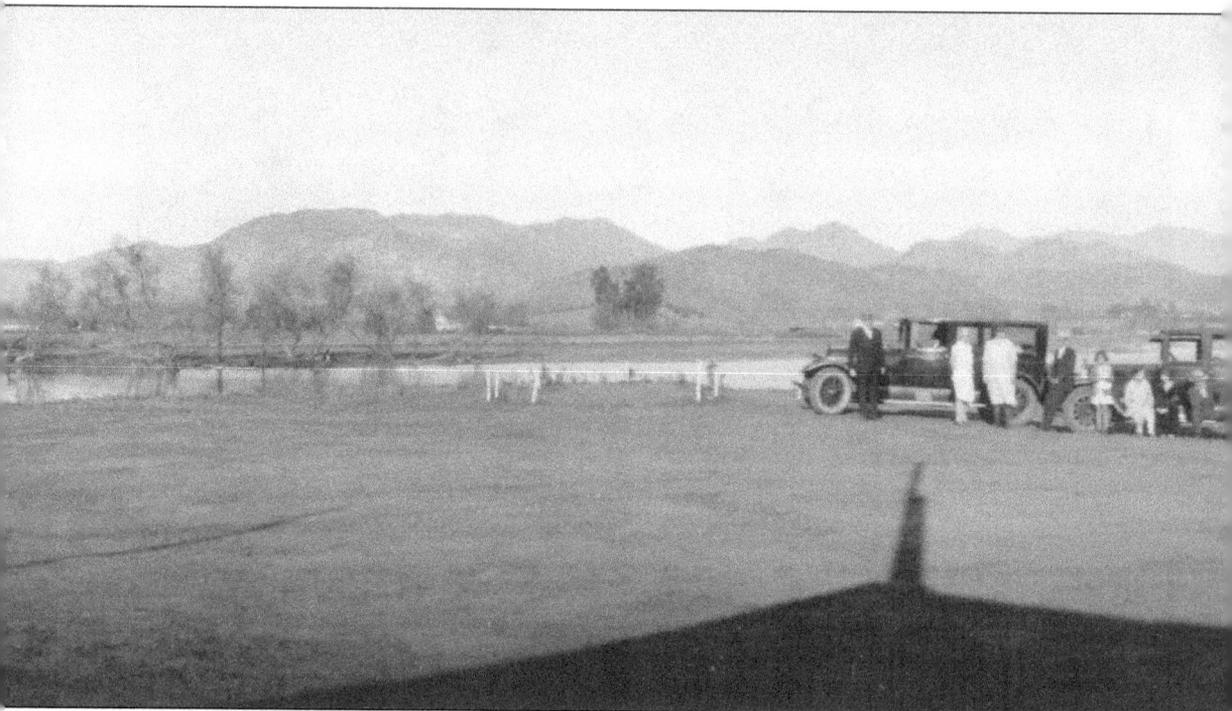

Newspaper articles dated June, 1920 had the headlines, "Lakeside to Open Park on July 5" and "Flight of Blimp Feature of Day." The articles went on to say that there would be an all-day,

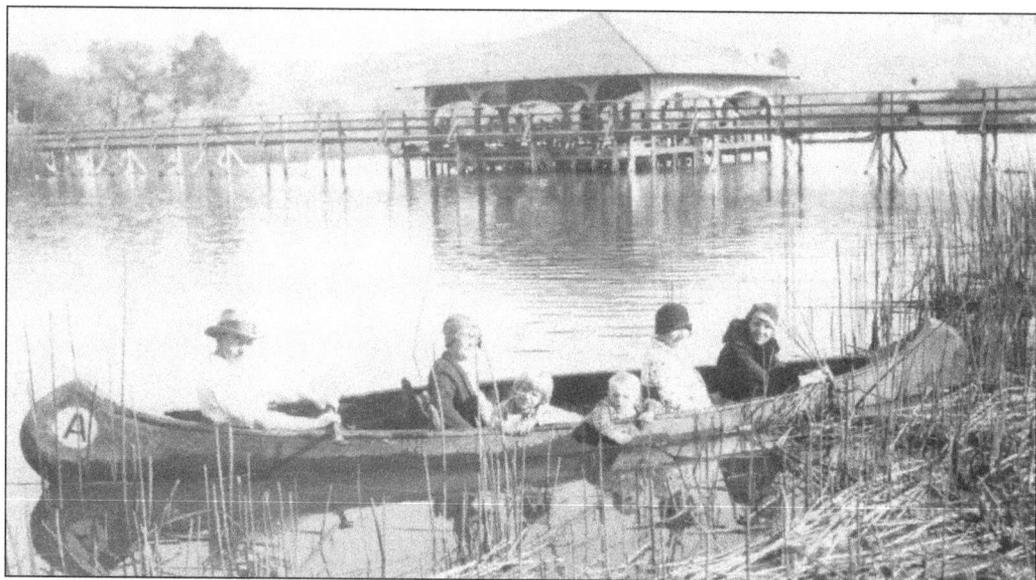

The *San Diego Union* at that time reported: "Comprising 90 acres, this is the only public-owned park and lake in San Diego County, and the people of Lakeside invited their friends and the public to spend the day with them, enjoy back country hospitality, and lend their presence to the dedication exercises, which will throw open to the public this beautiful park around which the town is built."

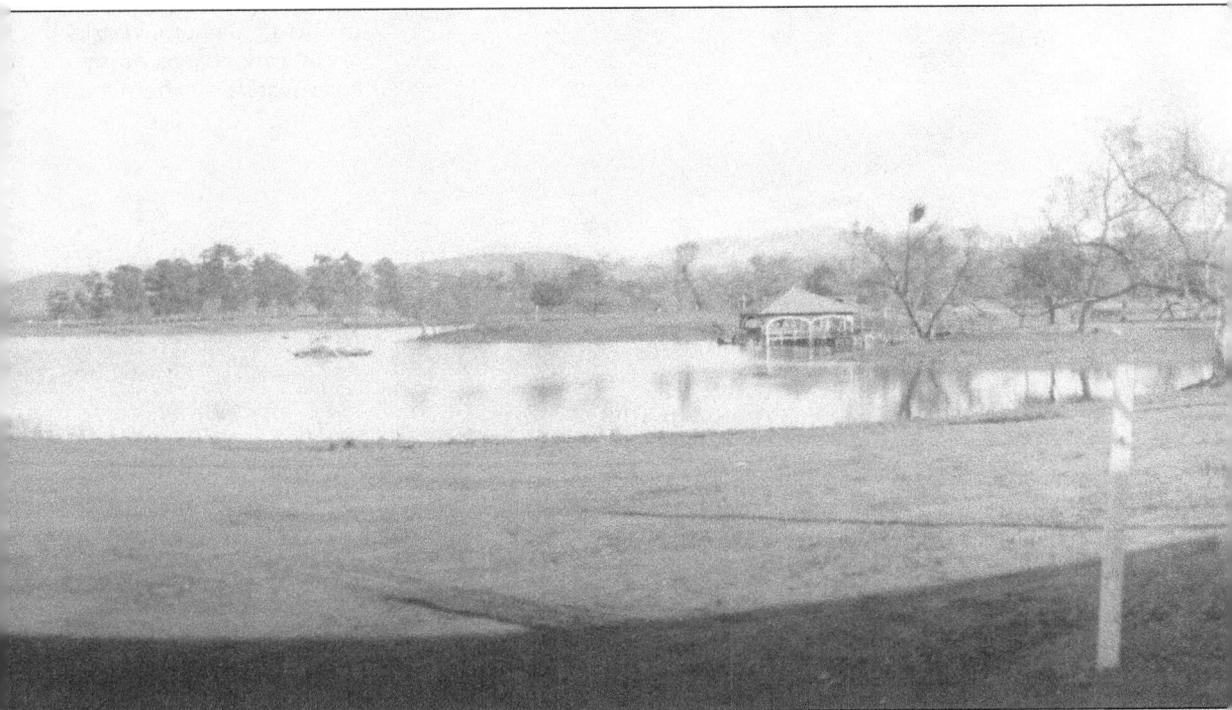

old-fashioned, 4th of July celebration and barbecue when Lakeside dedicated the opening of Lake Lindo Park on Monday, July 5.

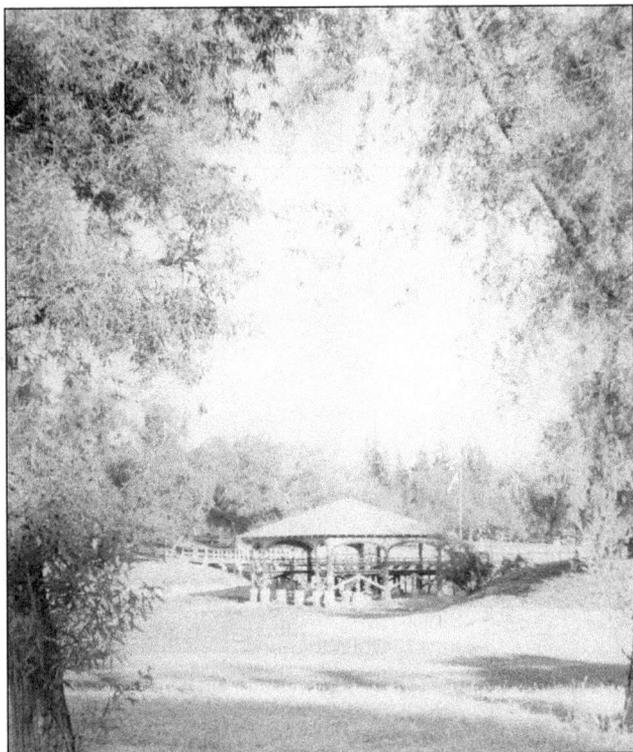

In addition to the barbecue dinner, the program included Indian war dances, Indian horse races, horseback potato polo, bronco busting, various games and sports, fireworks, and an all night dance with band music. A blimp from North Island was the big feature of the day. About 700 feet of cable and a number of cement blocks were necessary to equip the landing. According to one article, "After these are established, the landing place at Lakeside will be maintained permanently."

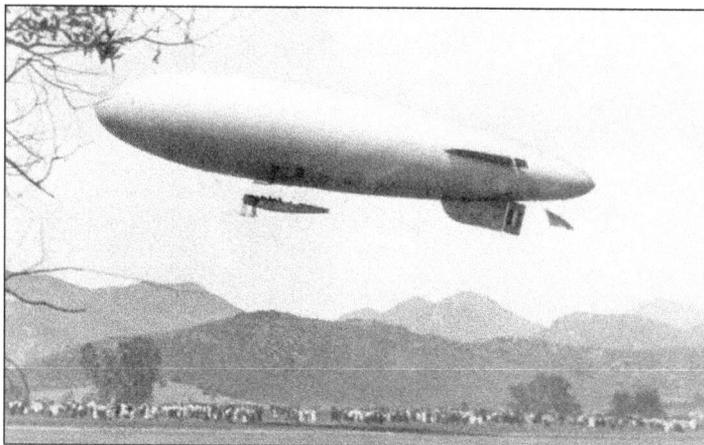

In this 1930 photo, visitors to the park enjoy a sunny New Year's Day afternoon.

In the 1930s, family boating was very popular on the lake. Pictured in the canoe are Harvey Goodman, Mrs. Carlton, Barbara and Stan Goodman, Demis Kanady, and Myrtle Goodman.

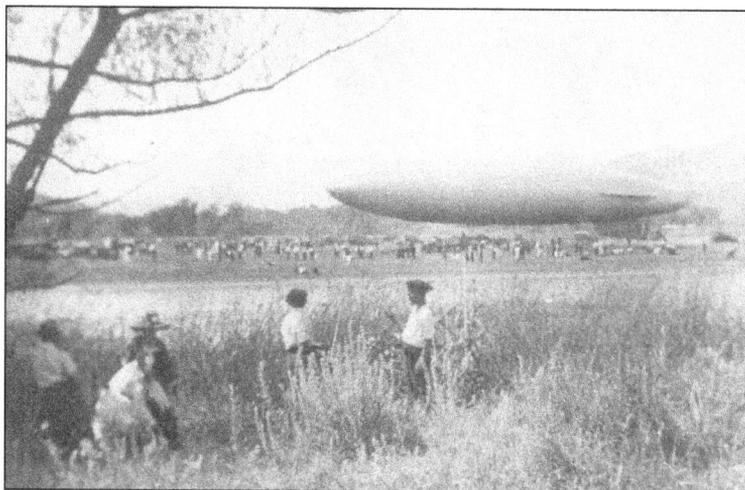

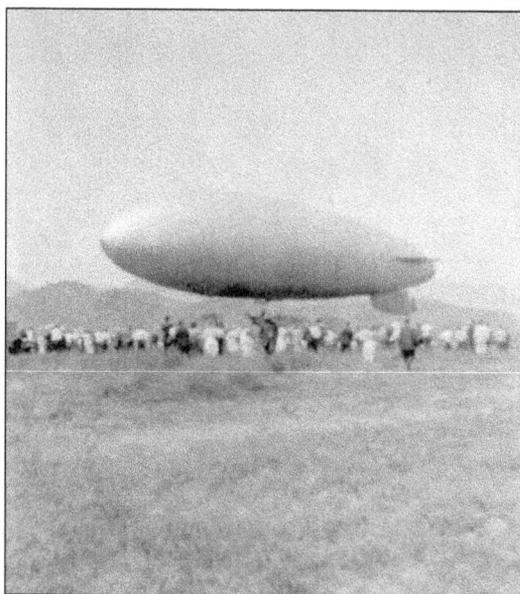

History of the park would not be complete without the courageous fight led by Flossie Beadle and others to "save the boathouse." The County Board of Supervisors proposed moving the boathouse from the center of the lake to shore so the county could seal the bottom with soil cement and refill it with water, as the lake had not been filled with runoff since 1940.

Flossie admitted her first failure when the boathouse was removed to dry land prior to September of 1966. It became known as the Lakeshore Summerhouse.

Perhaps inspired with Flossie's attempt to keep the boathouse in the center of the lake, the Lakeside Historical Society, with monies given to this group by the 1976 Bicentennial, plus volunteer help, moved the boathouse back into the center of the lake in 1977.

Four

DOWNTOWN AND MAINE AVENUE

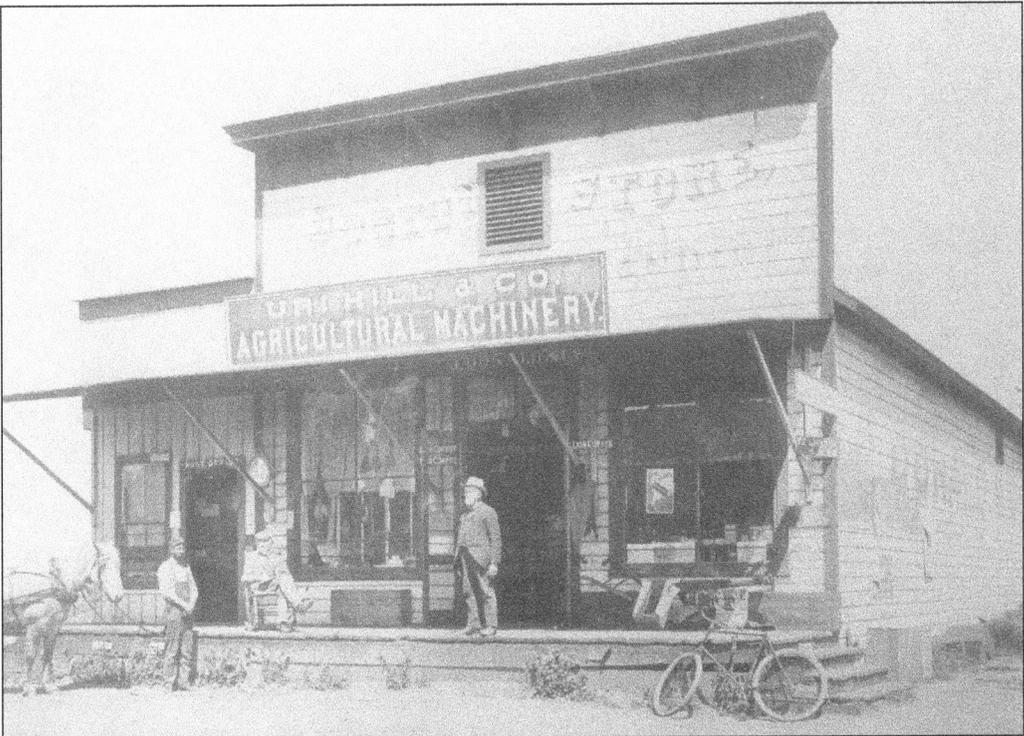

In the 1880s, the Bostonia Store and Post Office served Lakeside's needs. As seen in this photo, it was also a meeting place for casual conversation and for hearing the latest news from neighbors and travelers.

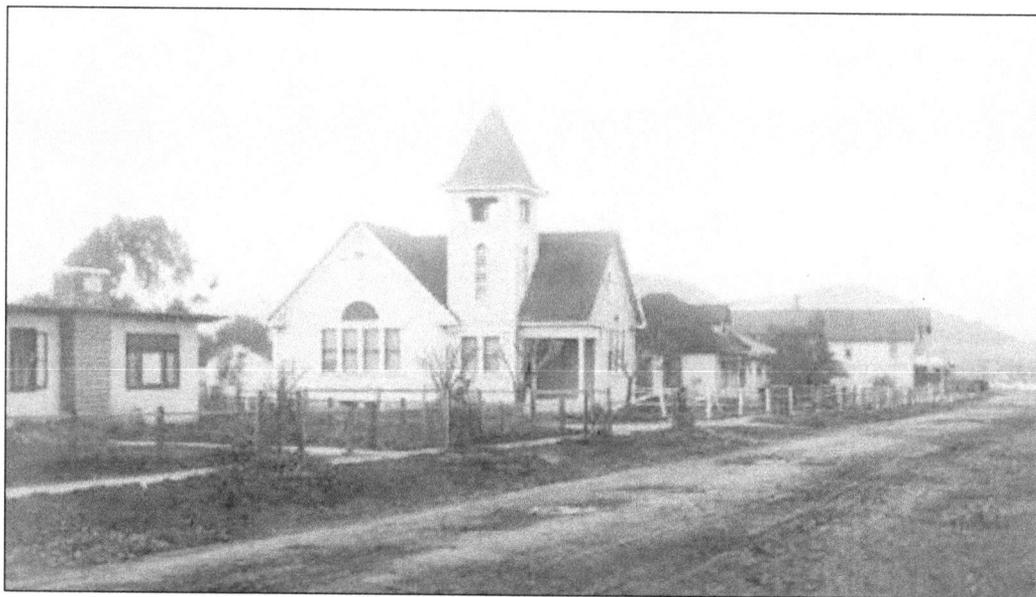

Lakeside's first church was organized in 1883 with 13 charter members. Worship services were conducted on the porch of the old Lakeside Inn, which was located approximately where the Lakeside Post Office now stands. In 1895, construction began on the sanctuary and the first services were held in it on February 9, 1896. The formal dedication was held on March 29, 1896.

The sanctuary, at the corner of Parkside Street and Maine Avenue, is now designated as a historical site within the Presbyterian Church. The Lakeside Historical Society took possession of the building in 1986 (Lakeside's Centennial) and began the long process of restoration. With the efforts of the Society, and generous contributions from the community, the Olde Community Church has been restored to its original beauty and stands as an enduring landmark of Lakeside's history.

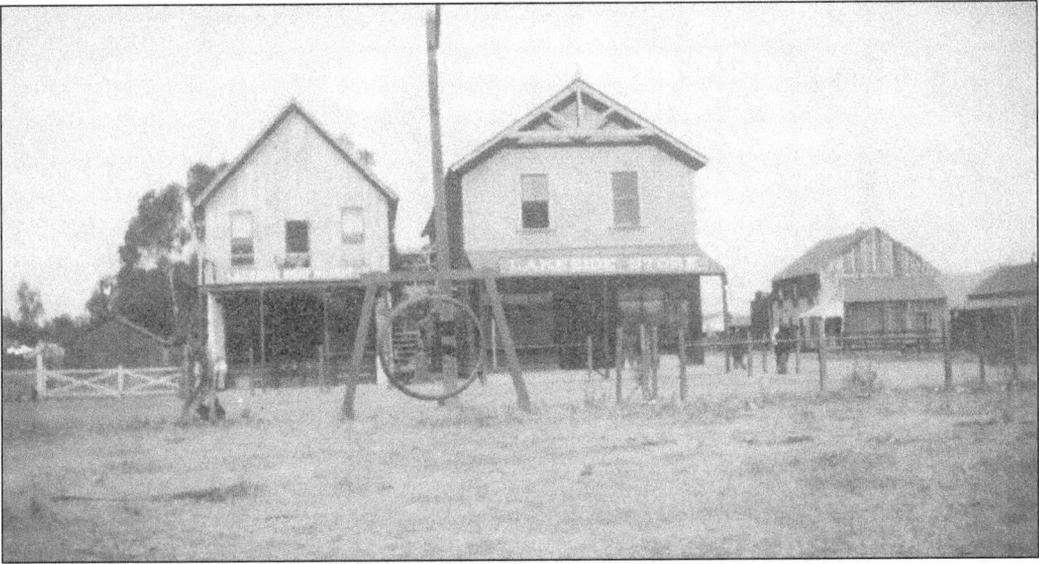

At the corner of Maine Avenue and Sycamore Street (Lakeshore Drive) in 1898, Neal and Forney's Lakeside Store stood on the right and the Lakeside Meat Market on the left. The large hoop in front was the Volunteer Fire Department's emergency bell.

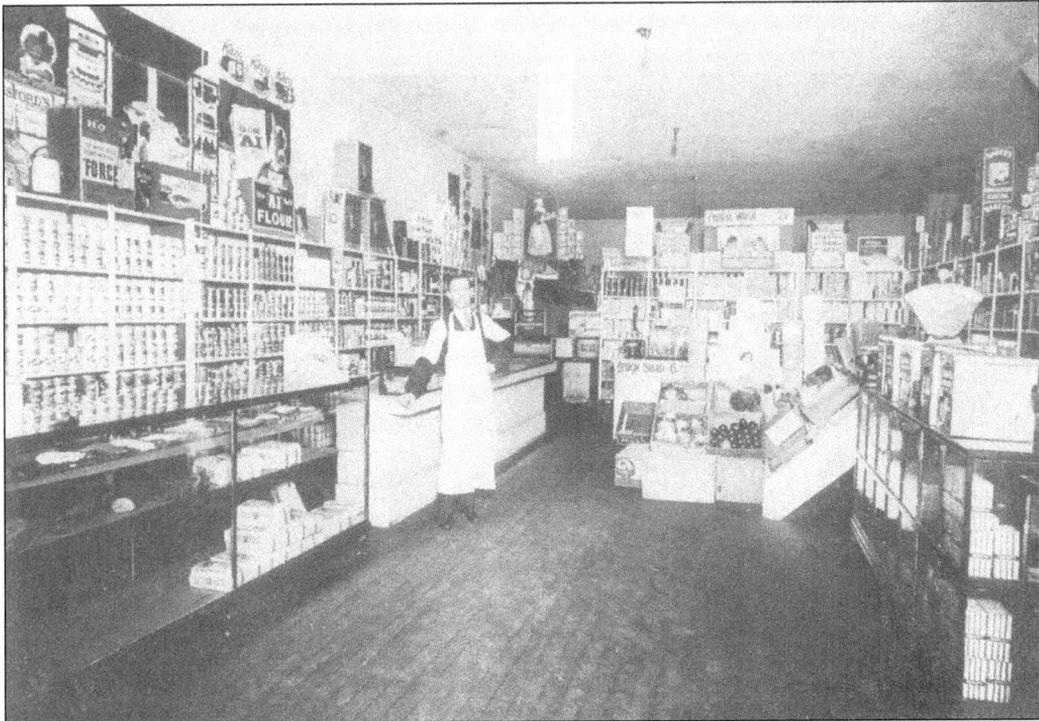

Mr. Neal proudly displays his general merchandise inside the Lakeside Store in 1898.

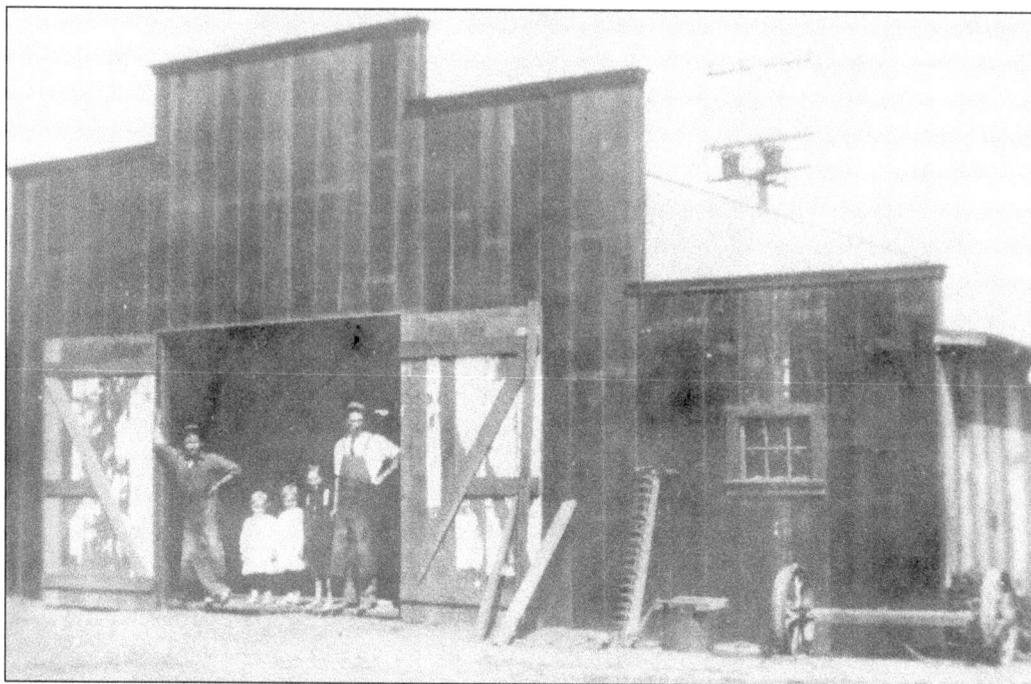

Lakeside's Blacksmith shop was located at the north end of Maine Avenue. The two men in this picture are Wallace Phillips and Ralph Gibbs.

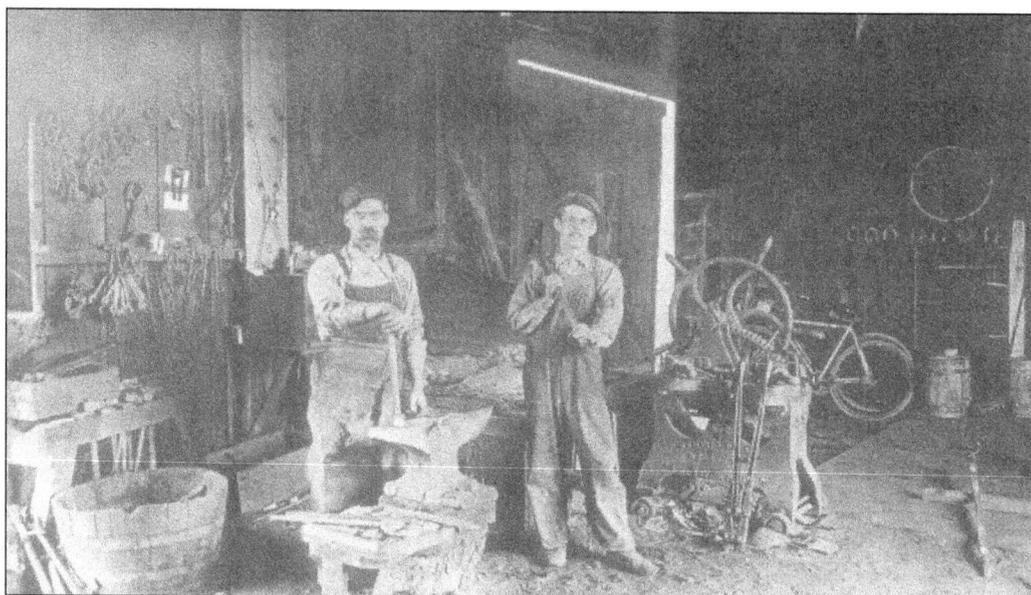

Above, Jim Beamer, Lakeside's first blacksmith, stands on the left. As seen in this 1900 photo, the town blacksmith's shop was a place for repairs of many kinds. Note the bicycles on the right and the numerous horseshoes hanging on the wall to the left.

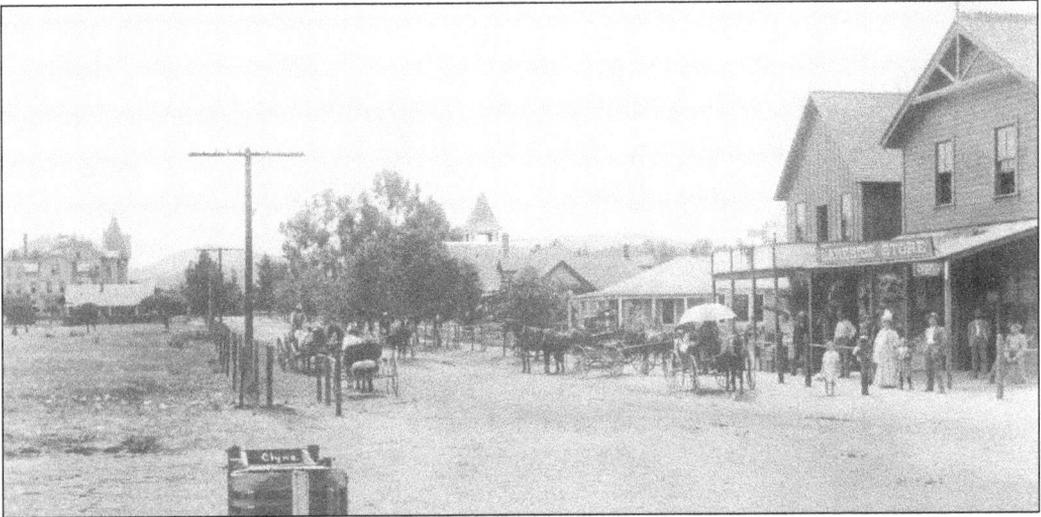

This view shows Maine Avenue looking south toward the Inn in 1904.

The Lindo Hotel was built in 1887 by Martha Swycaffer and was situated on the south side of Sycamore Street behind the Old Lakeside Store. It was started as a boarding house for construction workers on the Cuyamaca and Eastern Railroad, which extended, at that time, as far as Santee. Mrs. Swycaffer had previously run a boarding house in Santee, but moved to Lakeside in order to be more in the center of the railroad work. The right of way ended in Lakeside, but a spur line was laid to Foster. The hotel originally had four bedrooms upstairs, one large bedroom downstairs, and a kitchen and dining room.

About 1893, Mrs. Swycaffer moved the building to its present location on Sycamore and River Street. She continued to run a boarding house there for a number of years. In 1900, it was leased to the Martin family, who turned it into a grocery store and post office for approximately five years. Charles Greenleaf also used it as the headquarters for his stage line to Alpine, Descanso, and Cuyamaca.

43

This photo shows the Lindo Hotel in about 1910 with Mrs. Martha Swycaffer standing next to the automobile. Seated inside is her granddaughter, Mrs. Katie Leng, and Dr. J.T. Ireys, the first doctor in Lakeside.

Howard Shaff was owner of the Lakeside (Lindo) Hotel in 1944.

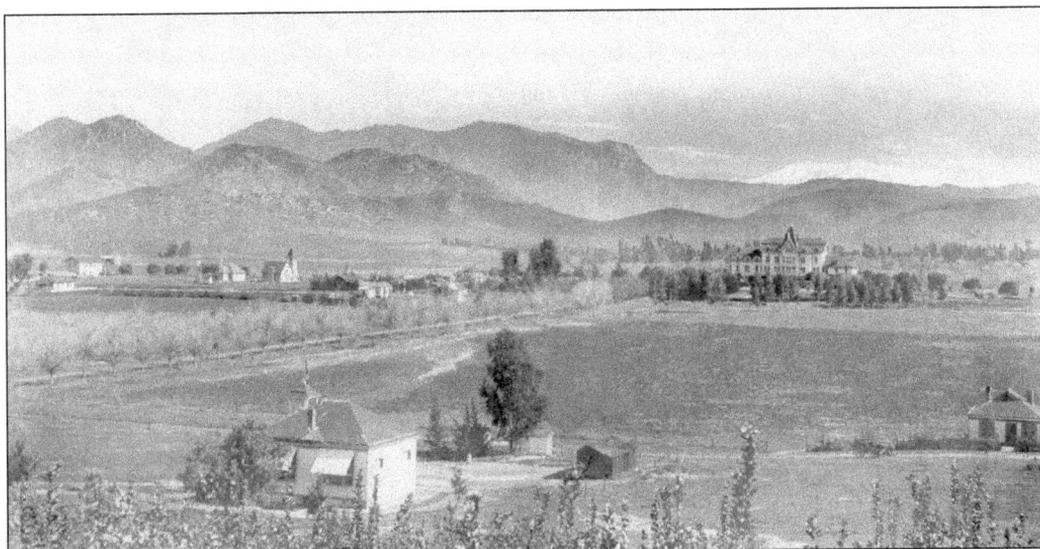

This was Lakeside and the surrounding valley in 1910. Lakeside's first one-room school building, built in 1890, is in the foreground. The Cuberson house (right) was later moved to River Street. The Lakeside Inn, built in 1887 and torn down in 1920, is shown in the background. The cork elms can be seen near the center of the picture along Woodside Avenue planted Arbor Day, 1889. Originally there were 50 trees on each side of the street. Sadly, now there are none. On Main Avenue, the Community Church (1896), the former Neal house next to the church, and the store of Forney and Neal, can be seen. The home of Dr. Ivey and the Kinney house are on River Street. In the background, the majestic El Cajon (El Capitan) Mountain and Cuyamaca Peak, with a rare heavy winter's snow-pack, can be seen.

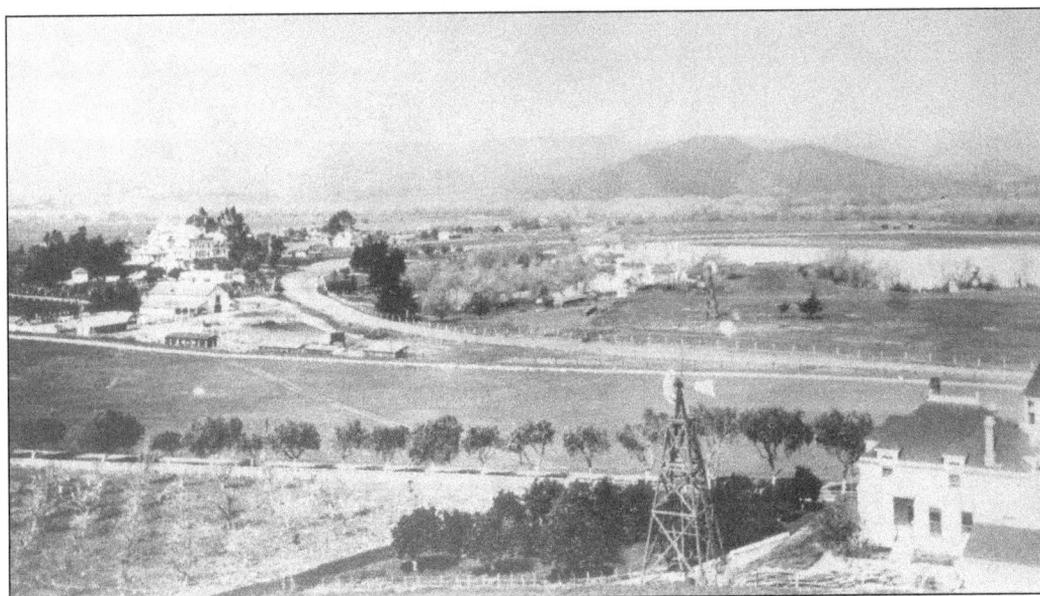

This is a panorama looking north of the Lakeside valley with the Inn, Lindo Lake, and the racetrack in 1910. To the right of the Inn the Lakeside Community Church is visible. In the foreground is the Castle House on Orange (Castle Court).

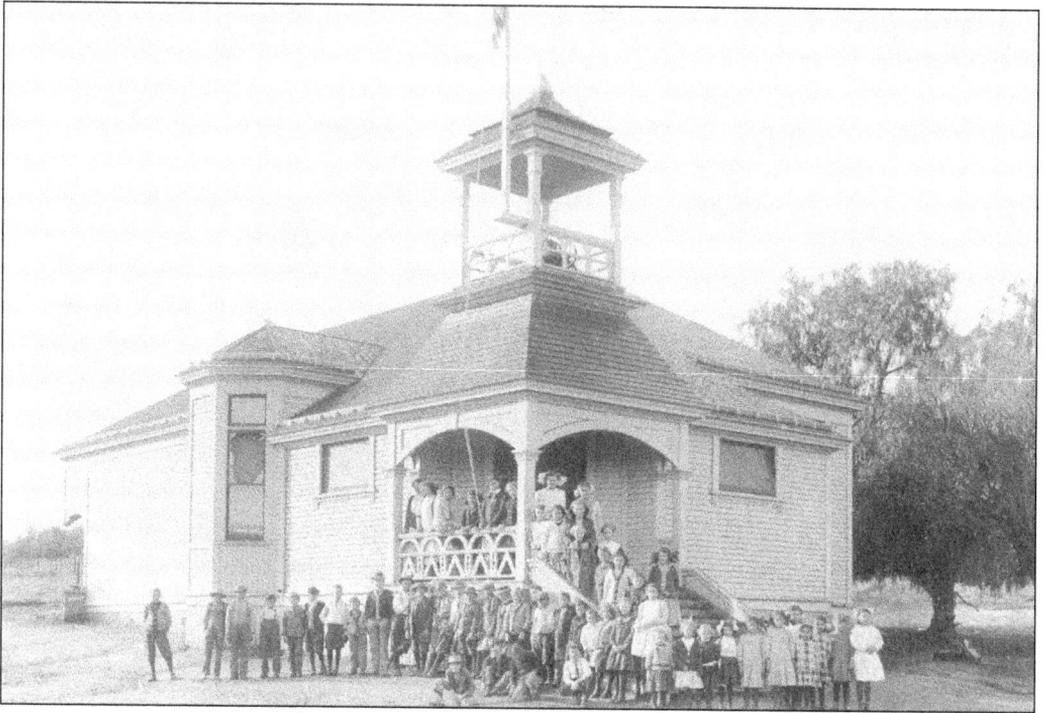

Pictured is the Lakeside School class of 1909–10. This is Lakeside's first school built in 1890; it burned down in 1916. Miss Jennie Moore was the principal, and Miss Mary Harney taught the primary grades.

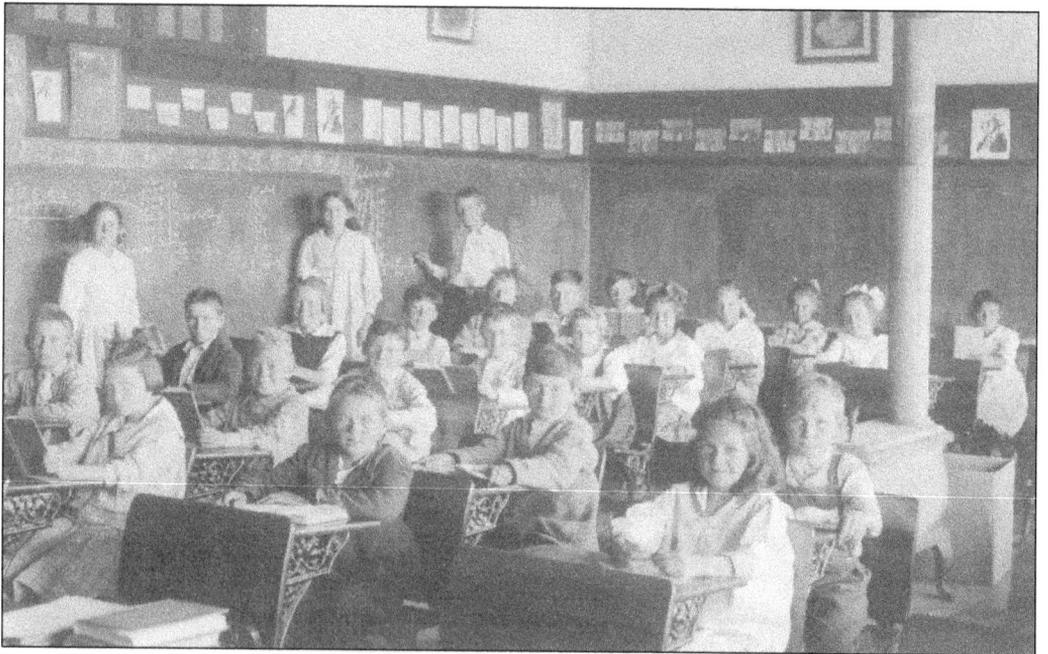

Standing at the chalkboard of the Lakeside School classroom is Dorothy Whitaker, Mabel Newcomb, and Edward Walker.

After the Lakeside School burned in 1916, children were transferred to this building. The stucco building had been built in 1912 and housed third, fourth, and fifth grade students in one room. The sixth, seventh, and eighth grades were held in a second room. Also during this time, a tent was used at this site for one year. The first rain of the season caused the tent to leak so the children happily went home early.

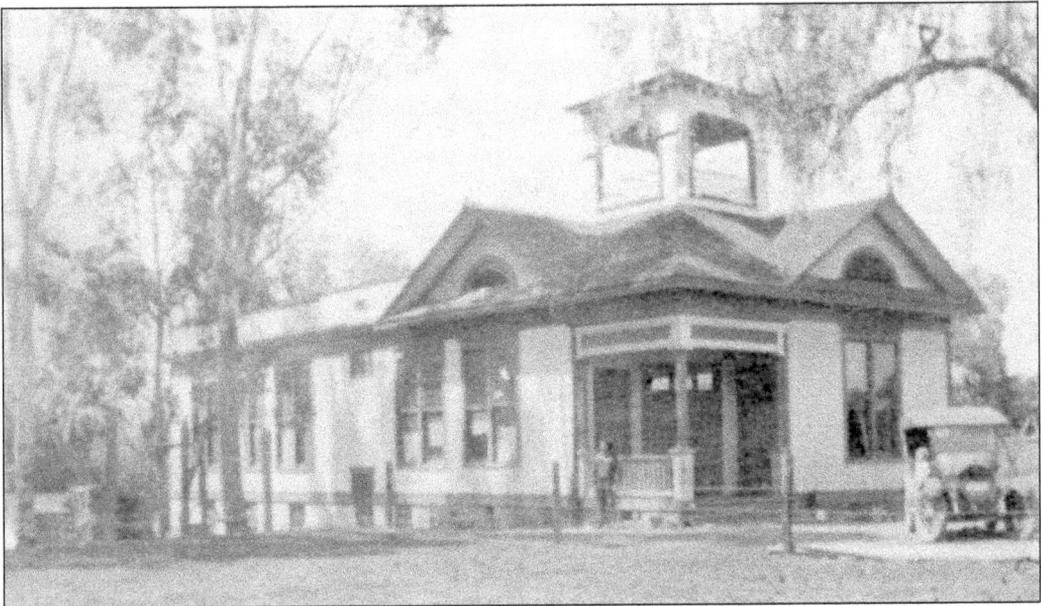

For a year and a half before the Lakeview School was built in 1895, classes were held at the old adobe house on Los Coches Road owned by Julian Ames. The Lakeview School closed in 1920, and pupils then attended Lakeside District schools, or El Cajon School. The school was bought by Wellington Hoover and is still used as a residence, though it has had many owners.

This photo shows the view looking south down Maine Avenue in 1908. At the end of the block on the left is the Lakeside Inn. On the right are the Ross home, the Neal house, and the Lakeside Community Church.

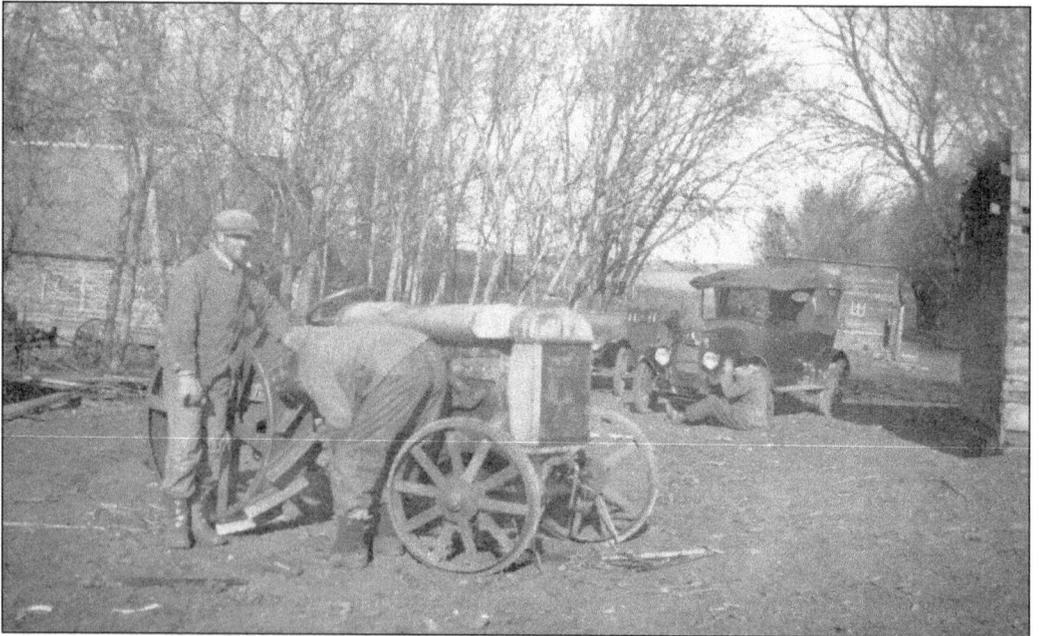

Auto and tractor repair around 1910 is pictured above.

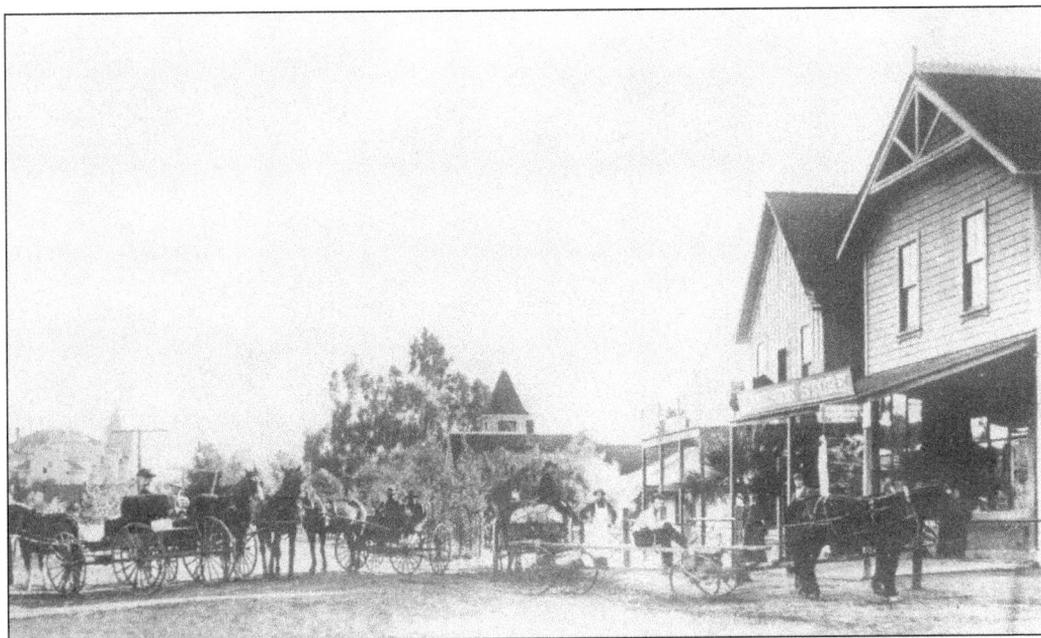

This photo shows an early 1908 rush hour traffic-jam on Maine Avenue in front of the Lakeside Store.

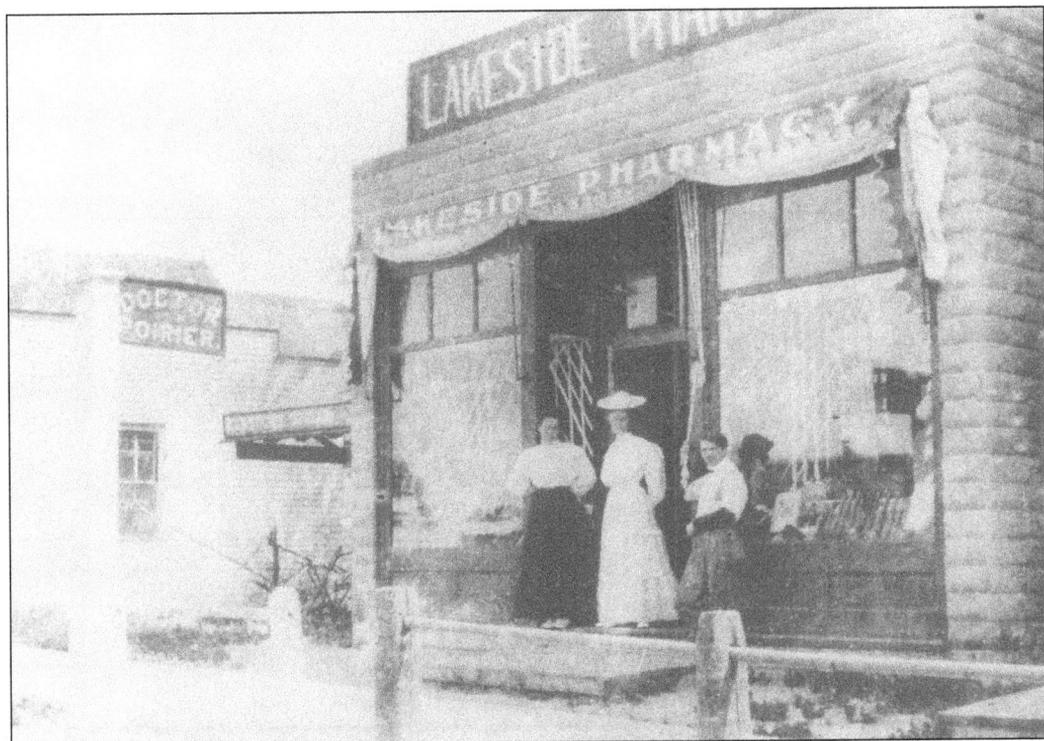

Dr. Poirier's Lakeside Pharmacy on Laurel Street is pictured above, *c.* 1910.

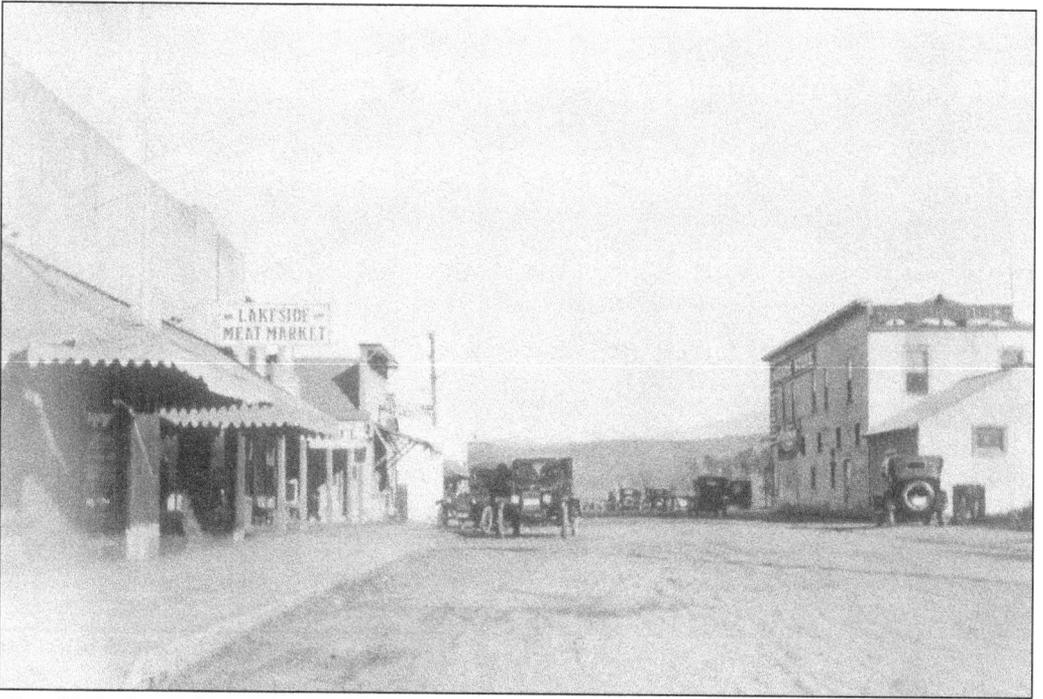

This 1909 photo shows the view looking east on Sycamore Street (Lakeshore Drive) from the corner of River Street. On the left is the Lakeside Meat Market and on the right is the Lakeside Store at the corner of Maine Avenue.

The U.S. Army Signal Corps bivouacked on Maine Avenue by the Lakeside Inn in 1911.

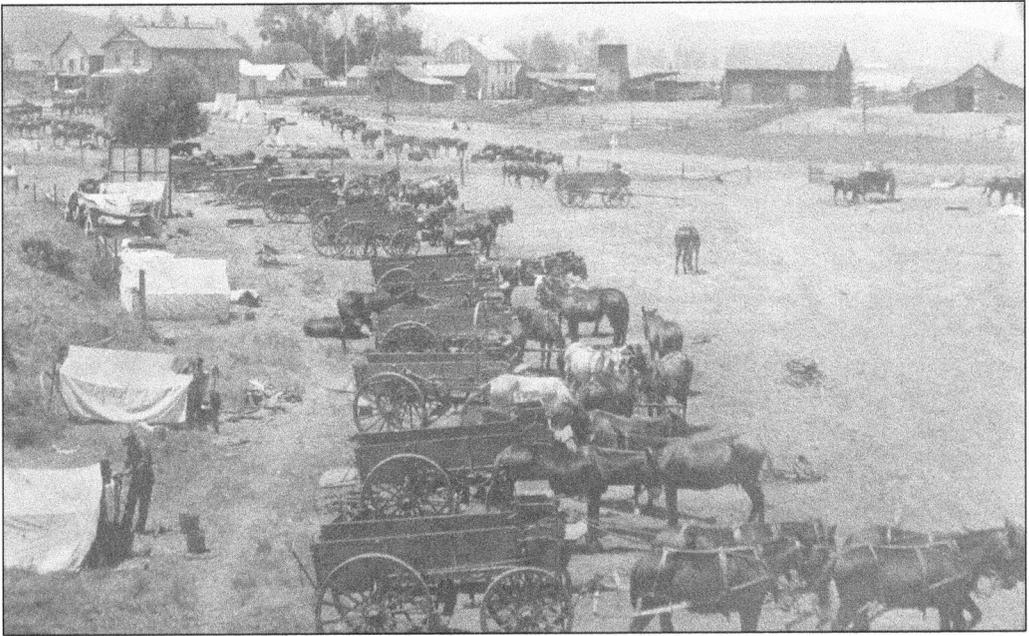

Army wagons were parked at the corner of Sycamore Street and Maine Avenue. The Lakeside Store can be seen in the upper left corner.

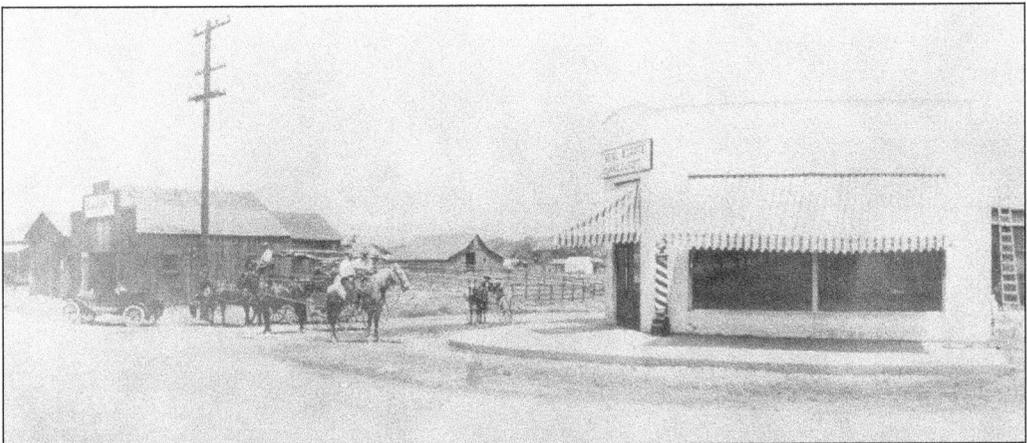

This 1912 photo shows the corner of Maine Avenue and Sycamore Street looking west. Wallace Phillip's Blacksmith Shop is on left and J. L. Foote's Real Estate and Insurance office on the right.

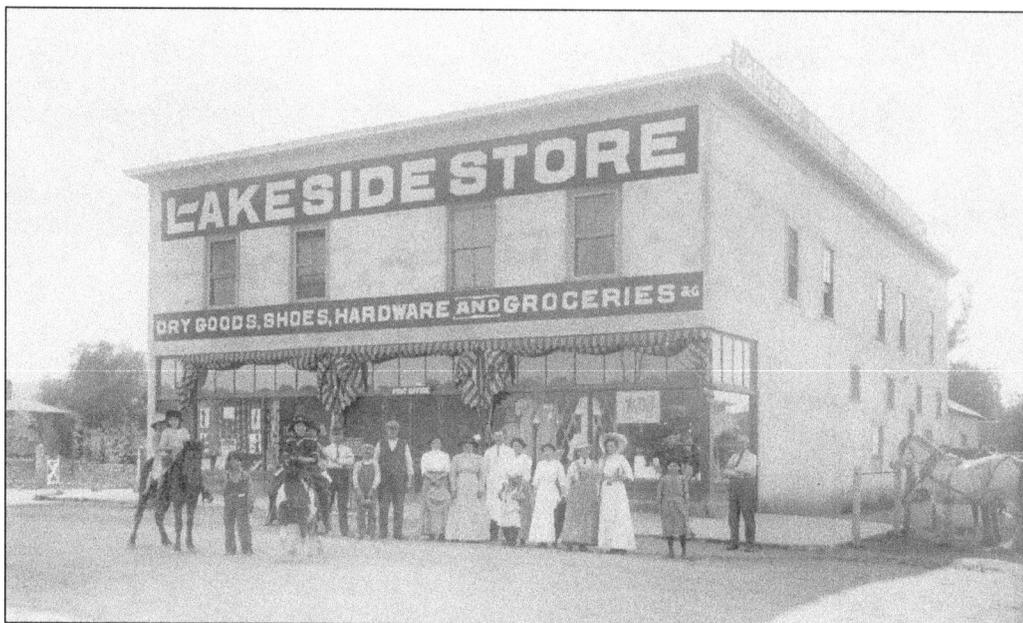

The Lakeside Store began as a narrow two-story frame building built by Will Carson in 1890 and was used as a boarding house. In 1898, J.H. Neal and Don Forney, a builder, took over the building and turned it into a General Store advertising hay, grain, produce, and general merchandise (previous page). The upper floor was used as a community dance hall. Five years later, in 1903, Klauber-Wangenheim Company bought the building and the one next to it. They joined the two to make one large square building as shown in this picture from 1912. When it opened for business, C.W. Ross was named as manager.

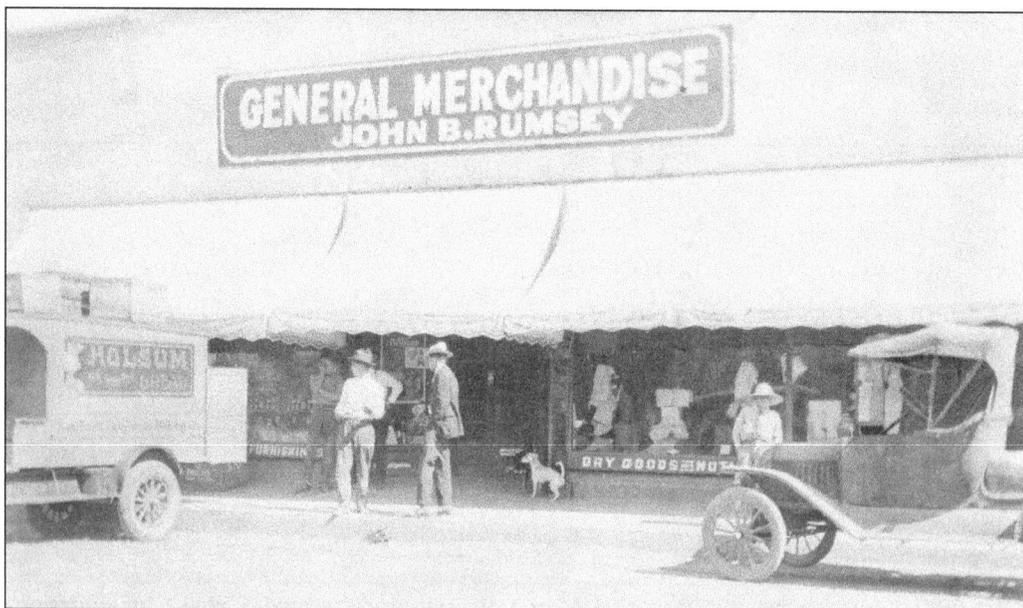

Pictured is John B. Rumsey's General Merchandise on the corner of Sycamore and River Streets with a Holsum Bakery delivery in 1915.

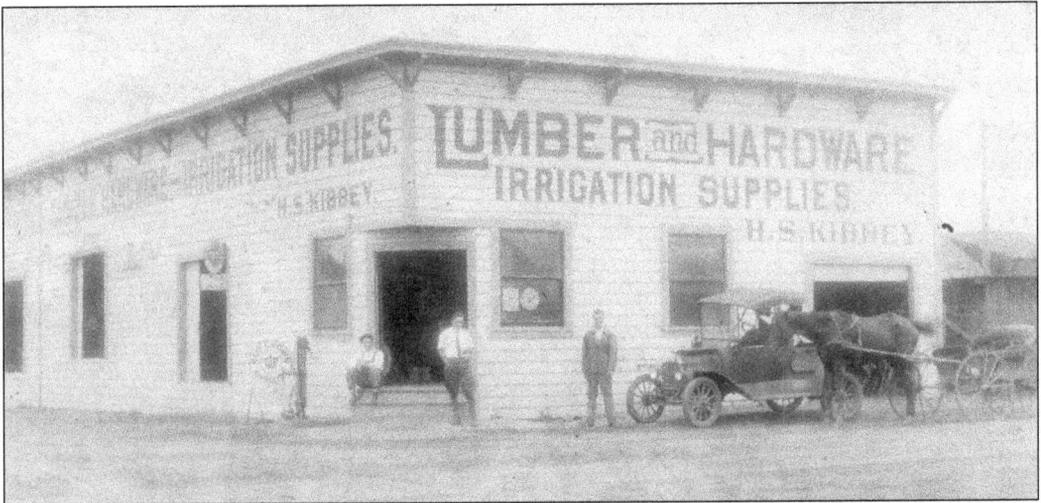

H.S. Kibbey Lumber and Hardware had the first gas pump in Lakeside (next to the man sitting on the steps) featuring Red Crown Gasoline at 21¢ per gallon. It came into existence in 1910 at the northeast corner of Maine Avenue and Laurel Street when Mr. W.D. Hall started it. In 1914, he sold it to H.S. Kibbey. Pictured in this photo from 1917 are Harold S. Kibbey and George Miller. The identity of the man on the left is unknown.

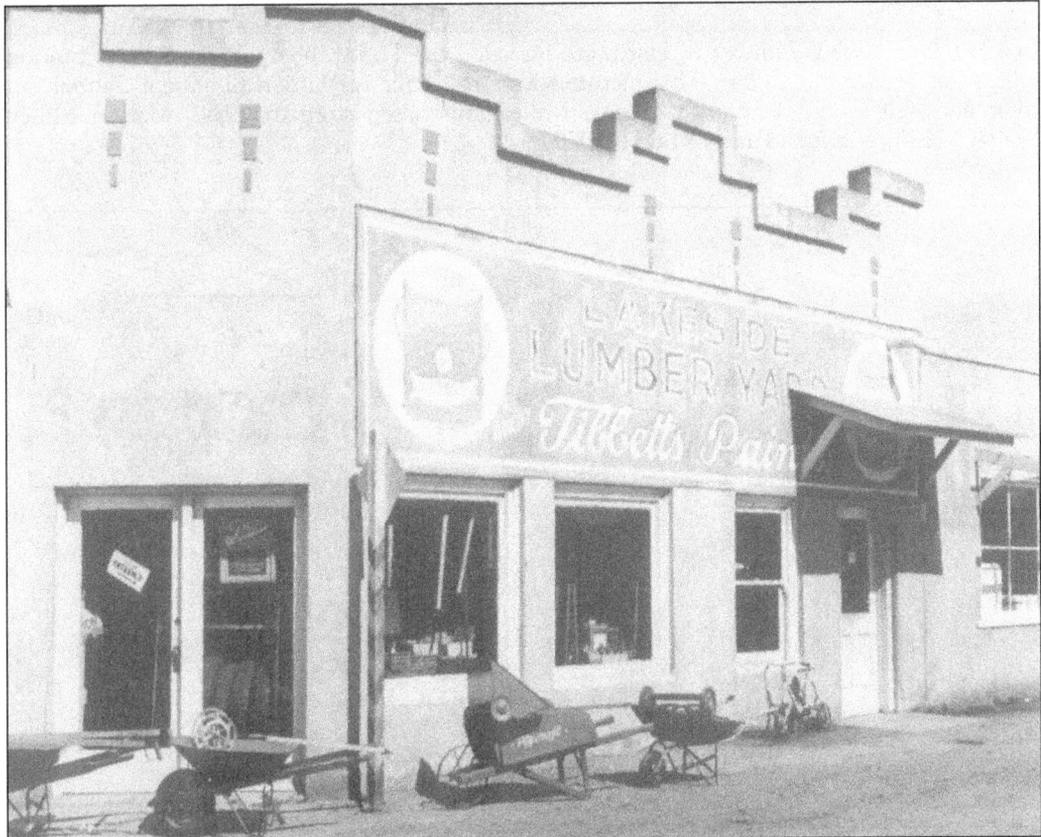

The new entrance to Kibbey's Lumber Yard at the west end in 1917 is shown above.

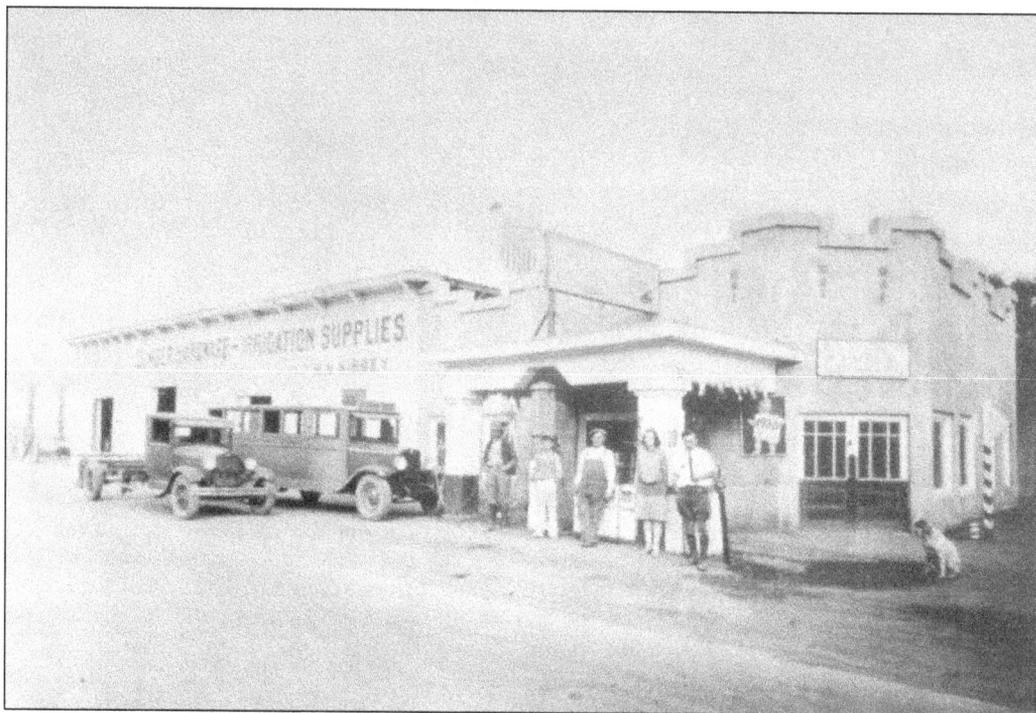

In 1930, H.S. Kibbey Lumber & Hardware included the H.S. Kibbey Union Service Station selling gas at 20¢ per gallon. This picture shows the Lakeside Union Grammar School bus (first enclosed school bus) with George Miller (purchased store in 1934), Marion Miller, Wallace Phillips, Erleen Parker, and H.S. Kibbey.

This is a view looking north on Maine Avenue from the corner of Sycamore Street in 1922. The Lakeside Commercial and Savings Bank is on the left, and the Town Hall is on the right.

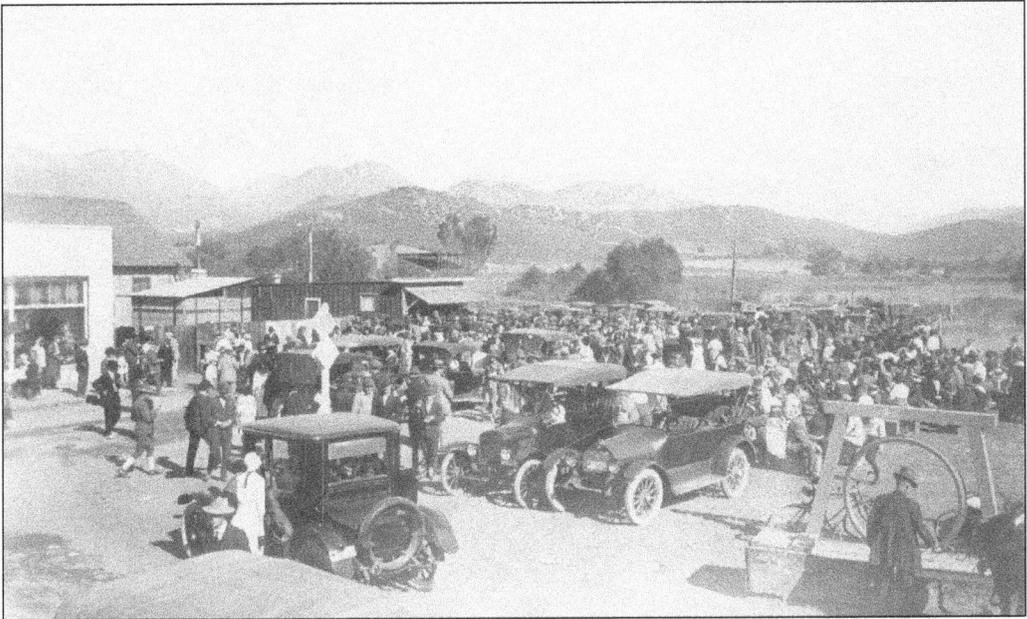

This photo from the early 1920s shows the corner of Maine Avenue and Sycamore Street. The fire bell is still at its original location in the front of this picture. In the center of the photo is Dent's Bakery, and just beyond are the bleachers for the racetrack.

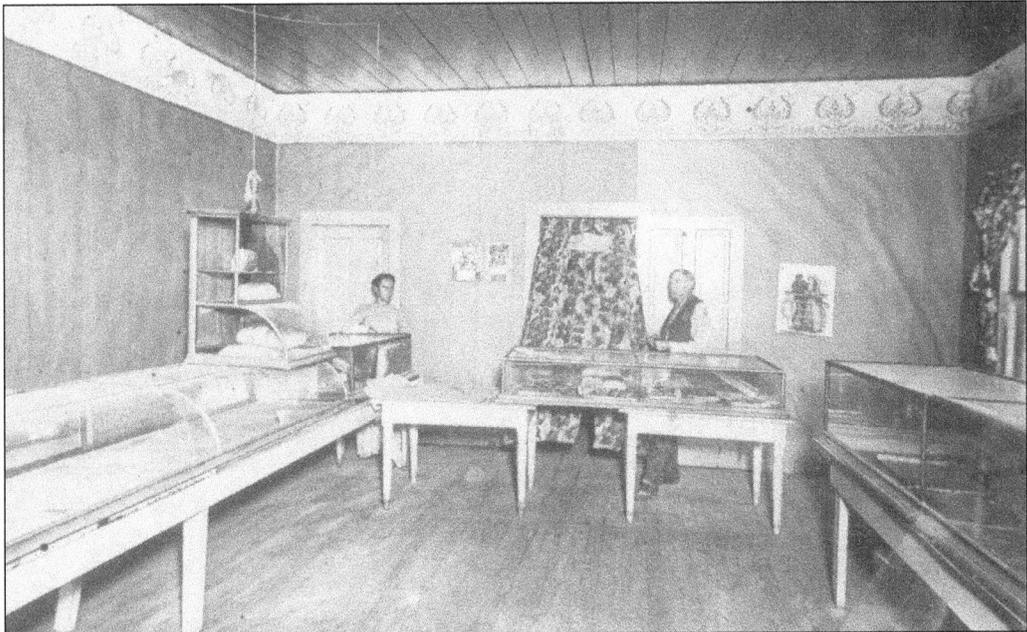

Mr. Dent stands on the right, inside of his bakery on Sycamore Street. In 1918, Samuel and Susie Dent bought the bakery from the Hartungs, who had opened it in 1914. At that time, the Dent's were also running another bakery on Magnolia Avenue in El Cajon.

A house and garage were built next to the bakery in 1925. A Mexican restaurant now occupies the old bakery building. The house and old brick oven can still be seen on Lakeshore Drive, across from Leo's Pharmacy.

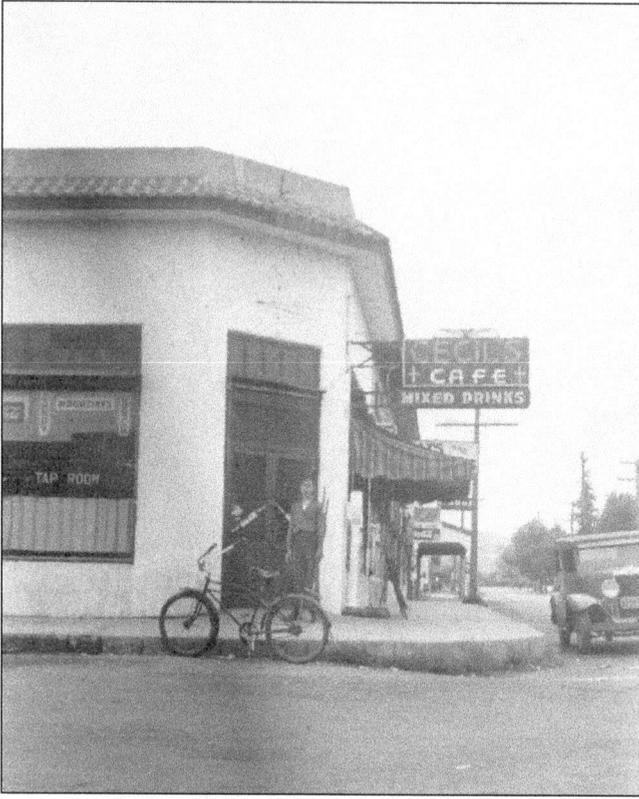

This is a view looking south at Cecil's Cafe on the corner of Maine Avenue and Sycamore Street. This building once housed Otto Marck's Grocery Store, later became Cecil's first café, then Anthony Held's Hardware and Supply Company. In 1963, Leo Ward moved into this building and it has been Leo's Lakeside Pharmacy ever since.

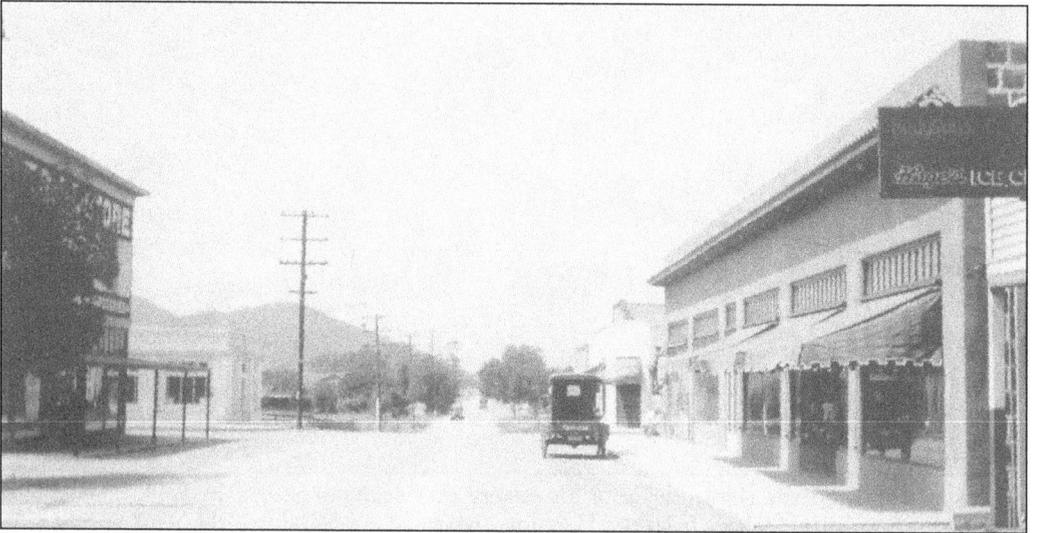

This is a view of Maine Avenue looking north from 1924. On the left is the Lakeside Store and the Lakeside Commercial and Savings Bank. On the right side of the street is Hodgson's Ice Cream, the soon to open Cecil's Café, the Club Room for the Lakeside Woman's Club, and behind it is Lakeside's Town Hall.

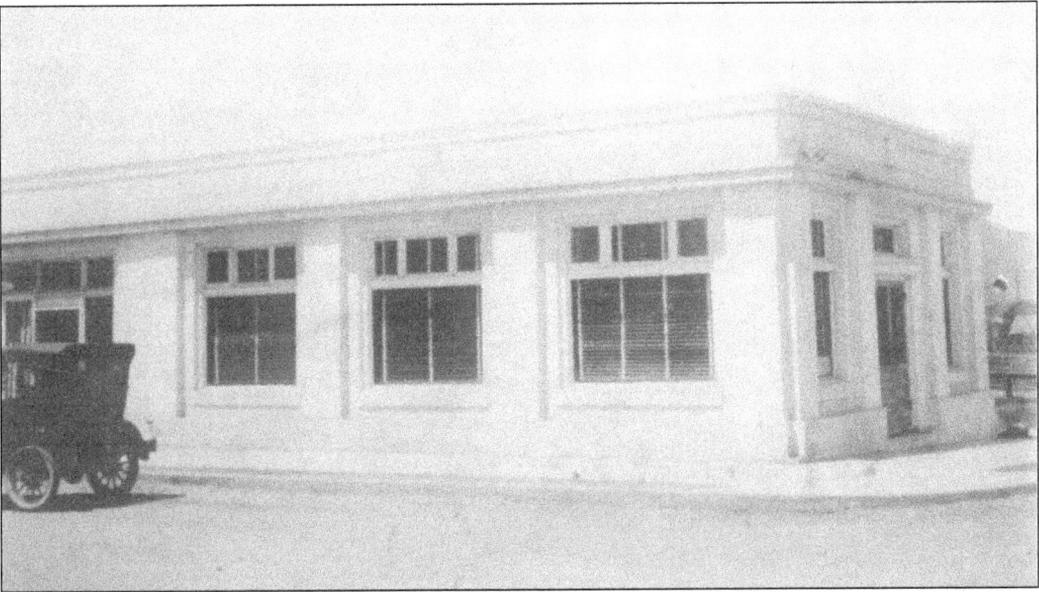

Lakeside's first bank, the Lakeside Commercial and Savings Bank, was organized by F.R. Bickell and was located at 10002 Maine Avenue. The building was demolished in the late 1960s. It opened to the public on April 15, 1922, with a capital of $25,000. The deposits on that day totaled $44,750. The original board consisted of C.A. Hopkins, F.R. Bickell, M.L. Ward, H.S. Kibbey, George Gibson, Harol Bacon, and Emil Klicka. Byron J. Conrad was the cashier until 1930.

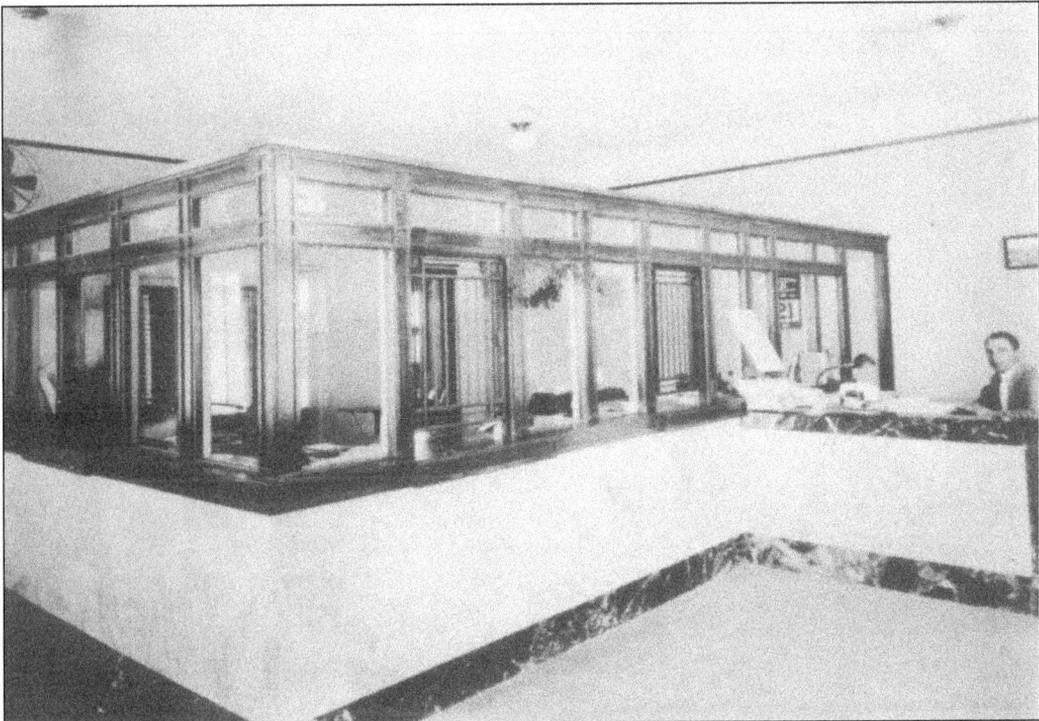

This photo shows the inside the bank.

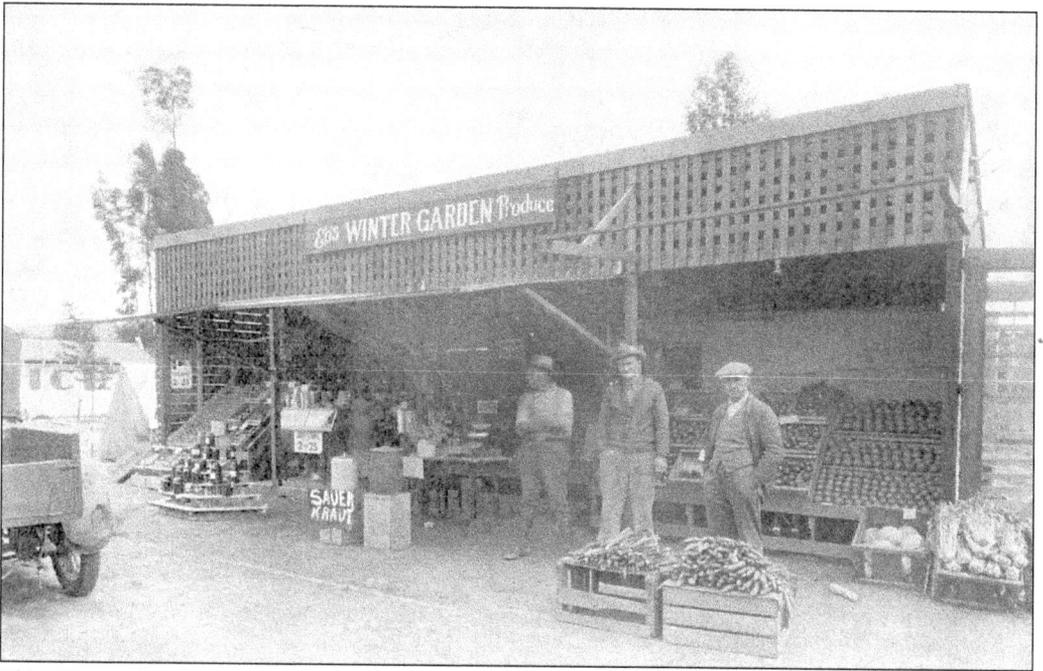

Eb's Winter Garden Produce on Wintergardens Boulevard in the 1920s is pictured above.

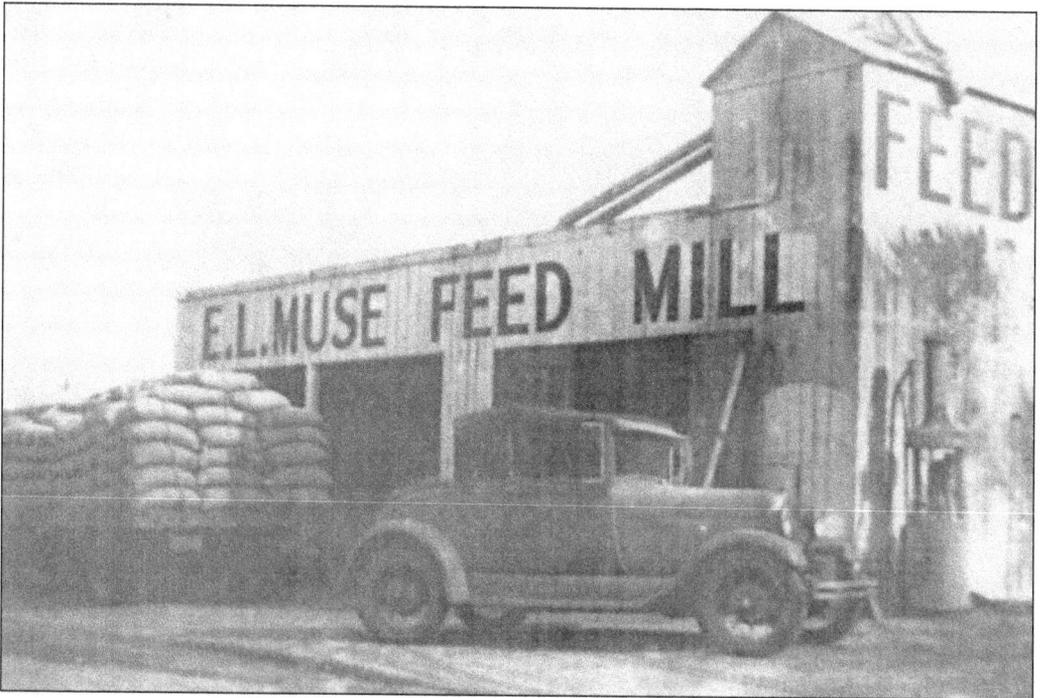

This is a photo of E.L. Muse Feed Mill from the 1920s.

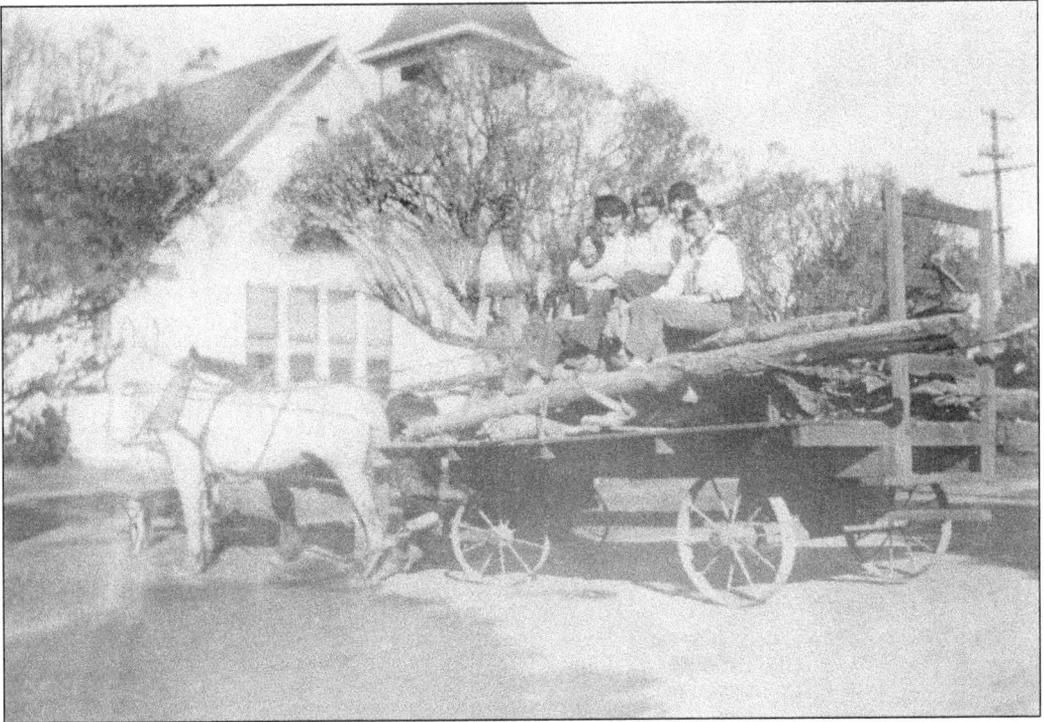

Here, church goers are bringing wood for the furnace of the Community Church in 1928. Pictured on the wagon are Grace Wilkinson, Ena Conger, Adeline Phoenix, Mabel Kephart, and Edna Swink.

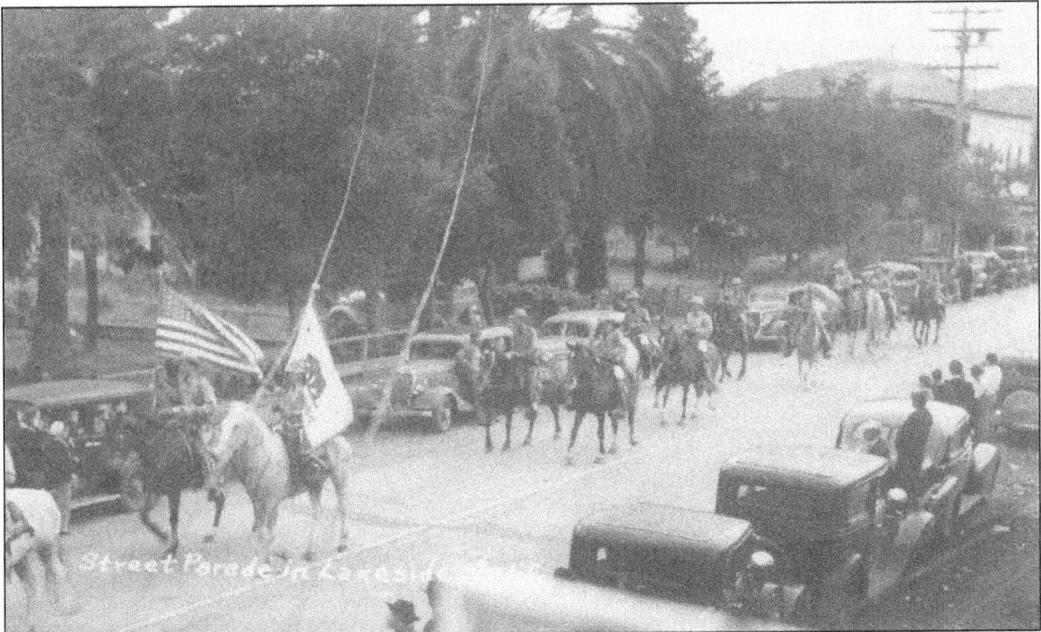

This photo shows a street parade on Maine Avenue in the 1930s.

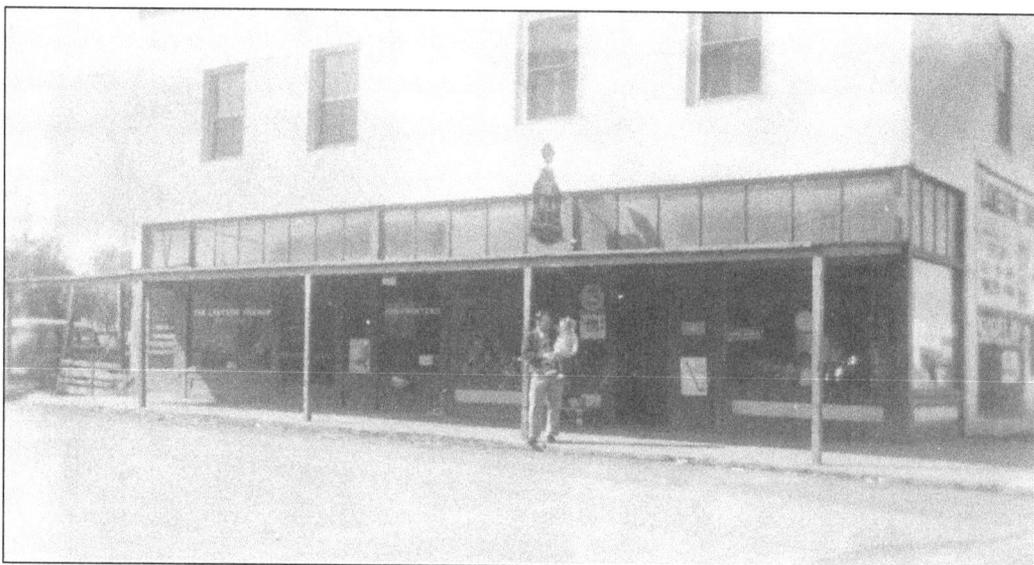

In 1920, after the Lakeside Store had closed, a partition was added to divide the building into two shops. On the left side, the *Lakeside Farmer* opened its newspaper office and print shop. And on the corner side, Robert and Onar Swearengin opened the Lakeside General Store. Later they sold their store to Anthony Held who started his Lakeside Supply Company, selling hardware and feed for livestock. He later move his business across the street. This photo shows Anthony Held holding Claudia Ann Morton in the early 1930s.

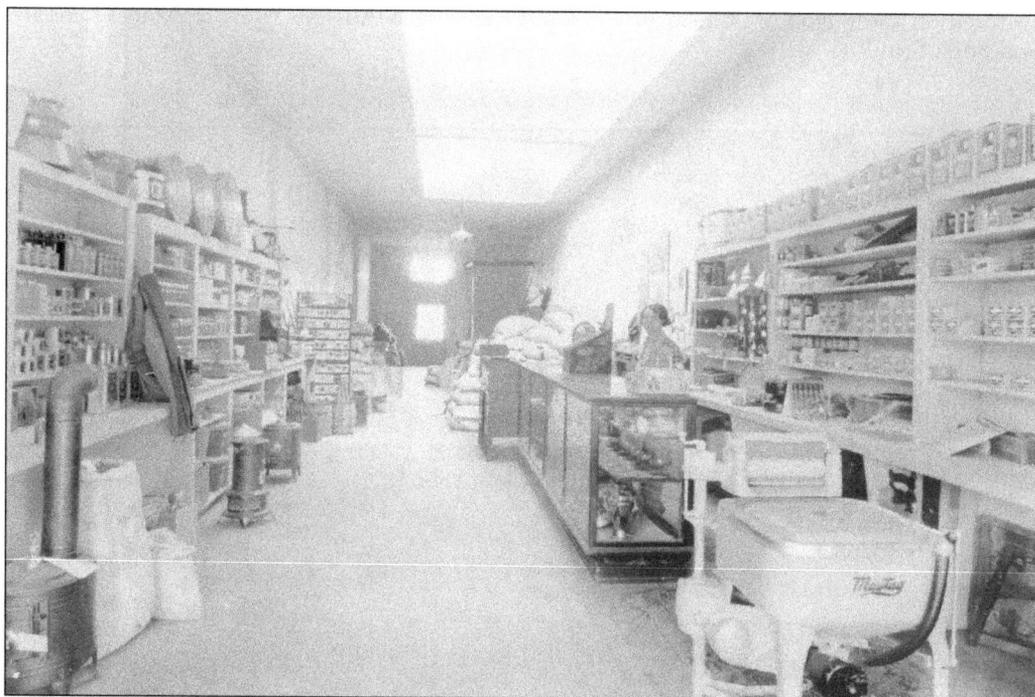

This photo shows the inside of Lakeside General Store in 1929. Onar Swearengin is standing behind the counter. They sold everything from Maytag washing machines to vegetable seeds and grain.

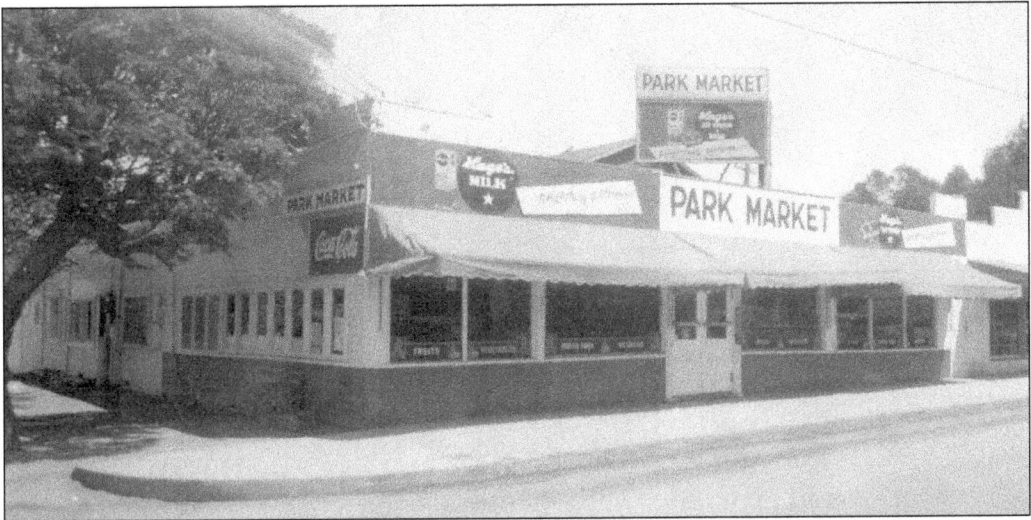

I.L. Blucher purchased the Park Store on the corner of Parkside Street and Maine Avenue in 1926. It contained a soda fountain, picnic supplies, and a few groceries. Mr. Blucher fixed the fountain, enlarged the grocery business, and changed the name to Blucher's Store. Due to the Great Depression, the store was closed in 1931. The same year, Augustus and Vera Huffman purchased the store and changed the name to Park Market. They added a meat counter with I.C. Cooper as the butcher. In 1933, the store was again sold to Ben T. Reid, who operated it until 1950. Bill Koppel and Mr. Brown bought out the Reids in 1950, then later sold it to Mr. Payton for a hardware store in 1960. This building burned to the ground in 1997.

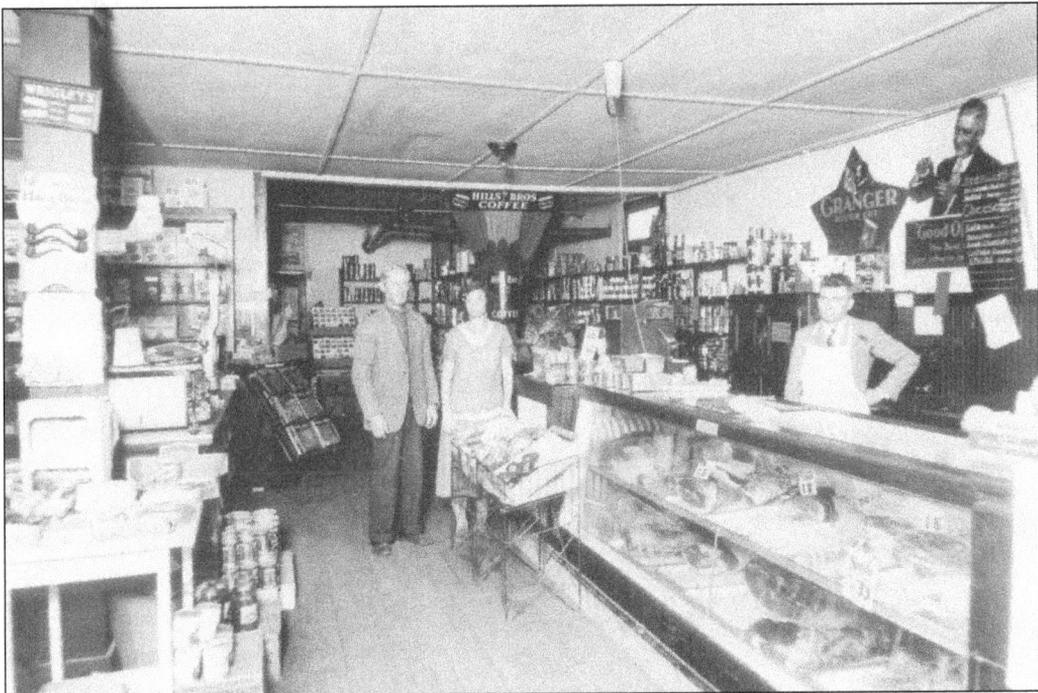

This photo shows the inside of the Park Market in 1931 with Mr. and Mrs. Huffman in the middle, and Mr. Cooper behind the new meat counter.

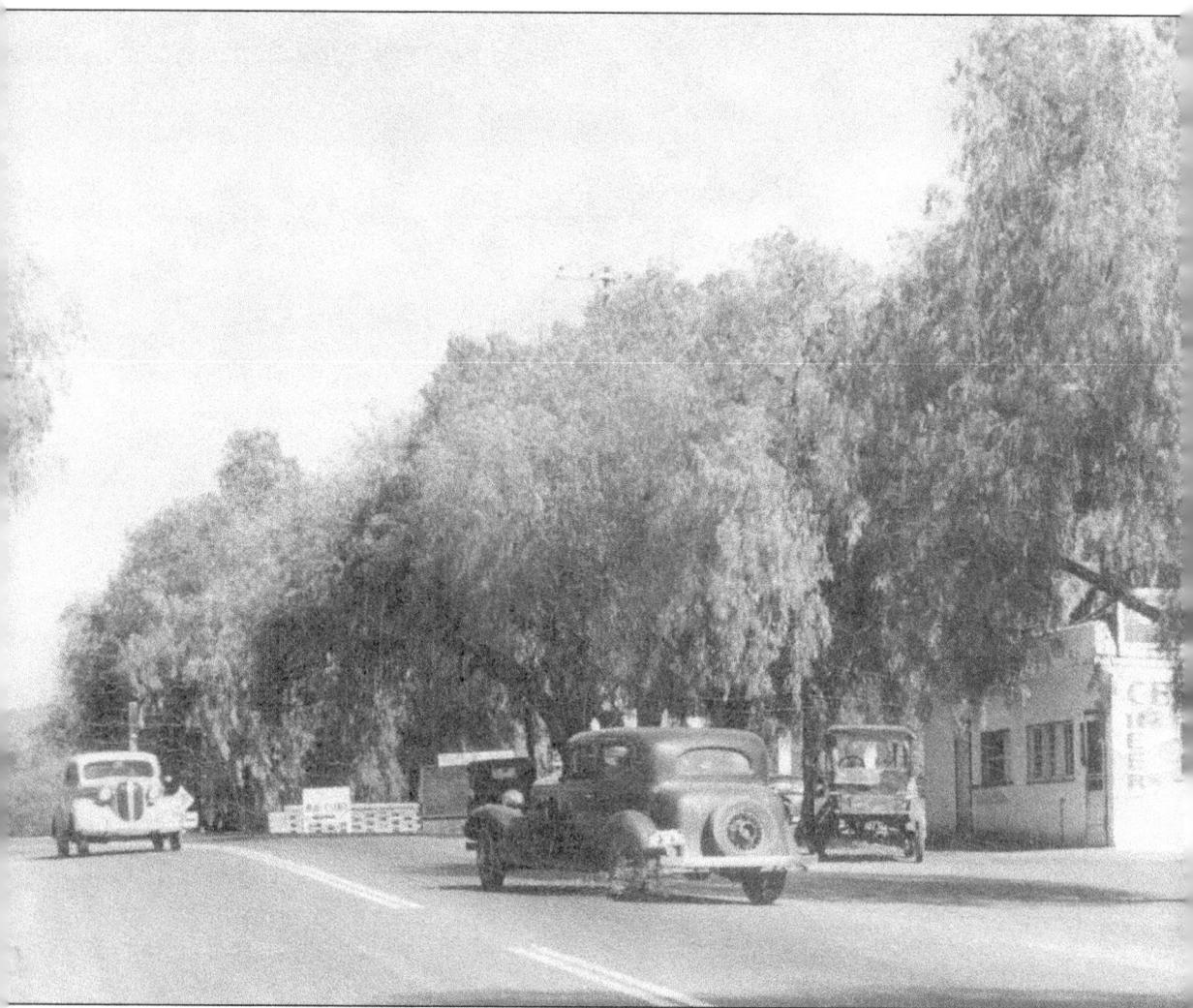

The new location of Cecil's Café is now a drive-in on Woodside Avenue near Maine. This building, the old spring house, is the only structure remaining from the Lakeside Inn after its demolition in 1920—it is still with us today in part. This picture looks east at where the Inn

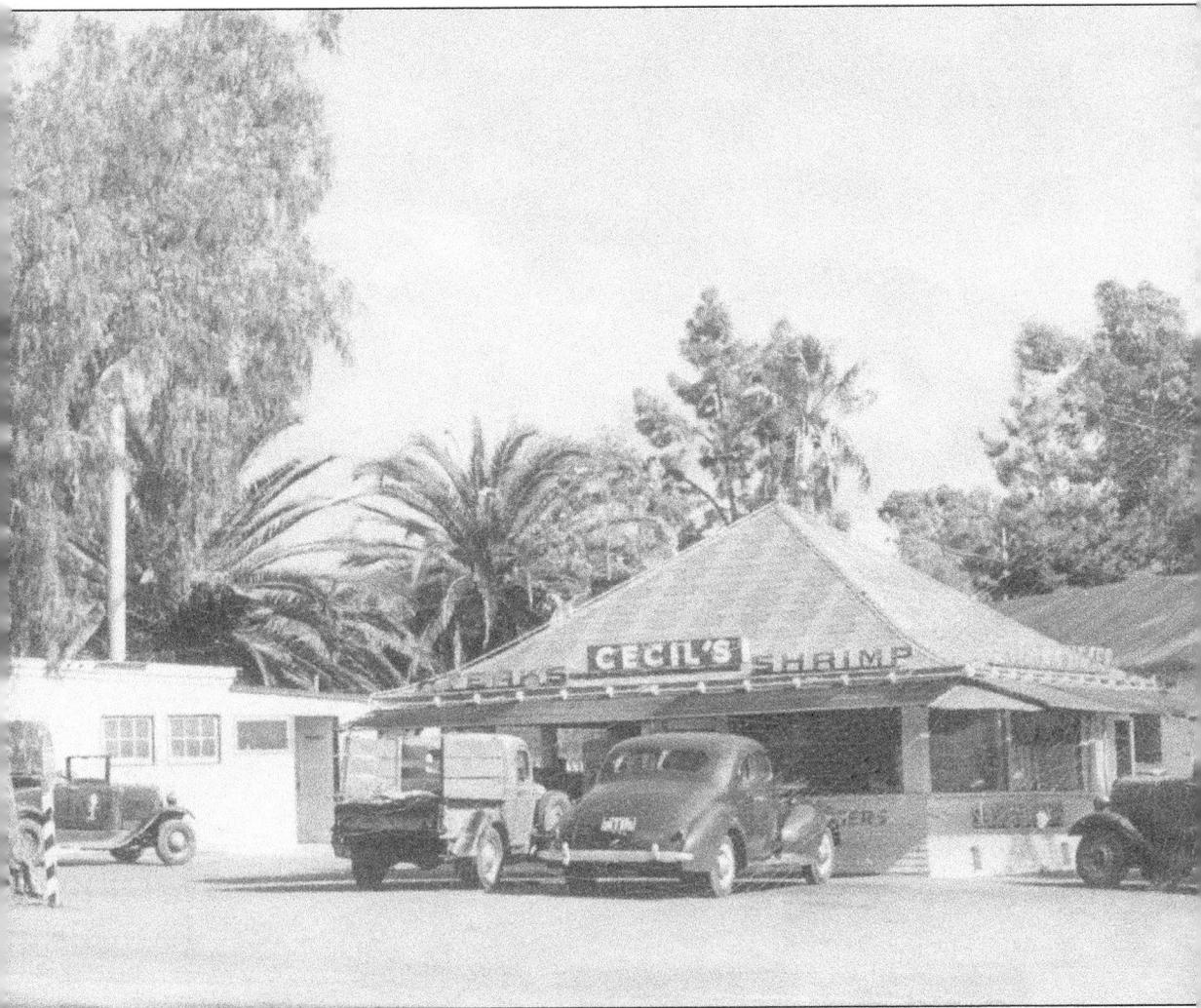

once stood. Behind the real estate sign a small part of the Inn's wall that was built in 1908 can be seen.

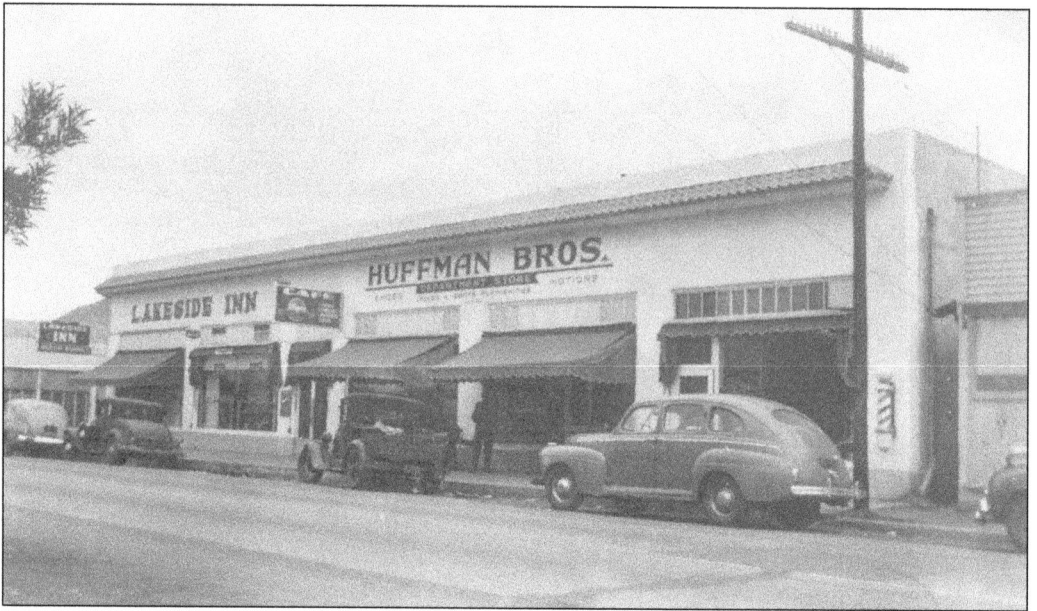

The Huffman's bought their department store from Francis DeWeese in 1936. Ten years later, they built a larger store south of the first store on Maine Avenue. Sons, Orville and Harvey, worked with their father. In 1950, the new store was sold to Jess Shaw who renamed it The Lakeside Department Store.

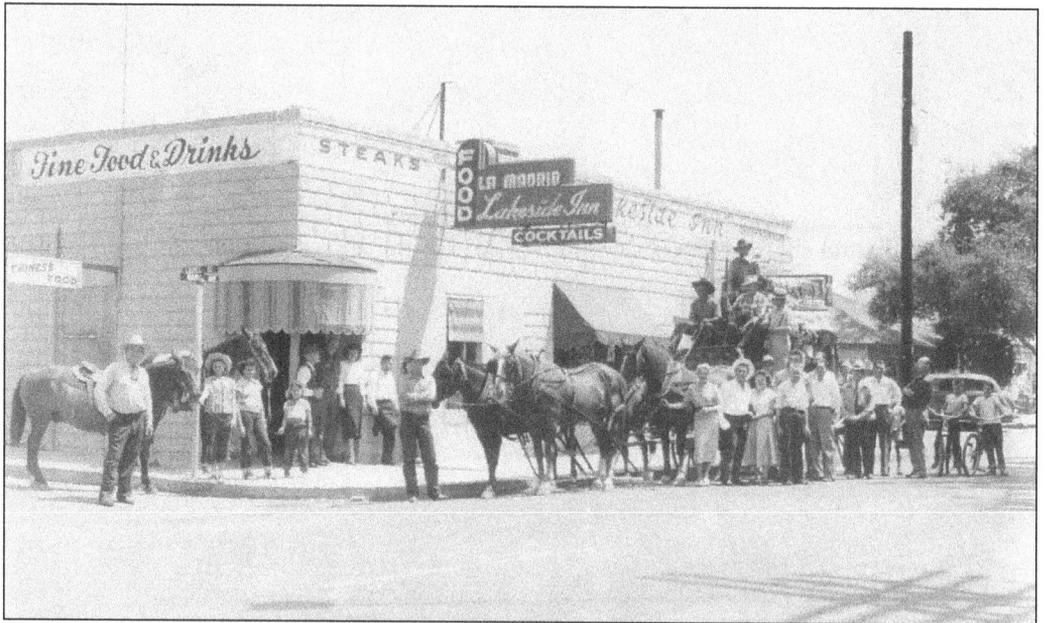

La Madrid's Lakeside Inn on Maine Avenue and Laurel Street was once the blacksmith shop operated by Tom La Madrid. It was also a shop where he built several stagecoaches (one can be seen at the right of the picture). He later converted the building into La Madrid's Lakeside Inn. This picture from the 1930s shows Tom standing at the left with his horse.

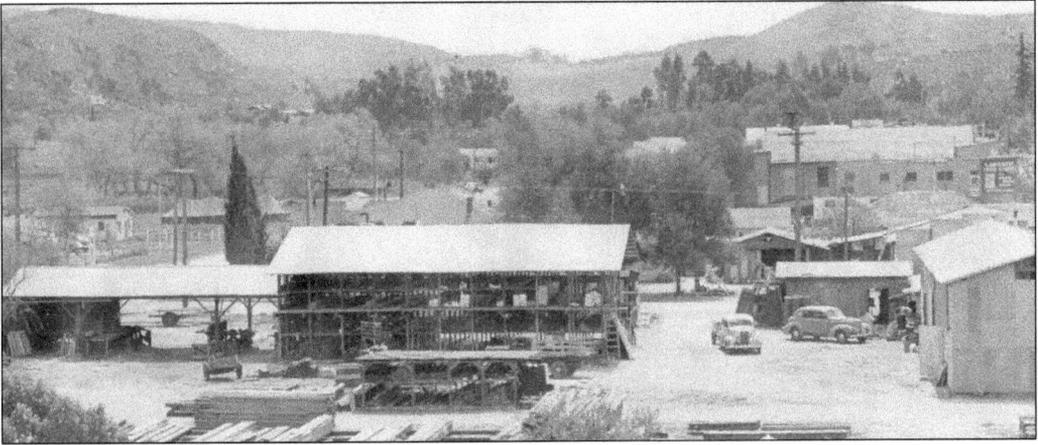

This photo looks south across the Lakeside Lumber Yard and Lakeside towards the Los Coches valley.

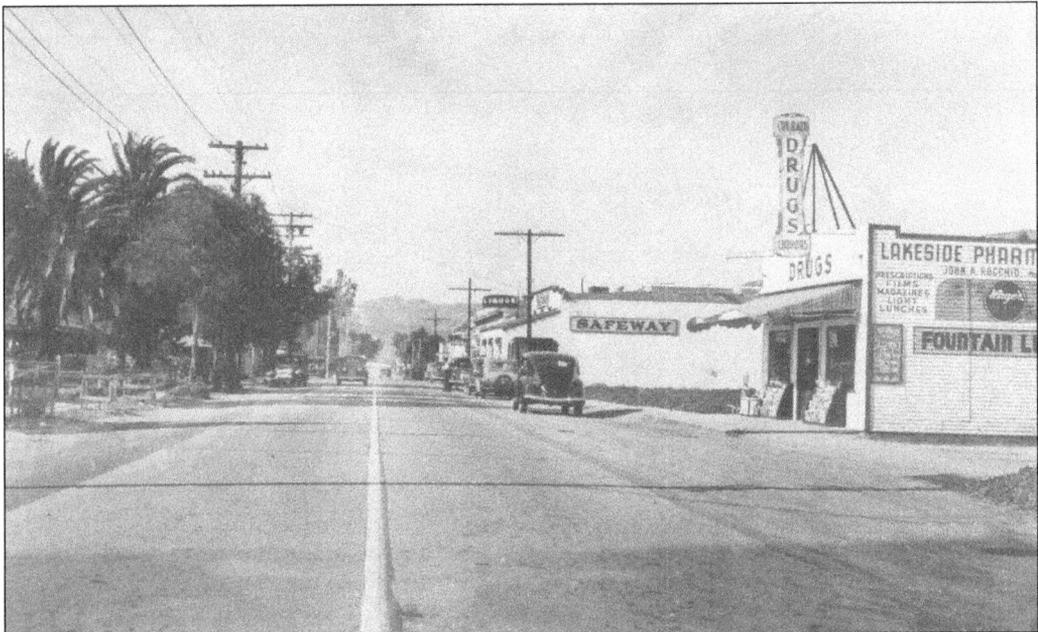

This view northbound on Maine Avenue in 1938 shows John A. Rocchio's first Lakeside Pharmacy offering fountain lunches. Further down the street is the recently added Safeway store.

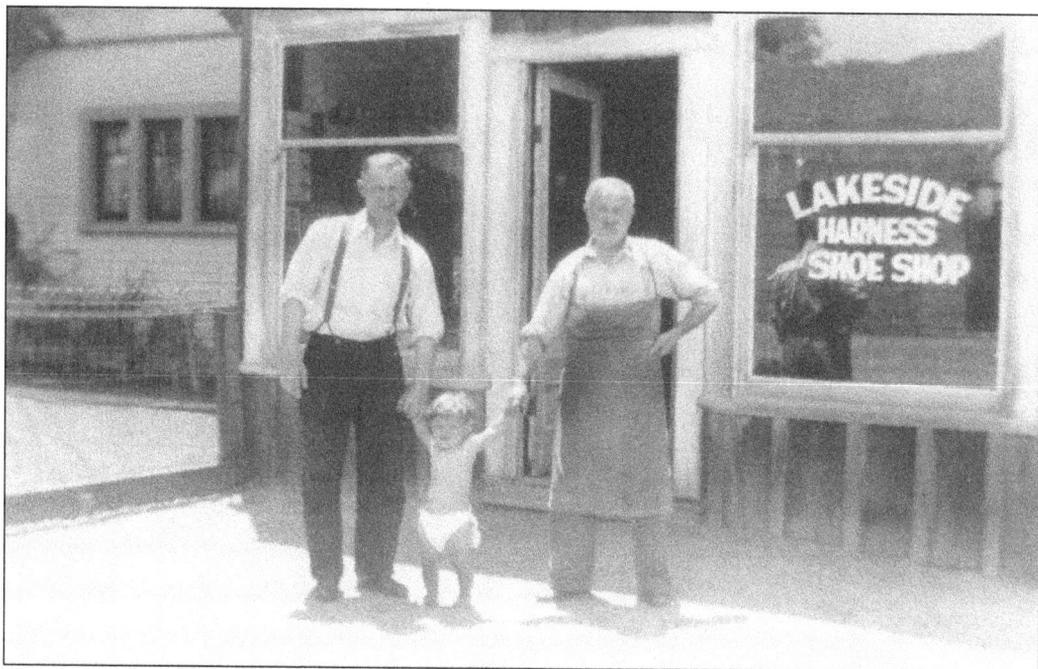

Lorenz Gandyra's Lakeside Harness and Shoe Shop was located at Maine and Laurel. The Gandyras came from South Dakota in 1911. He built his home and a Harness Shop in front—the home is still there. Posing for this picture are Clifford, Lorenz, and little Mary Catherine Gandyra.

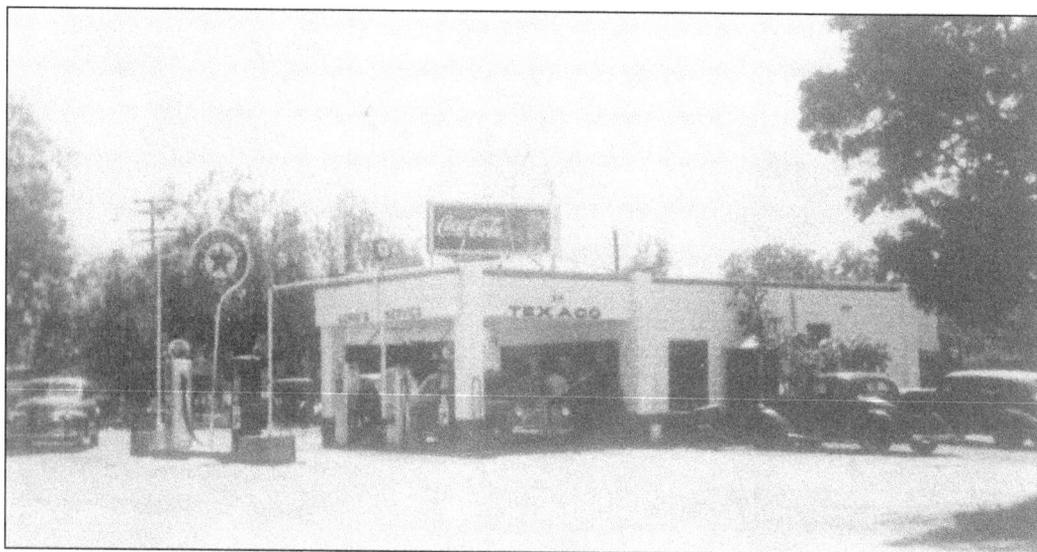

Hank Long's Texaco Service Station on the corner of Woodside and Maine Avenue is pictured here in the 1940s. Originally this station was owned and operated by Otto Einer.

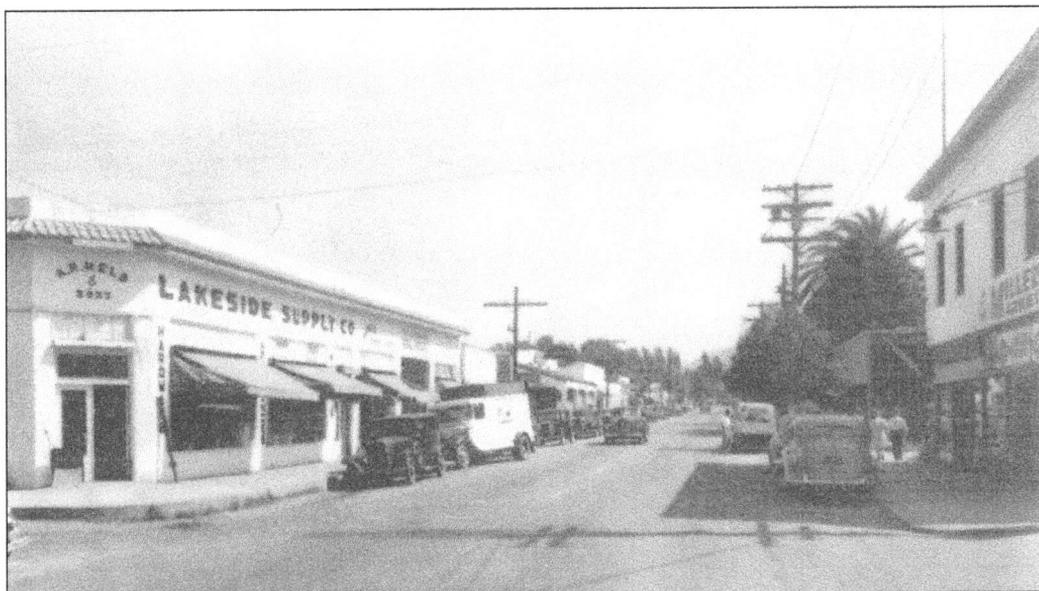

In this 1947 view of Maine Street, Anthony Held's new store is now on the east side of the street. On the right side, where he first opened his supply company in the old Lakeside Store building, is now Miller's Market. Next to Miller's, construction is underway for a new set of storefronts that are still in use today.

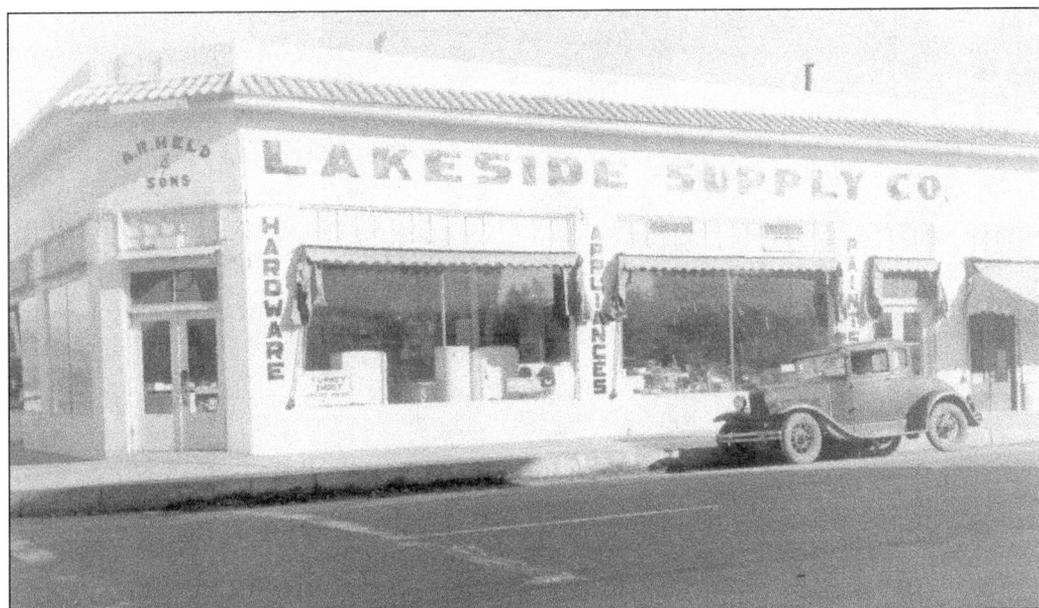

Anthony R. Held & Sons Lakeside Supply Company moved to the southeast corner of Main Avenue and Sycamore Street in the 1940s, and remained there until 1963 when Leo Ward purchased it for his pharmacy.

This beautiful archway of Cork Elms at the west entrance to Lakeside is believed to be the only lane of these huge old trees in the U.S. The trees had been imported from Australia by the El Cajon Land Company and were planted on Arbor Day of 1893 by the pupils of the first school in Lakeside. This picture was taken in the 1940s at the corner of Woodside Avenue and Channel Road looking east.

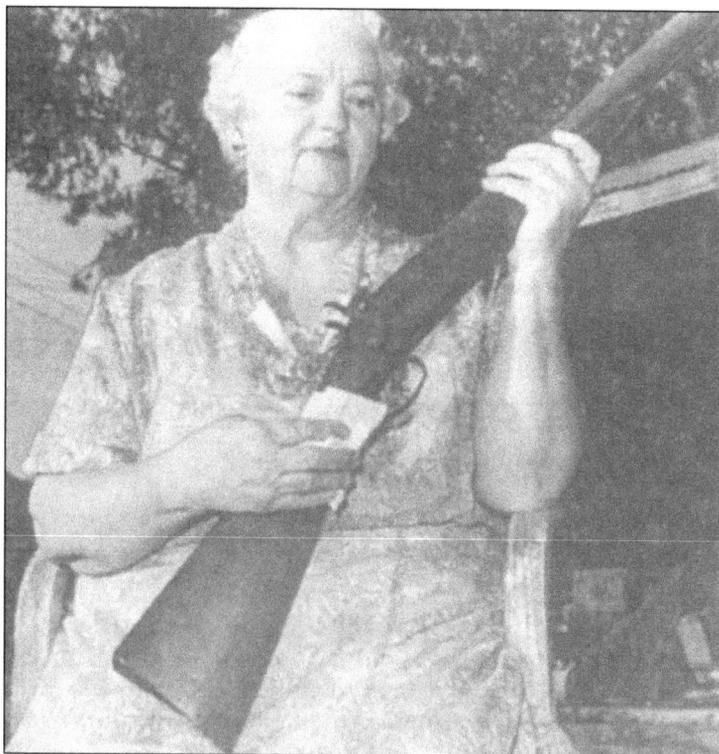

Originally there were over 50 elm trees on each side of Woodside Avenue, but on February 6, 1956, the trees began to fall in the name of progress. Seven of these beautiful old shade trees were cut down from the south side for an entrance to a proposed shopping center. Flossie Beadle was so strongly opposed to the destruction of these trees, that she took her shotgun in arms to protest their removal. But her efforts were in vain, and today there is not a single tree left to justify the name of Woodside Avenue.

Pictured above are the Lakeside Community Church and the Lake Café on the corner of Maine Avenue and Parkside Street in the 1940s. Behind the gas truck the Lakeside Roll of Honor can be seen.

The Lakeside Roll of Honor displayed the names of those who served in the Armed Forces during World War II.

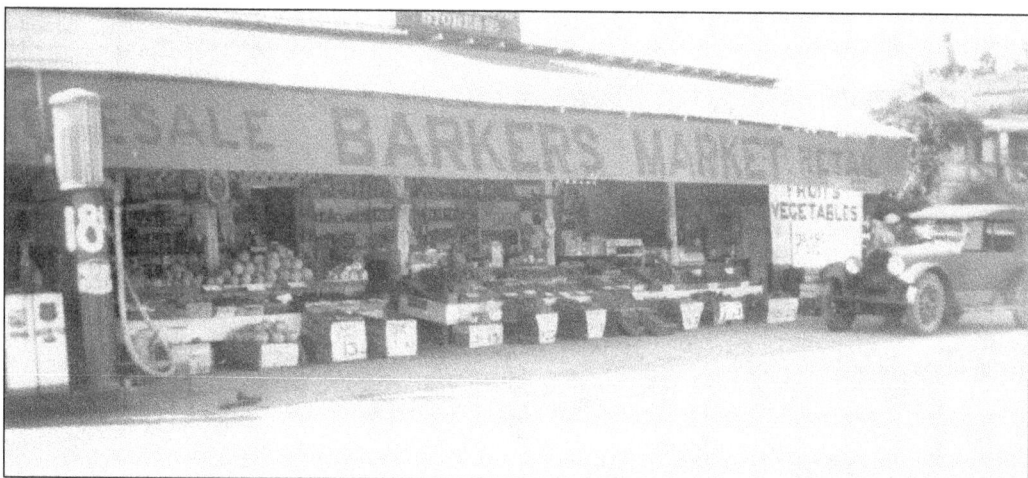

In 1929, Otis Barker began wholesaling fruits and vegetables from this store at San Vicente Road and State Highway 67 and operating produce trucks. From that, he worked into the grocery business.

When Otto Marcks died in 1953, Otis Barker moved into his store on Maine Avenue. Three years later he moved again to the Allied Food Store (originally Safeway) just a few doors to the south. Fred Prindle took over the meat department. The name of the market was changed to Barker and Sons, and Prindle and Son.

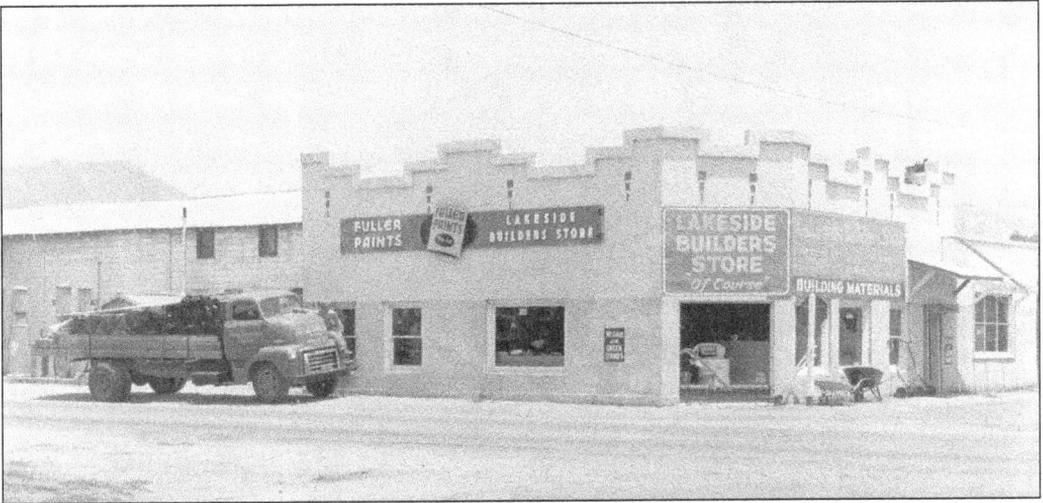

Formerly Kibbey's Lakeside Lumber Yard on the corner of Maine and Laurel in 1950, it is now Lakeside Builders Store "Of Course."

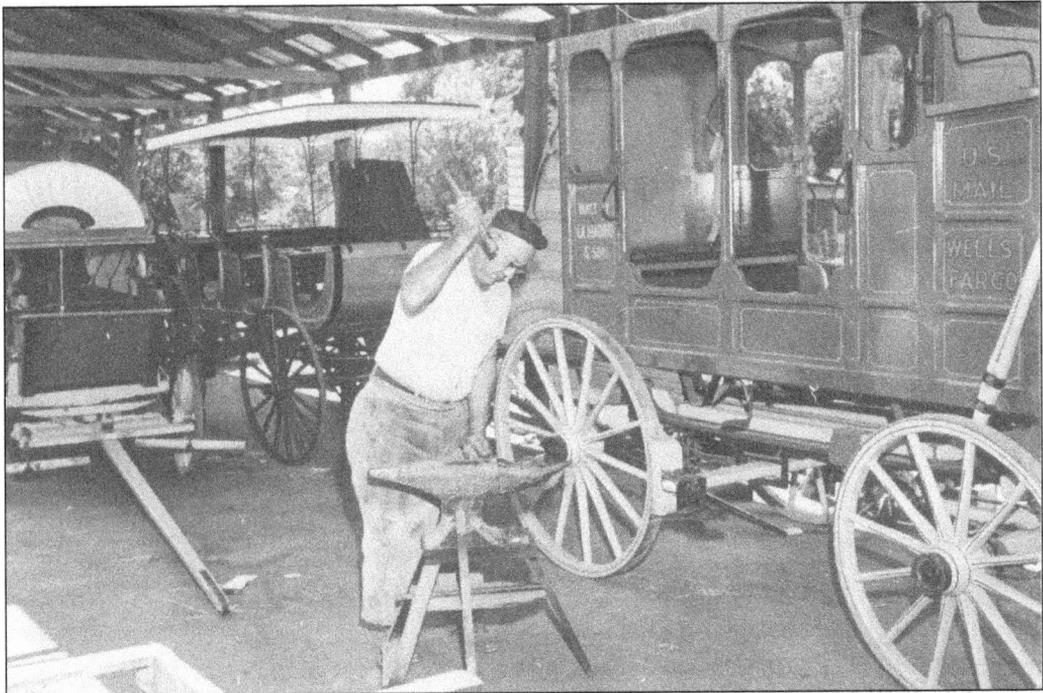

In this photo, Tom La Madrid is working in his Blacksmith's shop on Laurel Street in the 1950s. "I knew Tom La Madrid rather well as my blacksmith and as a friend. He worked on many of the old Butterfield Stage Coaches to restore them to perfection and had them in many parades, including the Historical Days parades in San Diego. He also restored the old covered wagons, for the same purpose, and did beautiful wrought iron work for many people who wanted it for decoration or purposeful gateways, etc. Tom and his wife lived on the corner behind the Lakeside Hotel (old Lindo Hotel). Tom had a son by the name of Fred, who is now also deceased. Tom was a hard, constant worker who couldn't stand laziness and would easily say so!" —*Sr. Anna Mary Meyer.*

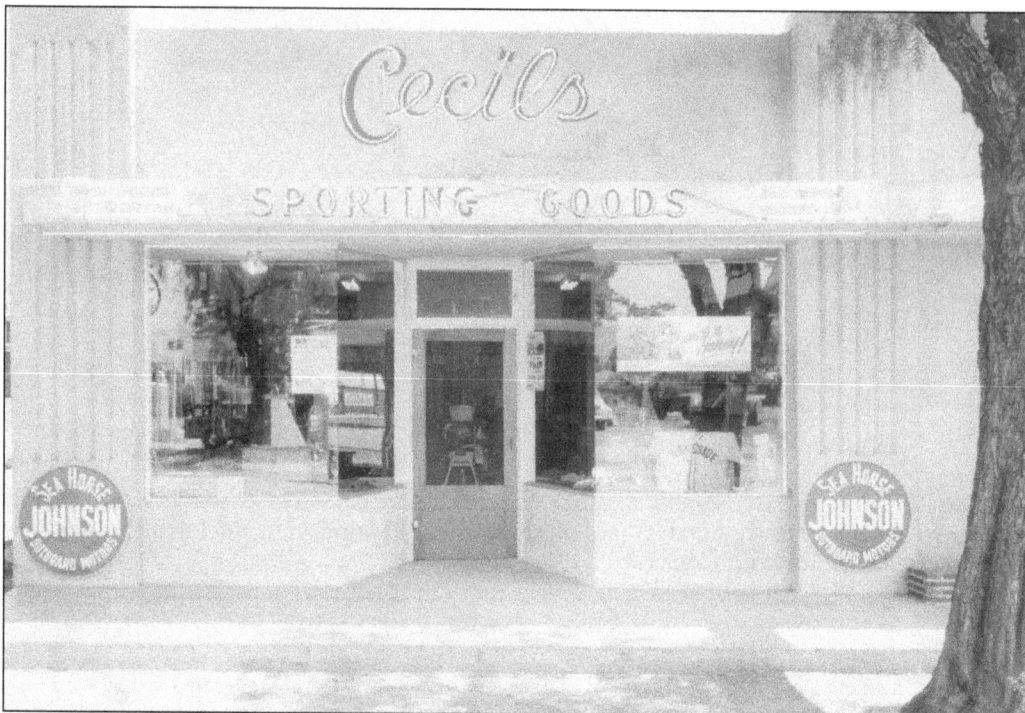

Next door to Cecil Carender's "Cecil's Restaurant," Cecil opened a Sporting Goods store near to the corner of Woodside and Maine Avenues.

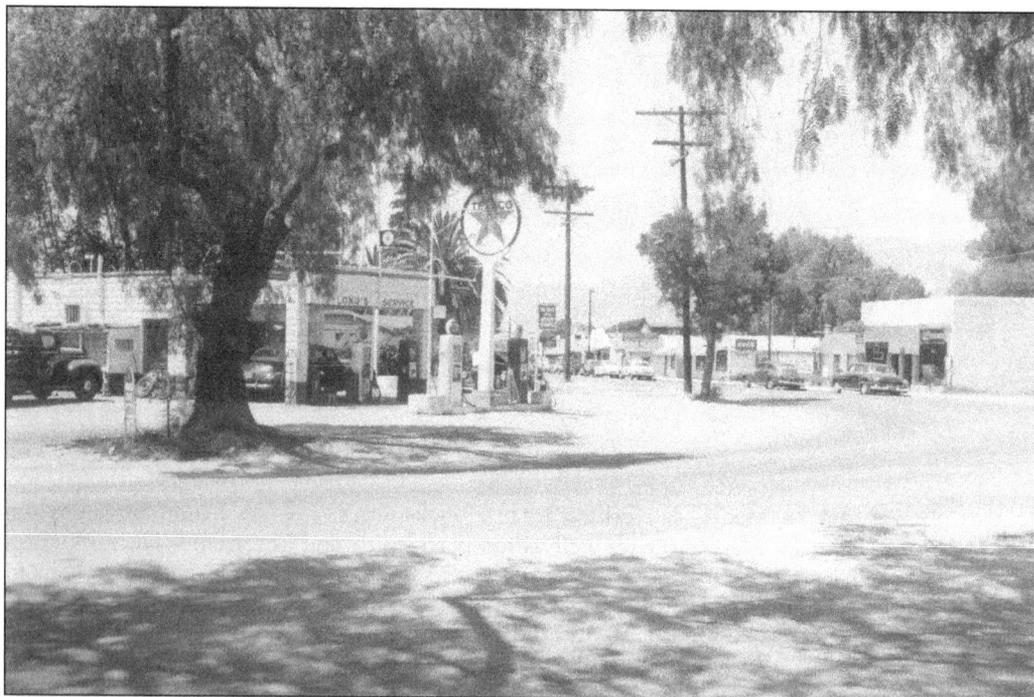

This picture looking north from the front of Cecil's Sporting Goods was taken on the same day as the one above, June 30, 1951. Long's Texaco Service Station is on the corner.

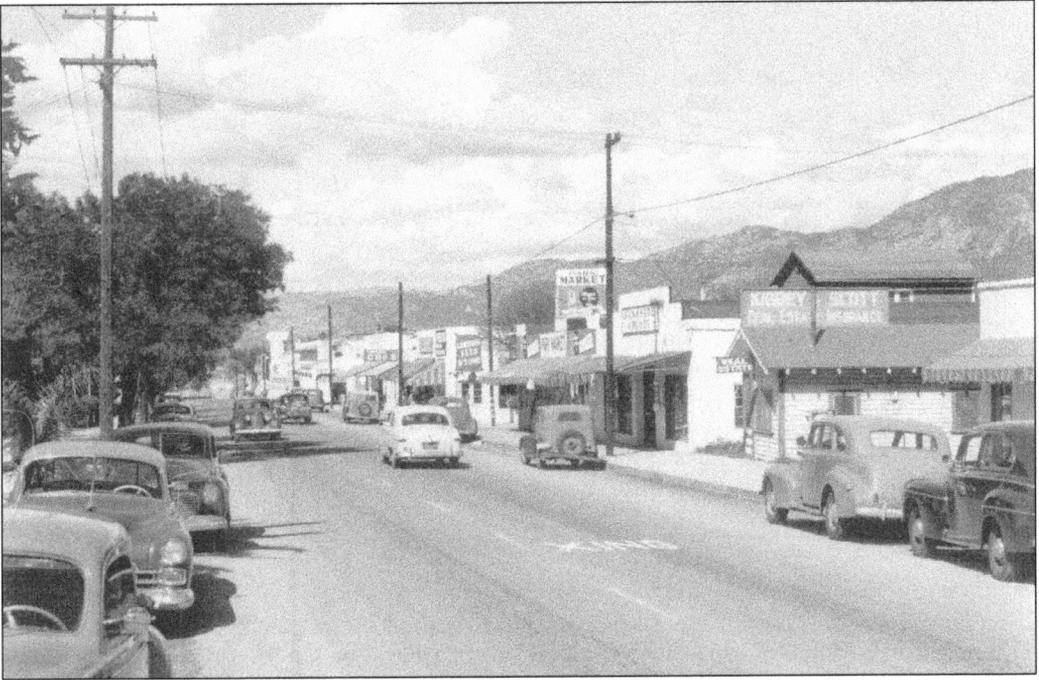

This view is looking north up Maine Avenue in 1951. On the right is Kibbey & Scott Real Estate and Insurance, Lakeside Arcade, Park Market, Lakeside Feed Store, Lakeside Café, Huffmans Department Store, Barker and Sons Grocery, Held's Lakeside Supply Company, Rocchio's Lakeside Pharmacy, and at the end is the Lakeside Theater (in the old Town Hall).

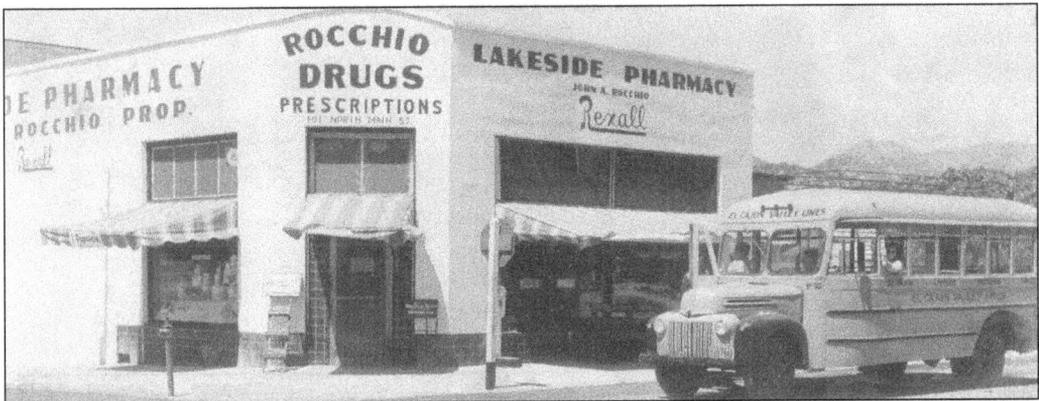

This building, at 101 N. Maine Avenue, was the Club Room for the Lakeside Woman's Club from 1920 until they sold it to John A. Rocchio in 1945. He remodeled the building into a very modern drug store. Leo Ward bought out Rocchio in October of 1960. Leo then moved across the street in 1963. This 1950 picture shows an El Cajon Valley Lines transit bus.

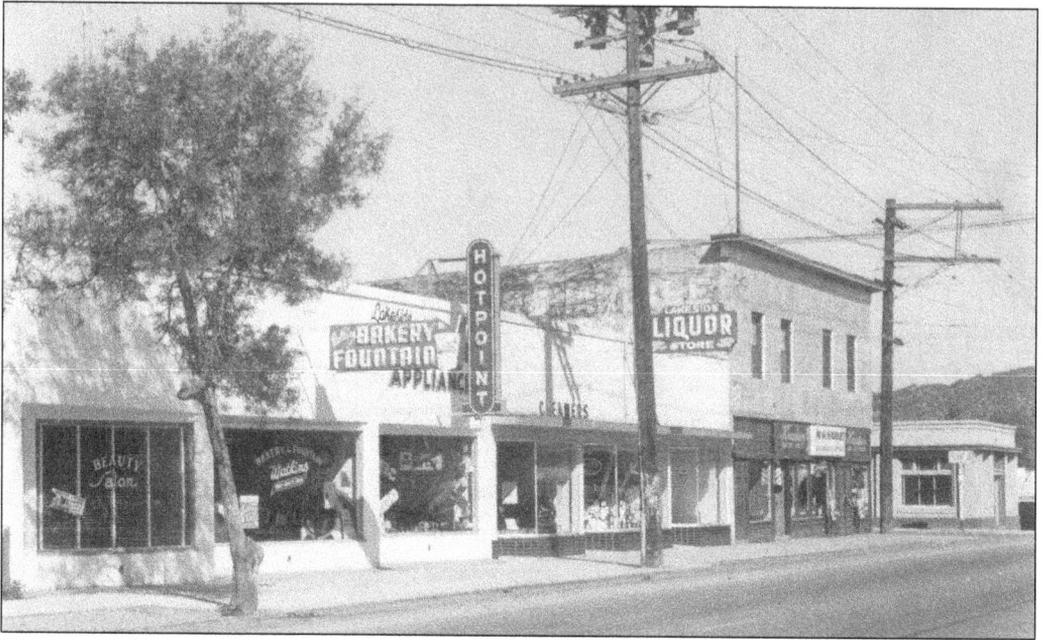

This image from March of 1951 shows the west side of Maine Avenue looking north. The shops are Burn's Beauty Salon, Watkins Bake-Sweet Shop, Lakeside Appliances, Sutton Cleaners, Sam and Katie's Lakeside Liquor, M & H Market (originally the Lakeside Store), and the Valley Commercial Bank of El Cajon and Lakeside on the corner of Lakeshore Drive.

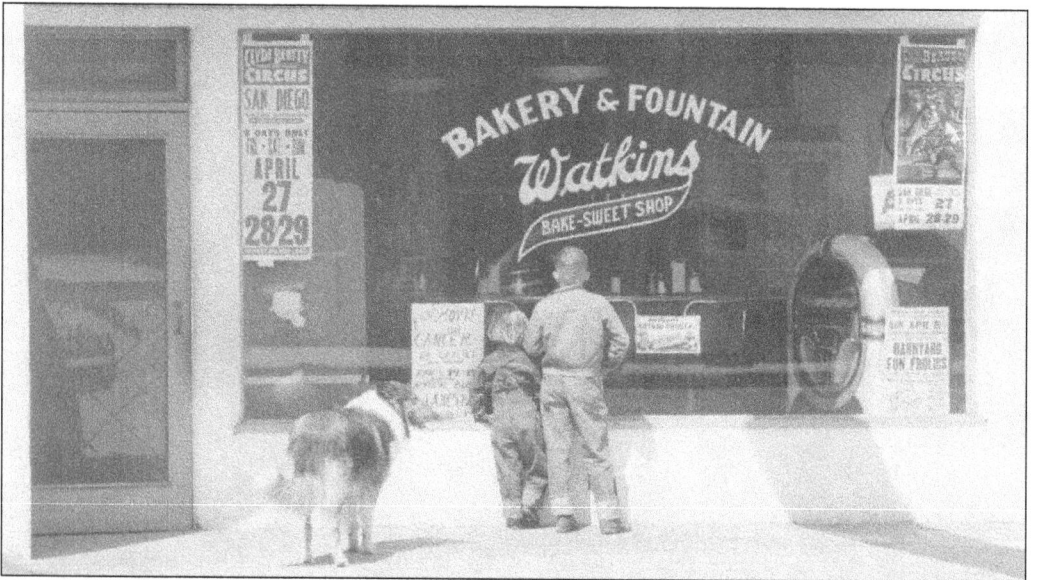

Watkins Bake-Sweet Shop opened in August of 1947 as a bakery, fountain, and candy store. Bob Watkins became famous for his fruitcake, which was shipped all over the U.S. His mail-order business became so successful that he had to set up his own mailroom in the back of the store. As seen in this photo from the 1950s, this was a favorite gathering place for people of all ages. The bakery was closed in 1962.

Five

RANCHES, FARMS, AND HOMES

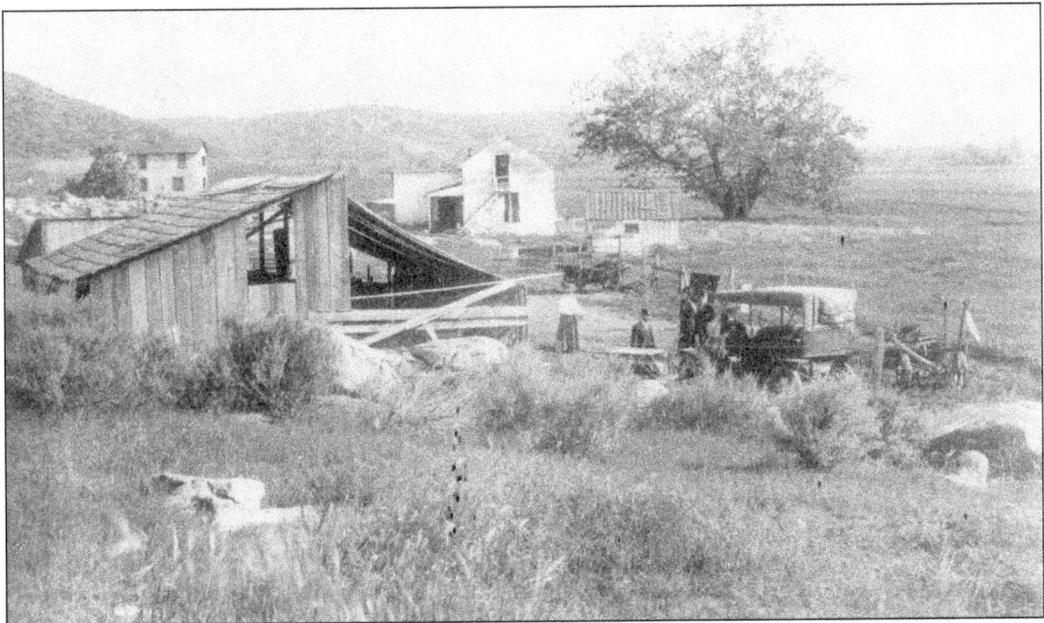

This is a view looking south toward Lakeside in the summer of 1911. Henry White and his family had just arrived from San Diego to inspect their new home, stock barn, and machinery. The old adobe house, center, had a sleeping room added for farm hands. Their newer four-bedroom home is in the upper left.

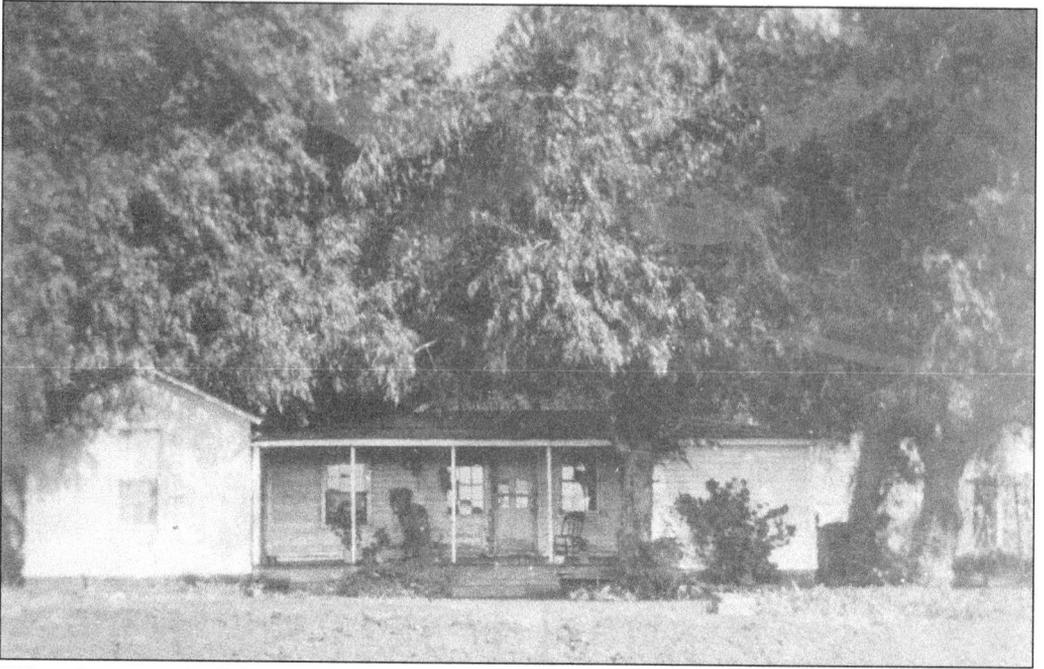

When Benjamin Hill first arrived in Lakeside in the fall of 1870, he built his first home at what is now Wildcat Canyon Road and Willow Road. Later it became part of the Pillsbury Ranch.

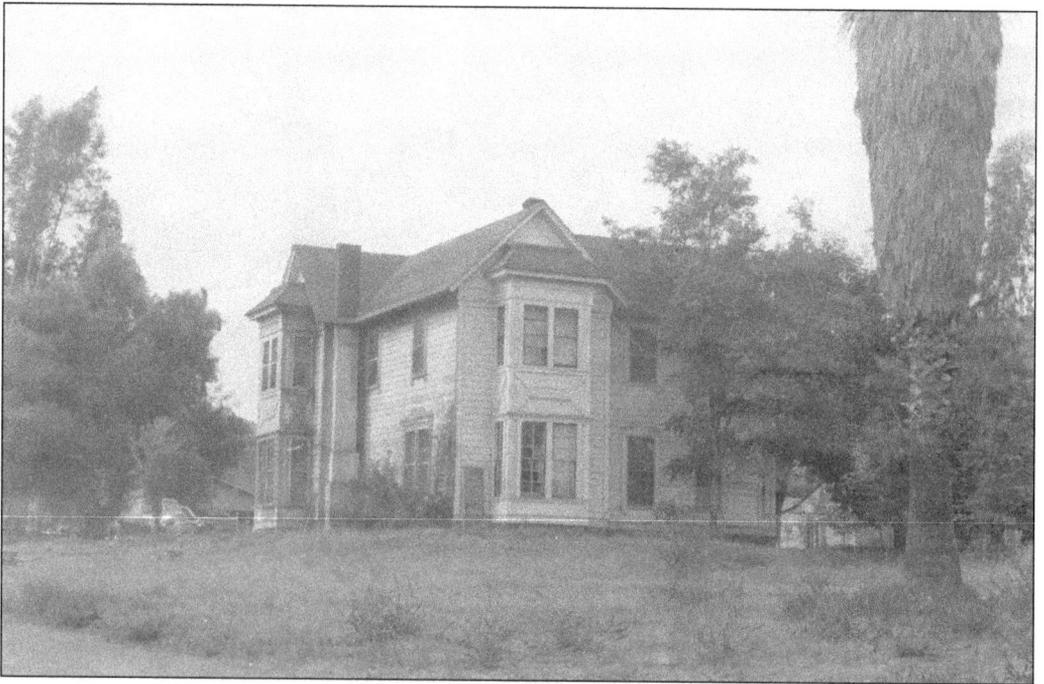

This photo, taken in the 1940s, shows Ben Hill's second home on the corner of Woodside Avenue and Marilla Road.

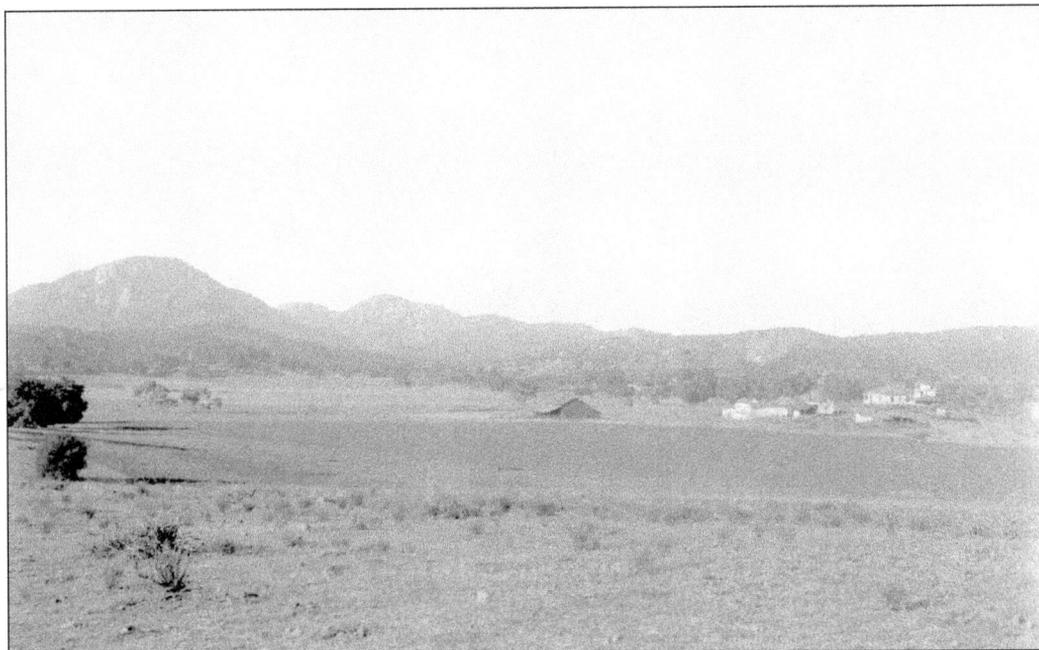

This picture from April of 1899 shows how the Barona Ranch looked when James Edward Gadhaw owned it. The ranch house is situated on a small knoll to the right. The ranch now belongs to the Barona Band of Mission Indians. They purchased it when they were forced to move from their land that was inundated by the formation of San Vicente Reservoir.

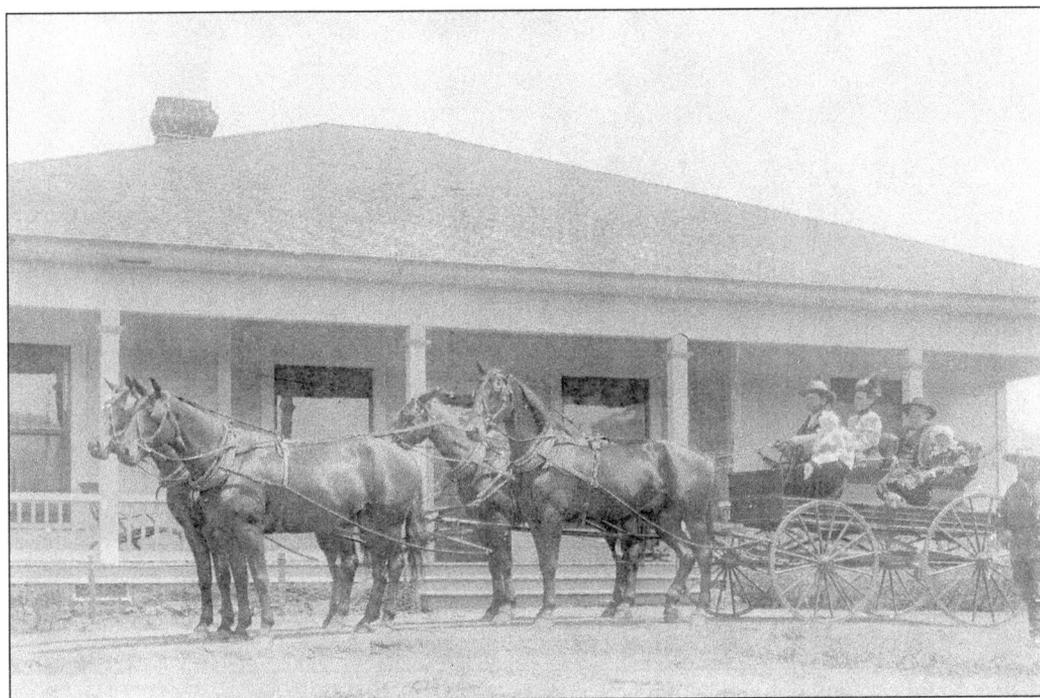

The Barona Ranch house in April of 1899, with James E. Wadham (later mayor of San Diego) and family, is shown here. Ollie Fankhannel is standing behind the buggy.

The Ross home on Maine Avenue is pictured here in 1909. This building is now a veterinarian's office.

When Klauber-Wangenheim Company purchased the Lakeside Store in 1903, C.W. Ross was named as manager. In June of 1904, Mr. Ross moved his wife, Mary, and his daughter, Josie, to Lakeside.

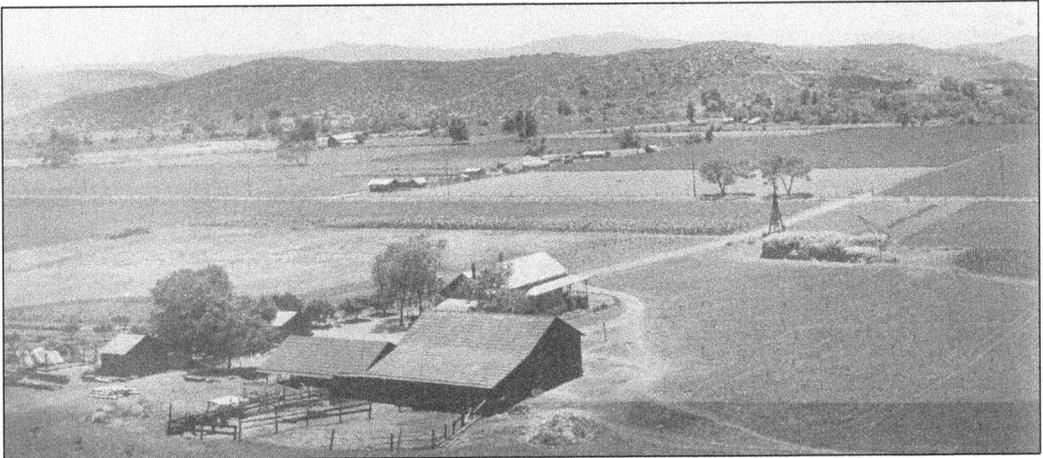

Pictured are Ira and Harriet Philbrook's ranch on Willow Road in 1915.

Pictured in this photo are (seated): L. Nathan Philbrook, founder of Laguna Beach, CA; Morris Philbrook of Lakeside (father of Ira, Grover, Essie, Irene, and Myrtle Philbrook). Standing: Hiram Philbrook of Laconia, WA; Thomas Philbrook of Pacific Beach, CA.

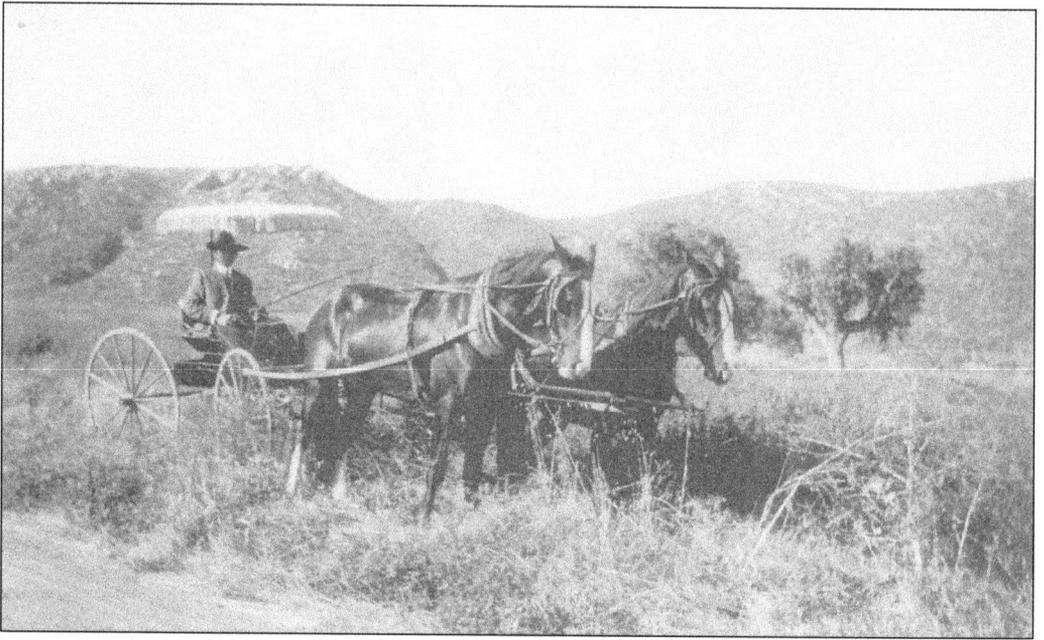
Ira Philbrook pulls off the road to pose for this photo taken on his ranch.

Irene Philbrook's Sunday School class has a party for Hazel Kouns after her recovery from a rattlesnake bite in 1919. Posing for this photograph are Ardis Smith, Gail Robb, Alene Smith, Mozelle Kouns, Dorathy Whitker, Lucille Kouns, Irene Philbrook, Pricella Logan, and Hazel Kouns. This picture was taken at the Thum Ranch.

The Thum Cactus Ranch was located on Ashwood Street where El Capitan High School is now.

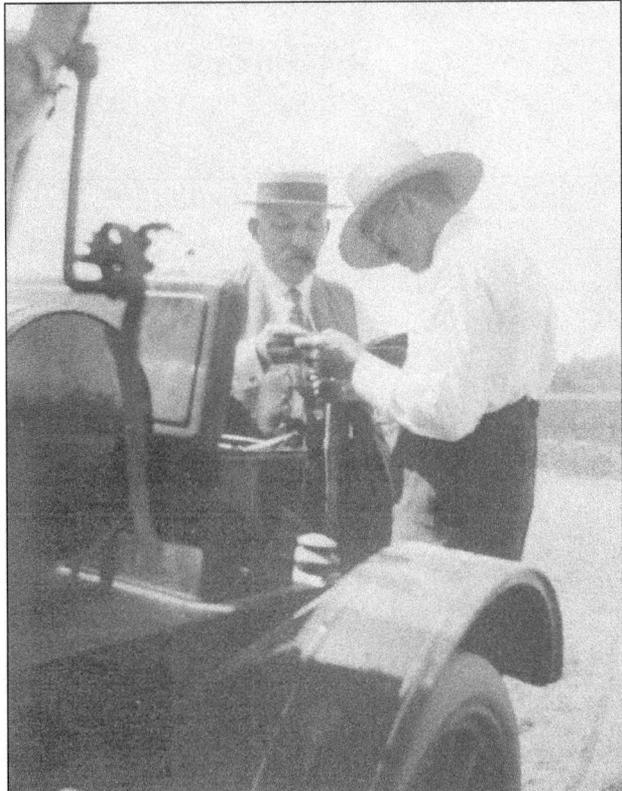

Hugo Thum, the inventor of flypaper, had started his ranch as an experimental project. In 1910, he had obtained 800 leaf pads of the spineless cactus from San Jose, which had been imported from Italy in 1903. Thum planted this cactus as an experiment in feeding cattle, but it was not very successful. Hugo is on the left with Robert Whitaker in 1911.

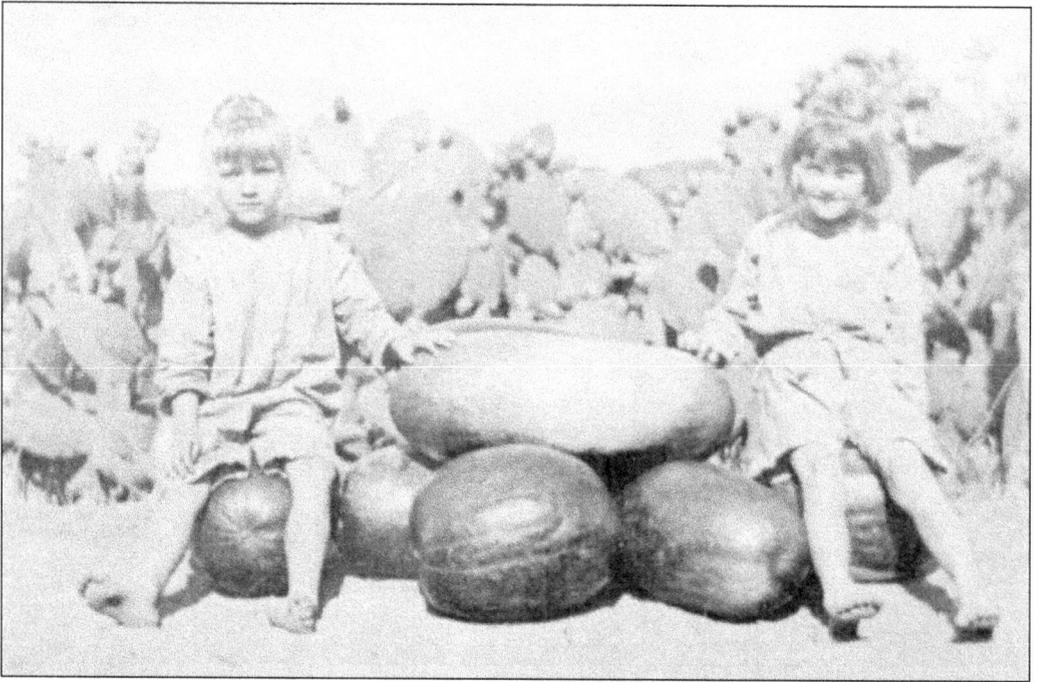

In this photo, Lucille and Eileen Kouns show that produce besides cactus was grown on the Thum Ranch in 1919. Lakeside melons were known for their superior quality.

This photo shows a family outing at the Thum Ranch in the early 1920s.

Above, citrus groves are seen in the Lakeview area during the 1920s with the Lakeview School in the center.

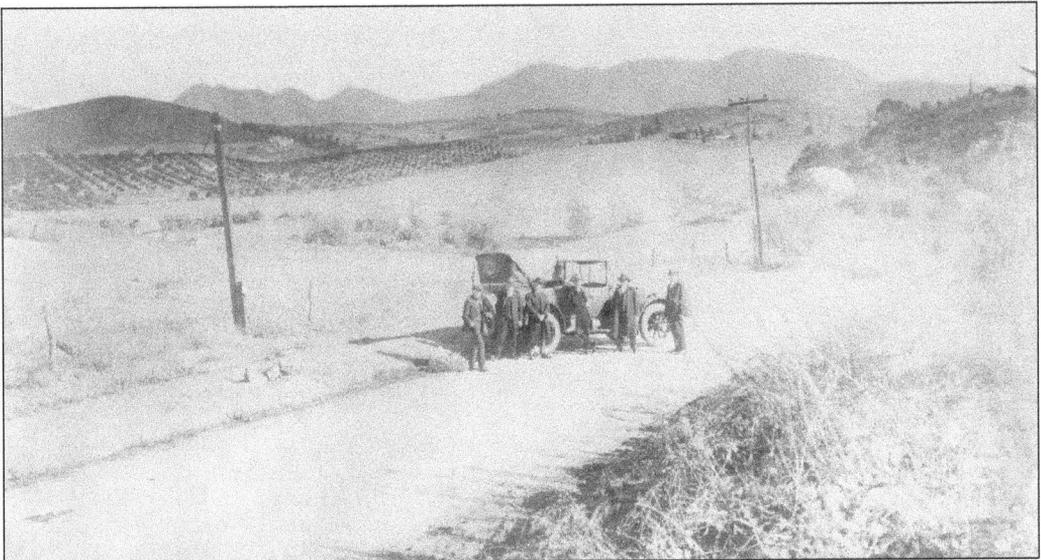

This photo overlooks Los Coches Rancho from Highway 80 in the 1920s. The Lakeview area is in the small valley beyond the citrus groves.

Luna Whitaker's home on Sycamore Street, pictured in 1925, and Robert Whitaker's house to the east are seen here.

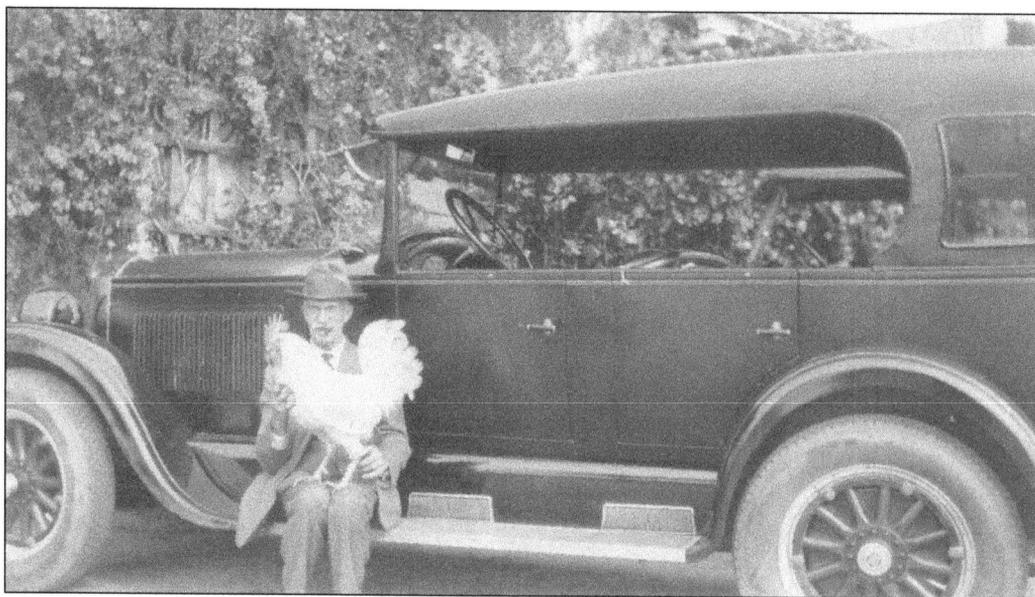

Pictured in December of 1924 is Robert Whitaker, showing off one of his prize winning roosters.

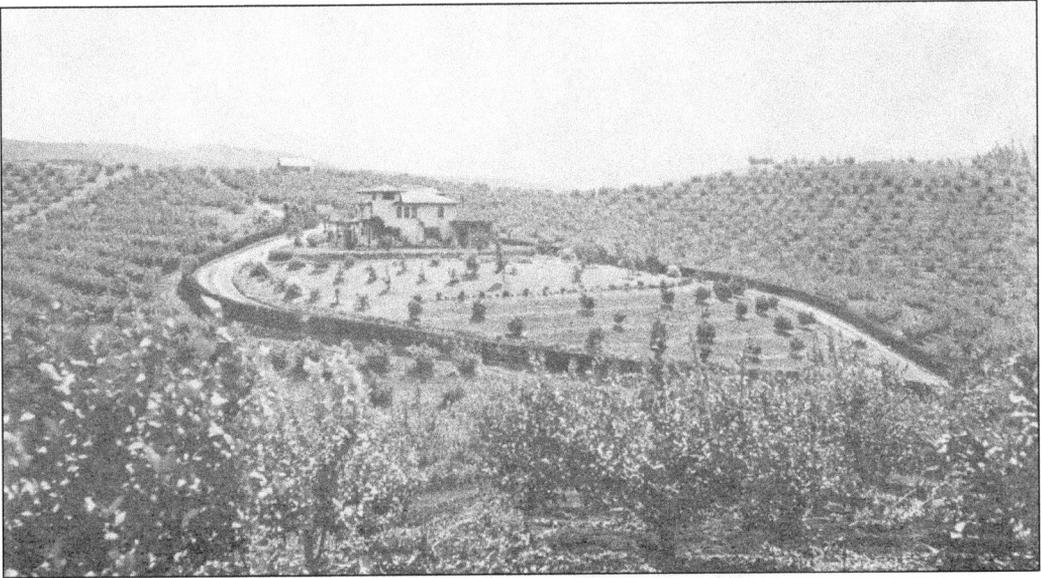

Built in 1886 by Mr. Klein, the Lemon Crest Ranch house has grown old gracefully and is as lovely today as it was when Irving Gill designed it. The 50 acres, which Klein bought, were cleared of sagebrush and cactus, then terraced for the lemon orchard that was planted about the same time. This picture dates from around 1900.

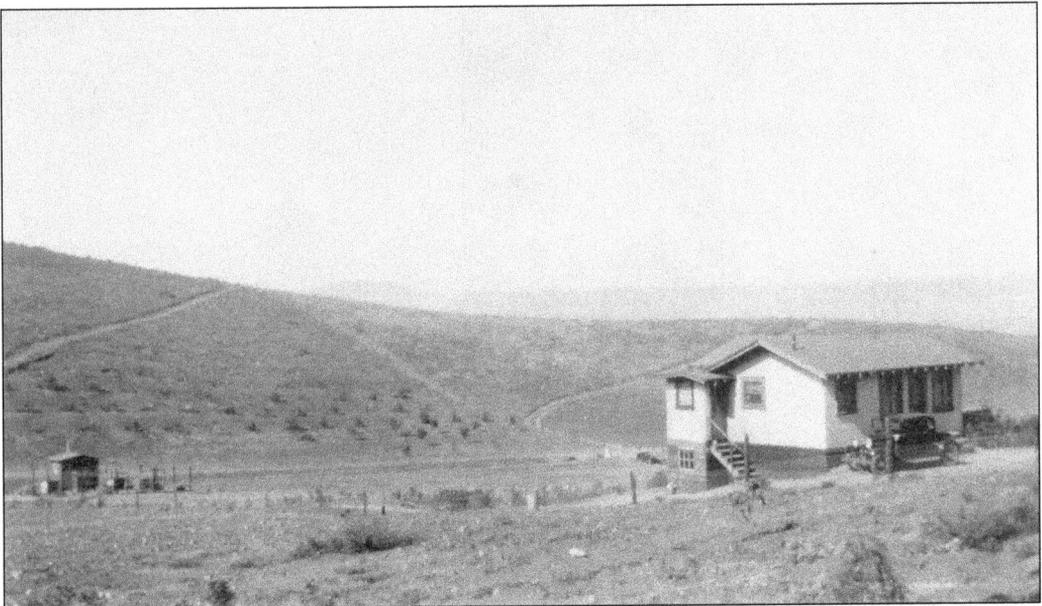

In May of 1929, John and Clarice Andrews came to Lakeside to raise avocados. John, a building contractor, purchased land on Maple Avenue (Westhill Road) and built his home. This image, looking to the west, shows their recently constructed house on October 23, 1930.

Bill Miller at his home on Lemon Crest Avenue in the 1920s is seen here.

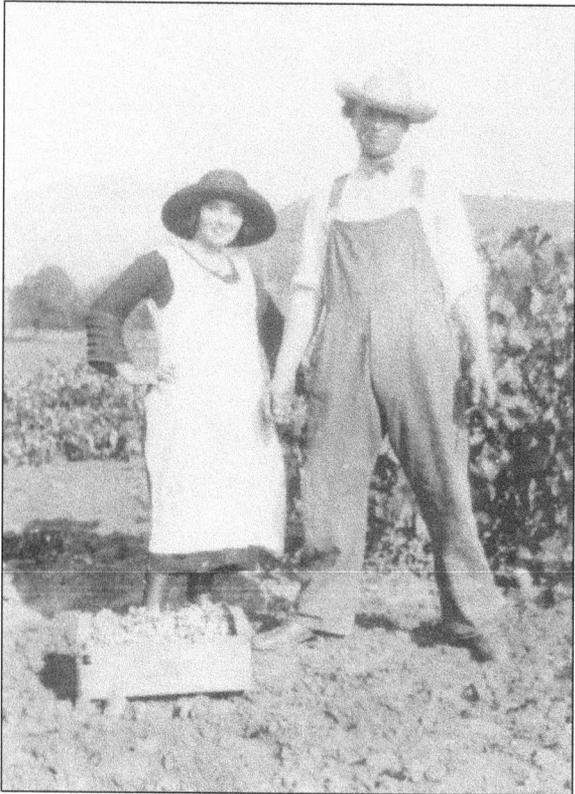

Sophie Smith and Fred Crosthwaite stopped to pose while harvesting grapes on the Hugh and Beatrice Smith Ranch in Lakeside during the summer of 1923. They were married the following year. Sophie's grandparents came to Lakeside in 1886 and lived in the old adobe house on the Rancho Canada de Los Coches, the smallest Spanish land grant.

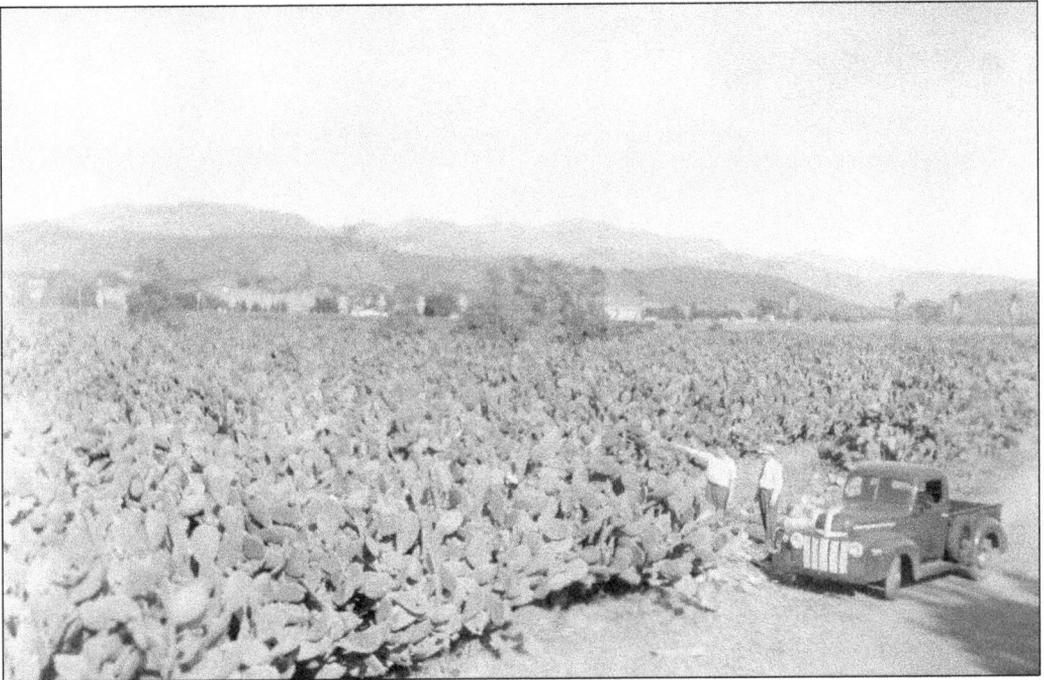

The Maniscalco's started growing cactus on the Thum Ranch. In 1929, Bernardo Maniscalco bought 45 acres from Fred Prindle and his sisters. This was in the area bounded by Riverford Road, Riverside Drive, and Palm Row Drive. They planted 28 acres with pads taken from the Thum Ranch. Production increased until between 14 and 21 carloads of prickly pears were being shipped annually.

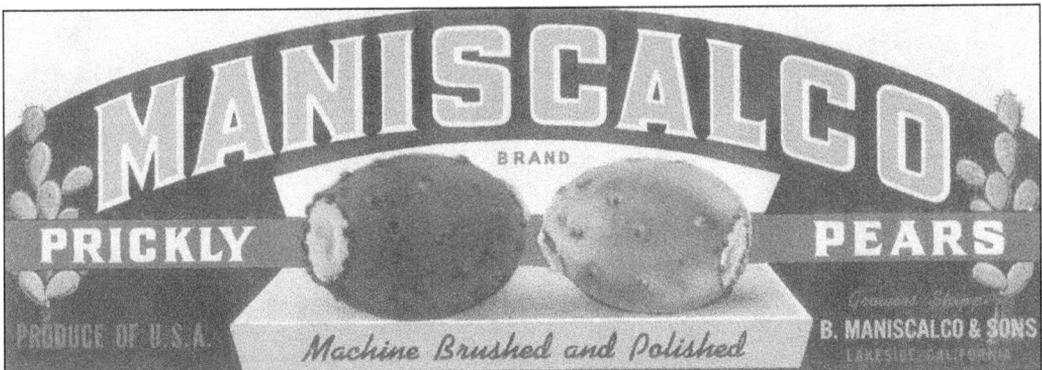

B. Maniscalco and Sons Prickly Pears box label is pictured above.

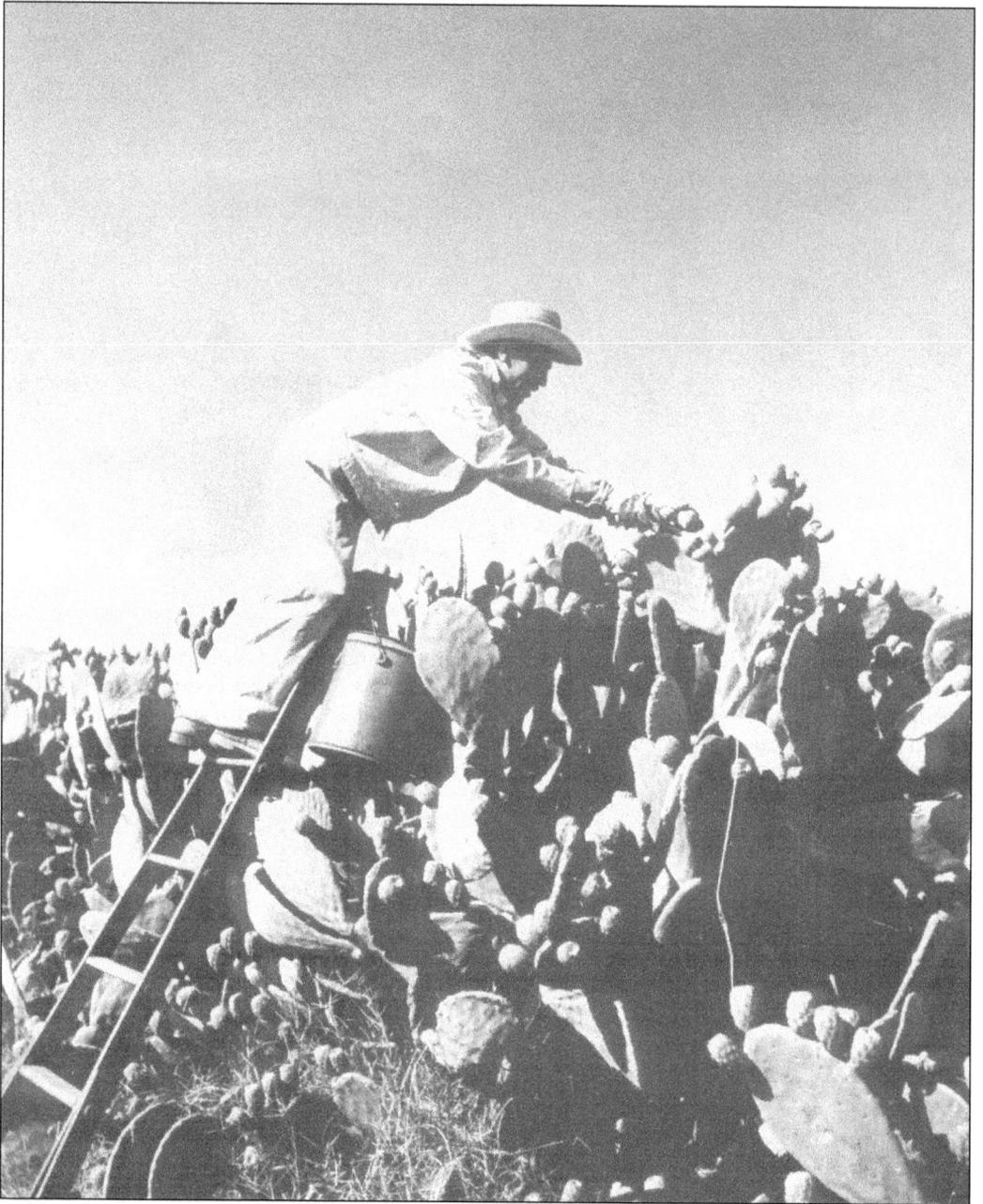

Leon Maniscalco is seen here picking prickly pears in 1949; he supervised the field work and shipping. Bernardo died in 1954 at the age of 78. The boys continued to operate the well-known "Cactus Farm" until 1968 when they bulldozed the cactus under.

The Paradise Chinchilla Ranch in the 1940s is seen here. In 1937, Earl C. Allen, owner of Allen Pharmacies, purchased 100 acres of lemon and orange orchards at the east end of Julian Avenue. Allen started the ranch, which was devoted to raising fancy and ornamental pheasants, peafowl, and other rare birds. Looking for something bigger and better, he became interested in chinchillas.

Chinchilla Cave is seen here in this 1951 photo. Allen paid $3,200 a pair, purchasing two pair for his initial stock. From this, he built a herd of more than 500 animals. The animals were housed in cages set in a vast concrete cave, which was air-conditioned to duplicate the climate of their native environment in the Andes of South America. In 1955, the property was sold to the Helix Irrigation District.

Six

WATER

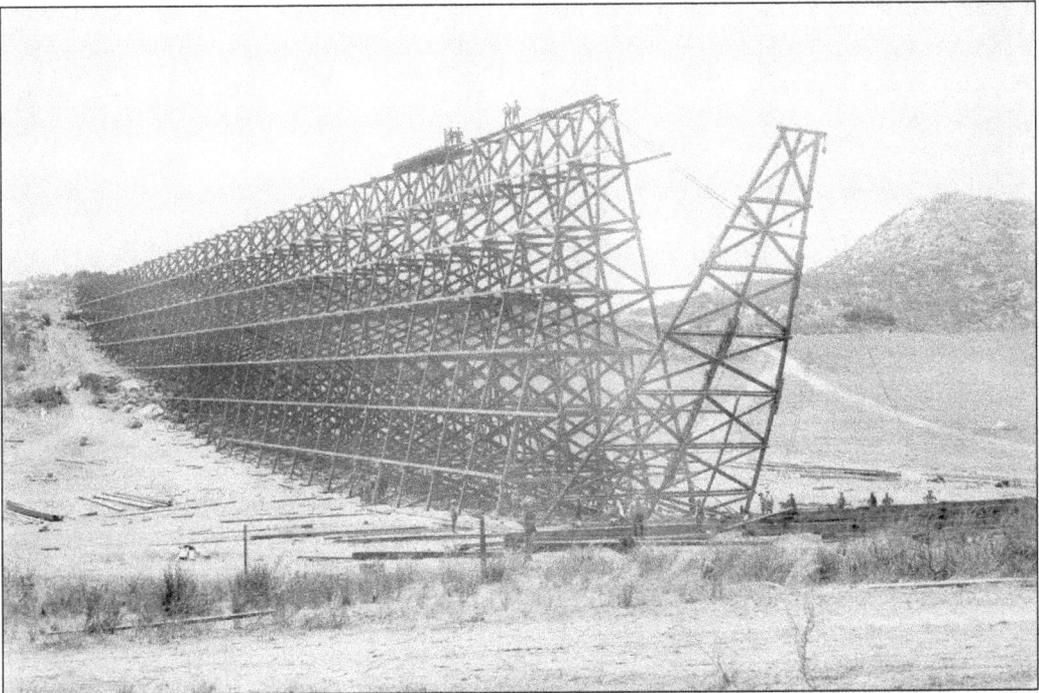

In 1885, the only source of water for the watering of small gardens and orchards was wells with windmills. In May of 1886, the San Diego Flume Co. was incorporated and the Cuyamaca earthen dam was built and construction of the flume began. The Sweetwater Trestle pictured here was 85 feet high.

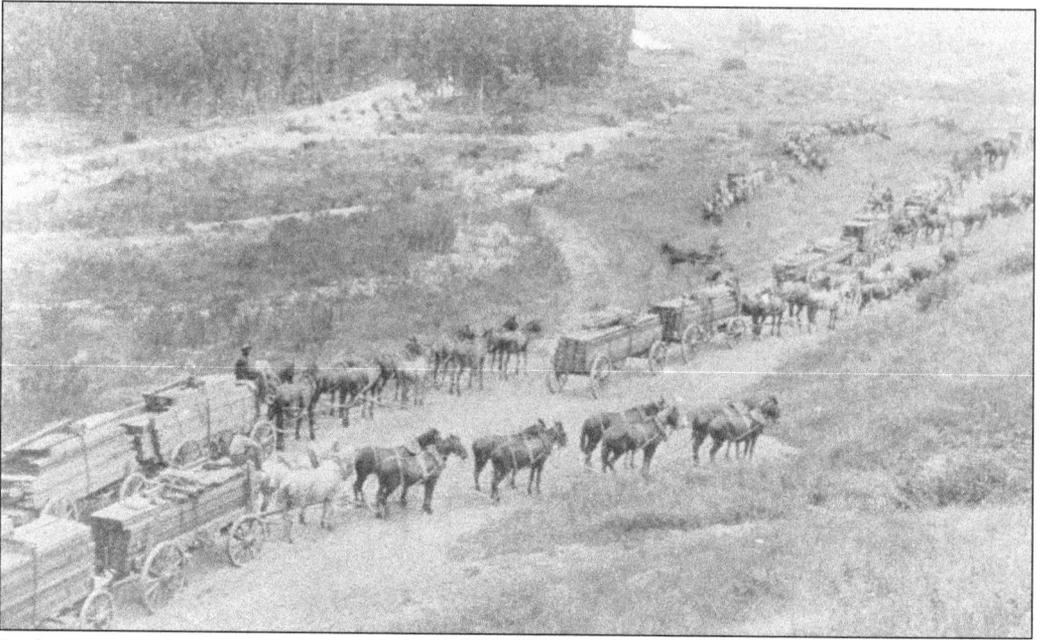

Redwood lumber was brought by boat to San Diego harbor, cut to the required lengths, and loaded on wagons for the trip inland. Over 800 mules and horses, and 100 wagons were required to transport the nearly 9 million-board-feet redwood used on this project. In this photo, freight wagons haul lumber for the building of the flume line and empty wagons pull off the road to let the loaded ones pass. This picture was taken on Highway 80 near the old Chase Ranch in El Cajon.

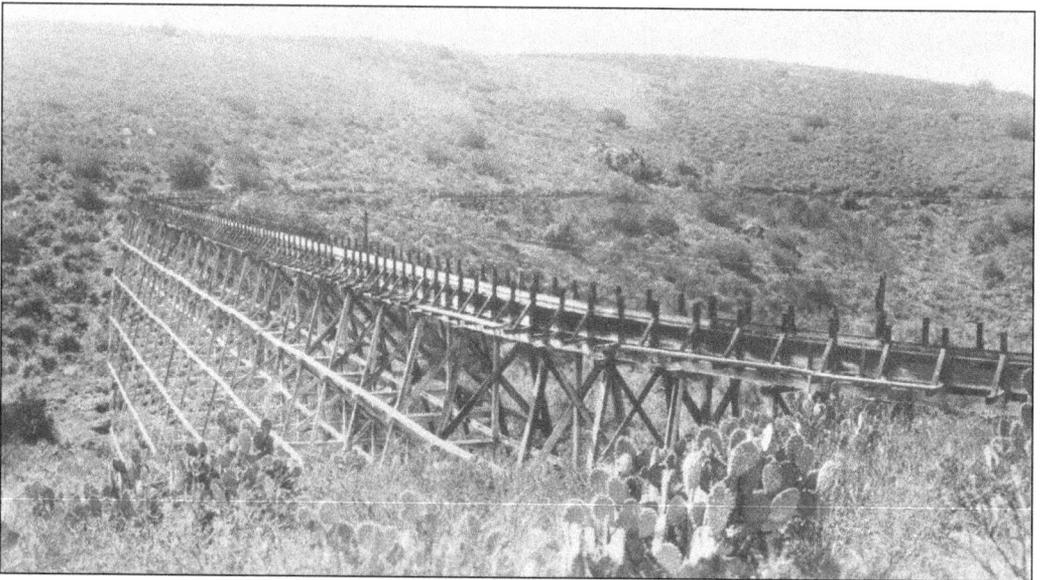

The diverting dam where the water was diverted into the 37-mile flume line to the El Cajon Valley was finished in 1888. The flume water went on to Grossmont where there was a small diverting dam known as Eucalyptus Reservoir. Later, La Mesa Dam was built and used until Murray Dam was constructed in 1916. This image of the Quail Canyon Trestle, now the site of Lake Jennings (Chet Herrit Dam), was captured in 1925.

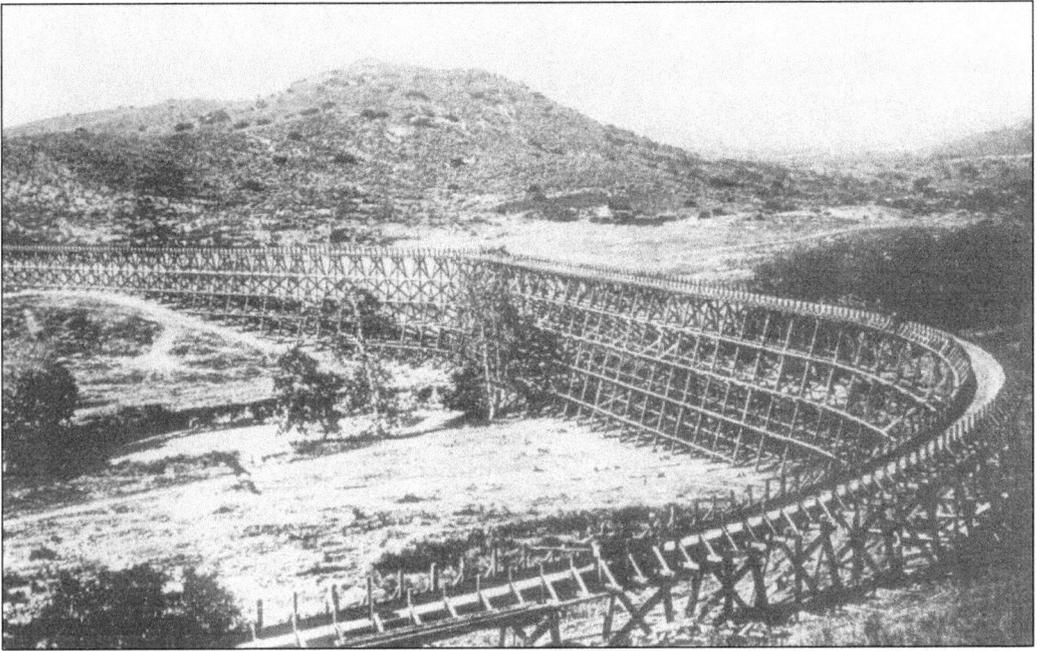

A total of 315 trestles carried the flume across valleys, canyons, and ravines—the longest being the Los Coches trestle, 1,774 feet in length and 56 feet high (Old Hwy. 80 and Lake Jennings Park Road today). The longest of the five tunnels was the Lankersheim Tunnel, which extended for 1,900 feet. Occasionally, daring people would take a thrilling boat ride down the flume line.

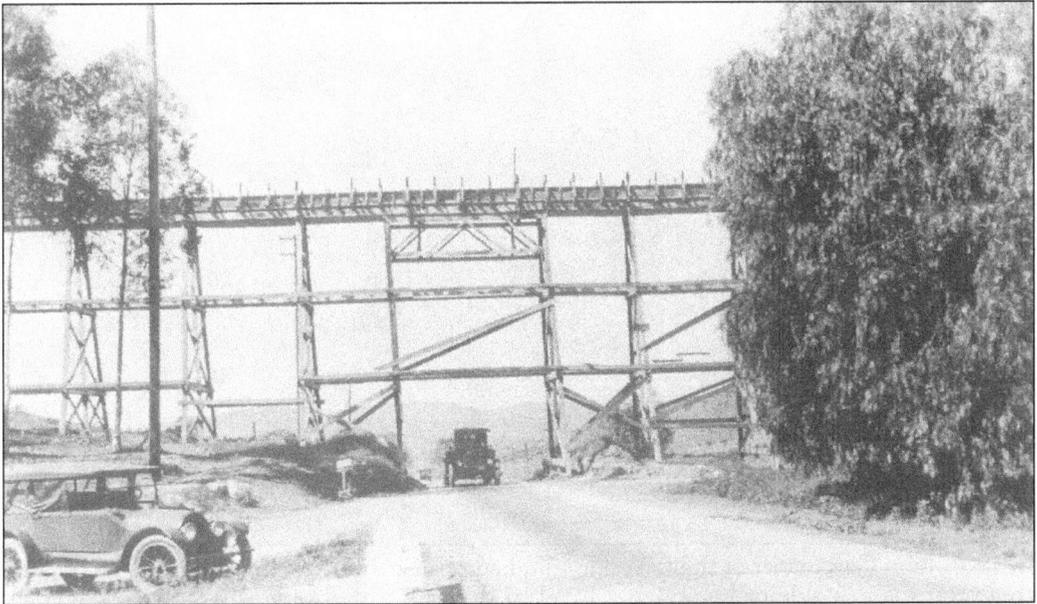

On June 1, 1910, James A. Murray and Ed Fletcher purchased the San Diego Flume Co. and changed the name to Cuyamaca Water Company. Due to a leakage of 25 to 30 percent of the water, the entire 37 miles of flume had to be relined with rubberized roofing at a cost of $44,000. Roscoe Hazard was contracted to do the work.

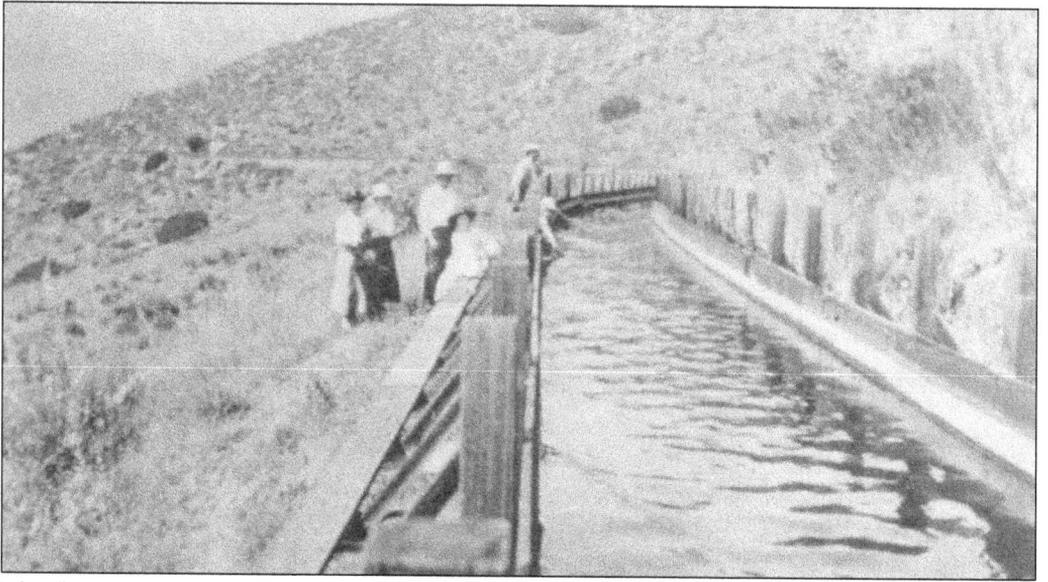

The flume was eventually replaced with other water sources and today there is little remaining of the old line. In this photo, the Denlinger family hikes up to the flume on the south hillside above El Monte Valley.

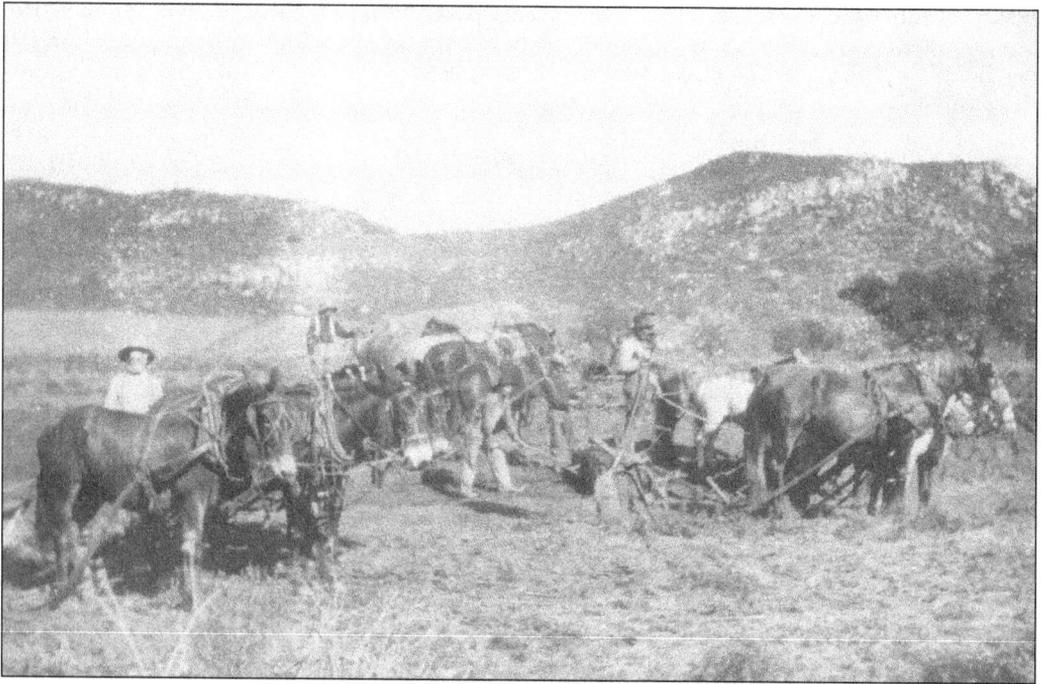

In 1907, John Gay, owner of the Lakeside Inn, had Los Coches Creek moved from its original course on the east side of Los Coches Road to the west side. Doing this stopped the creek from flowing into Lindo Lake and caused numerous floods throughout the 1960s, '70s, and '80s. Finally, a concrete flood control channel was completed in 1987, preventing the creek from trying to revert to it original course. In this picture are Charles Greenleaf with mules, Bill Miller with horses, Chauncy Burgess, and an unidentified Mission Indian.

The El Monte Pumping Plant in El Monte Valley on El Monte Road was built early in the 1900s as a means to pump water from the San Diego River into the flume as an emergency supply of water. The first pumps operated by steam from wood fires.

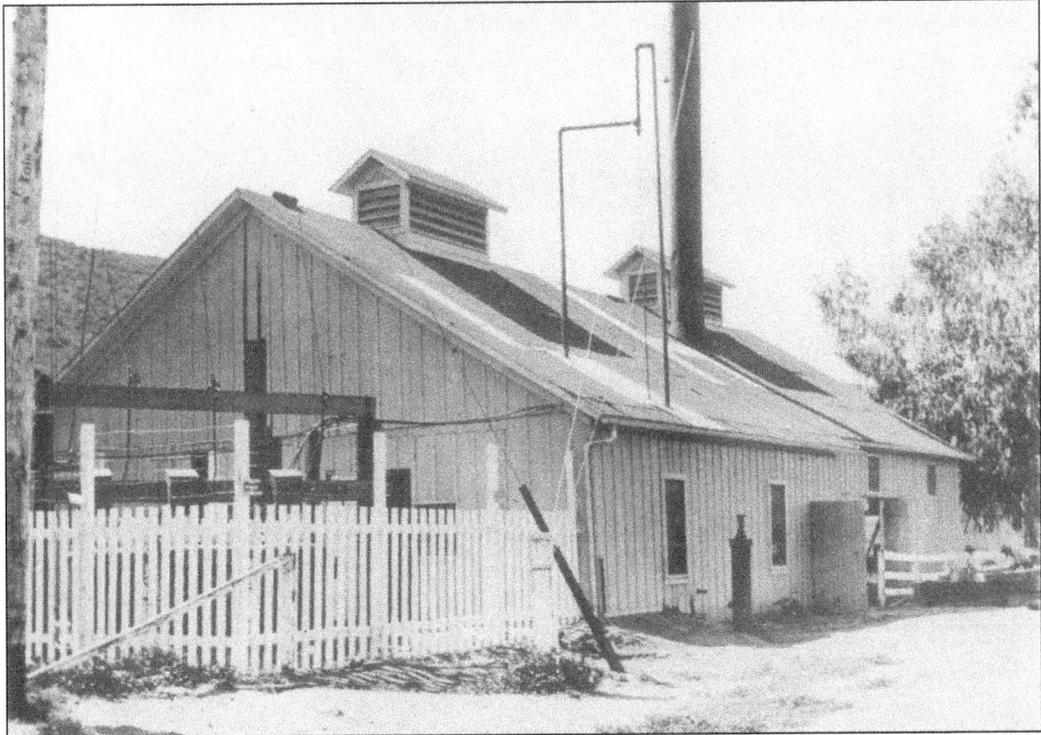

The original El Monte pump house is pictured here in 1919. It was torn down in 1925. Note the smokestack from steam operation and the air trap pipes. Soon after this picture was taken, the pumps were converted to electric.

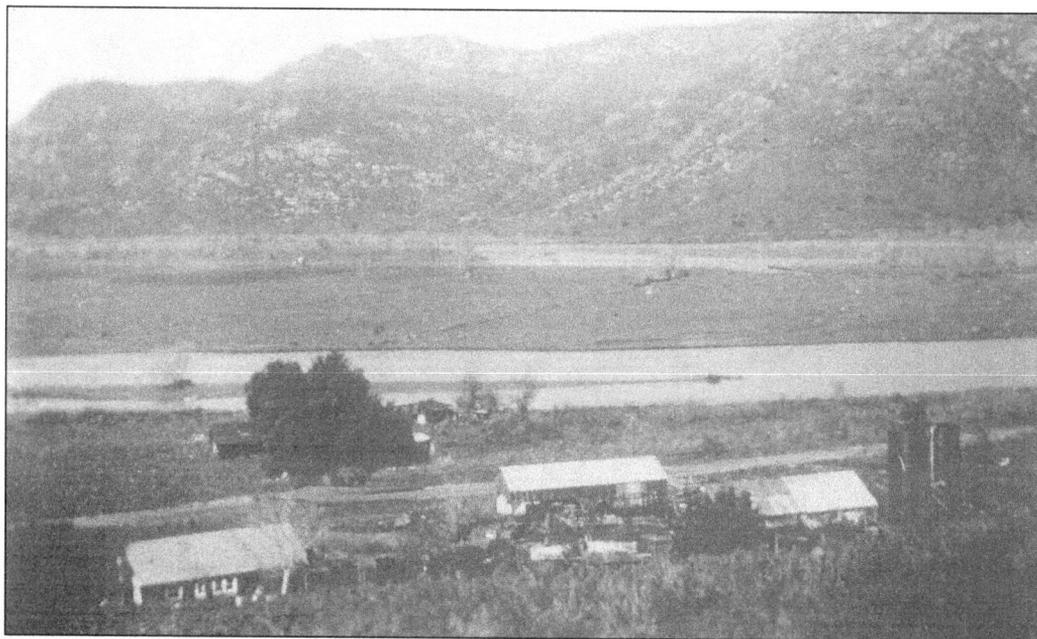

When Bill Koppel first came to manage the pumping plant in 1919, he had to start each pump by hand. Later, throwing several switches could start them. Koppel held his position there until his retirement in 1956. The El Monte pumping plant with the San Diego River in the background is pictured here during the flood in February of 1927.

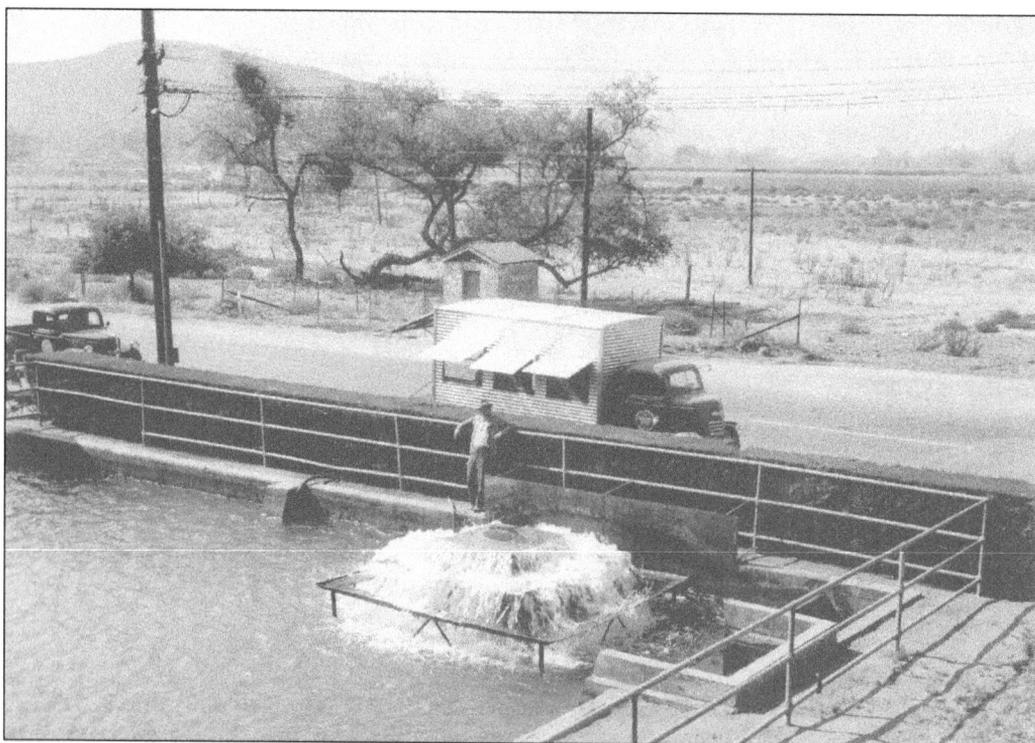

Pictured is the sump at the Helix Water El Monte Pumping Plant in 1947.

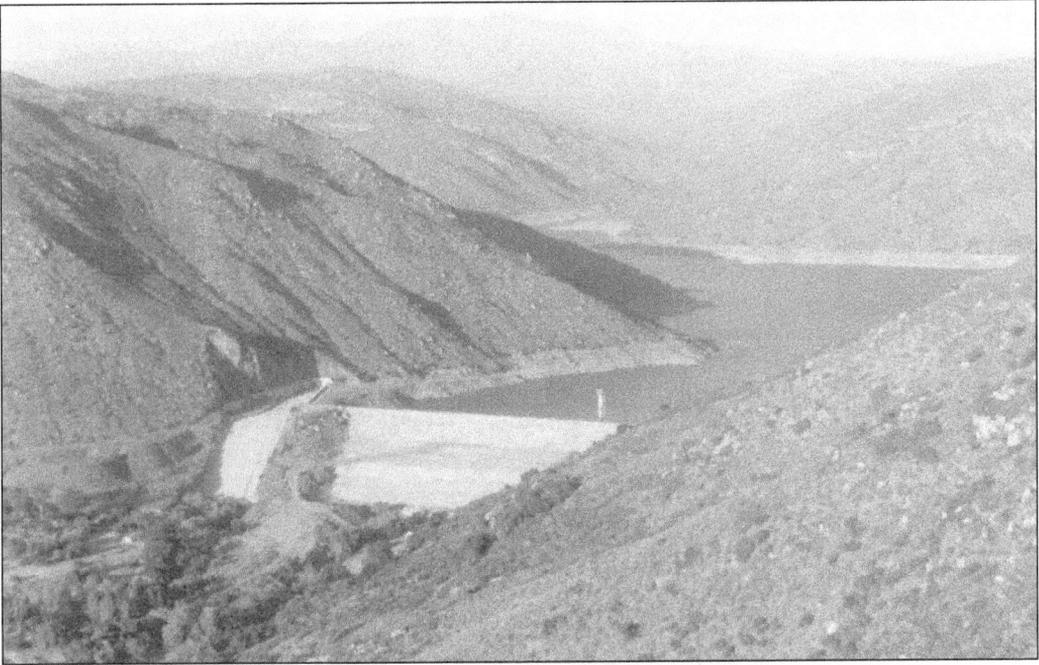

The construction of the El Capitan Dam was completed in 1935, and within three years the reservoir was full. The dam is formed by a hydraulic-fill rock embankment 1,170 feet long with a height of 217 feet above the streambed (the largest of it kind in the world).

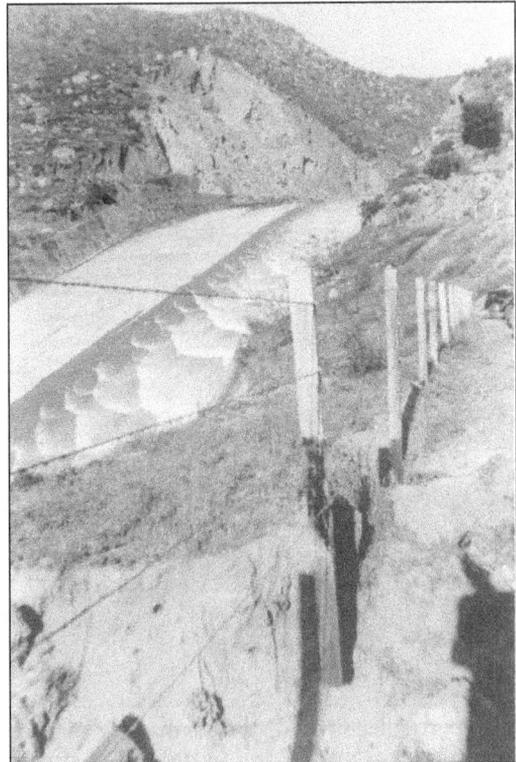

The 510-foot spillway is designed to control floods of 102,00 cubic feet per second. The spillway crest is at an elevation of 750 feet. Shown here is water flowing over the spillway during the flood of March 1941.

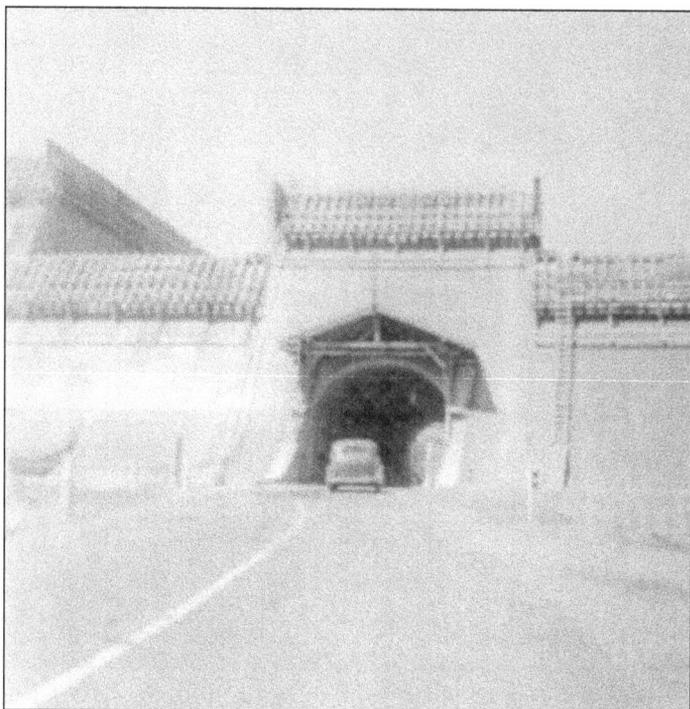

San Vicente Creek is one of the largest tributaries to the San Diego River, the two coming together in Lakeside. Engineers had long spoken of the good dam site just above Joe Foster's settlement, and finally in 1941, the city started construction. Shown here is the road to Ramona (now Highway 67) going through San Vicente Dam during construction.

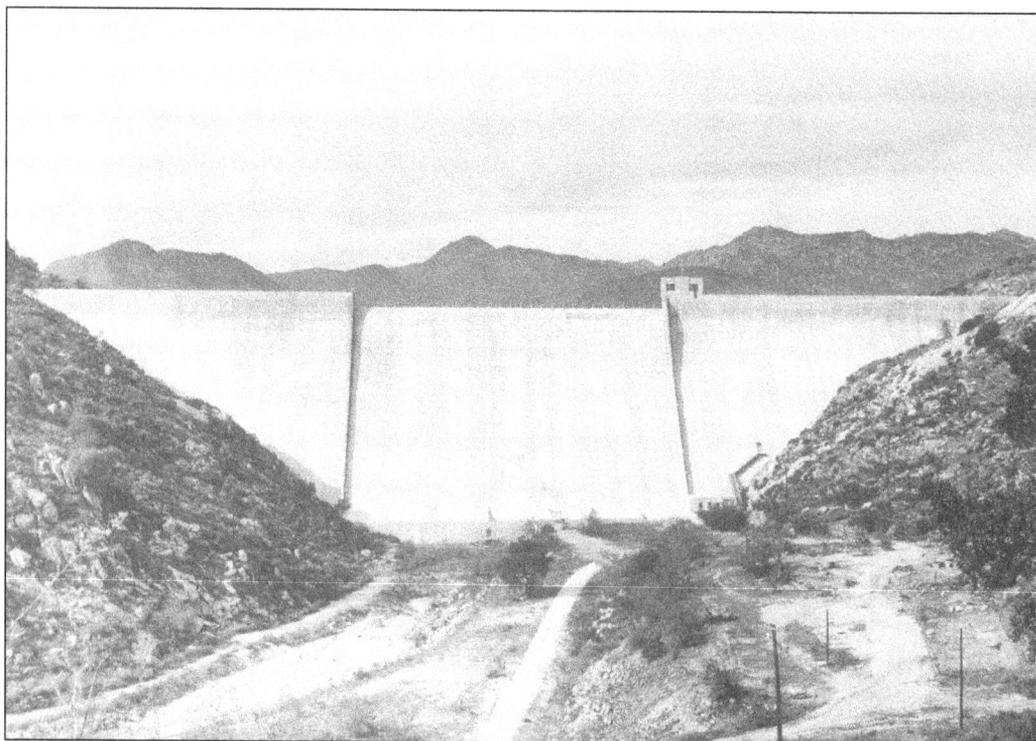

This particular site called for a massive masonry dam of straight plan. It was completed in 1943 reaching a height of 200 feet above the streambed, and is 980 feet long with a center spillway.

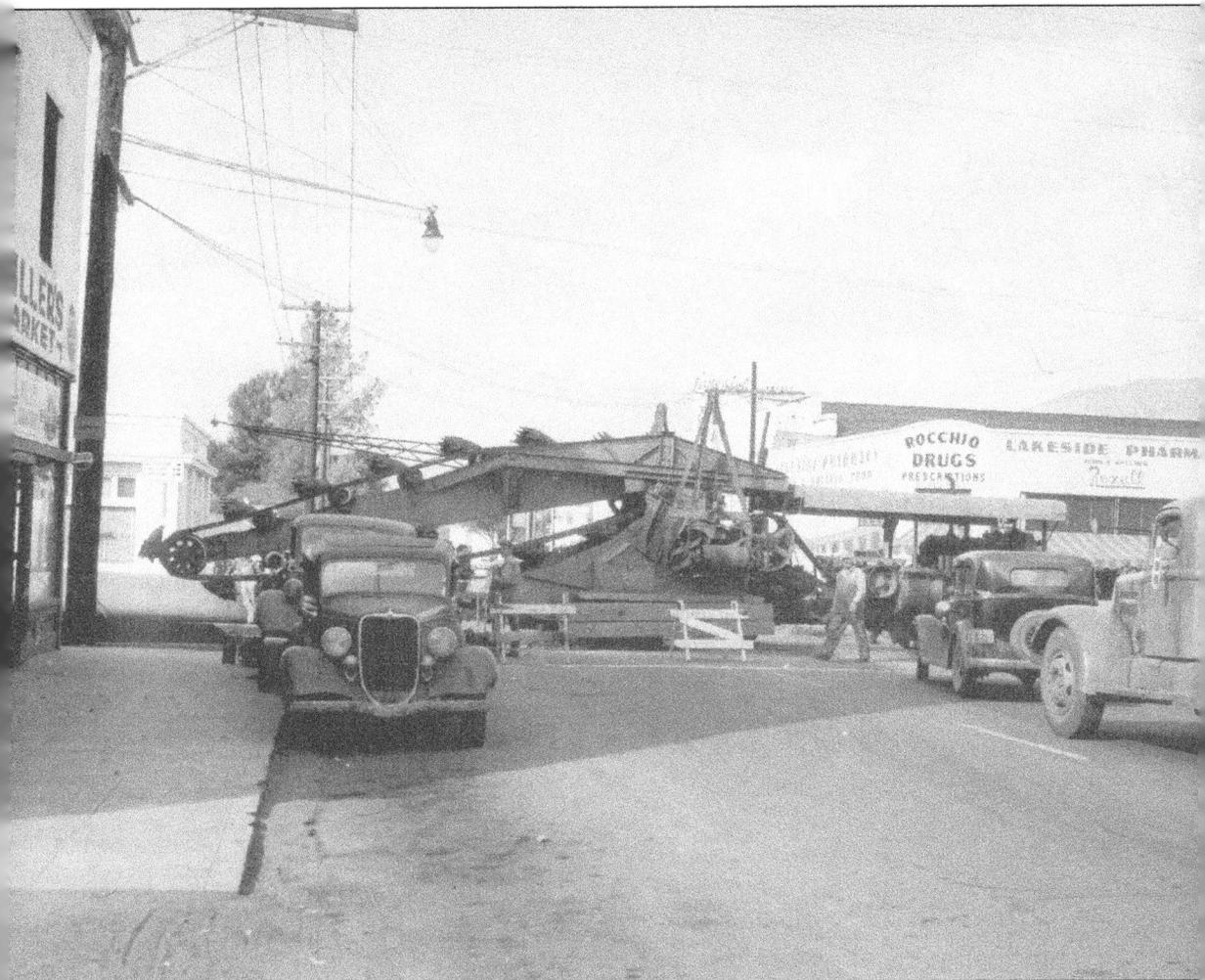

The installation of the El Capitan Dam/Lakeside pipeline at Maine Avenue and Lakeshore Drive is pictured here in 1947. Miller's Market can be seen on the left, and Rocchio Drugs and the Lakeside Theater on the right.

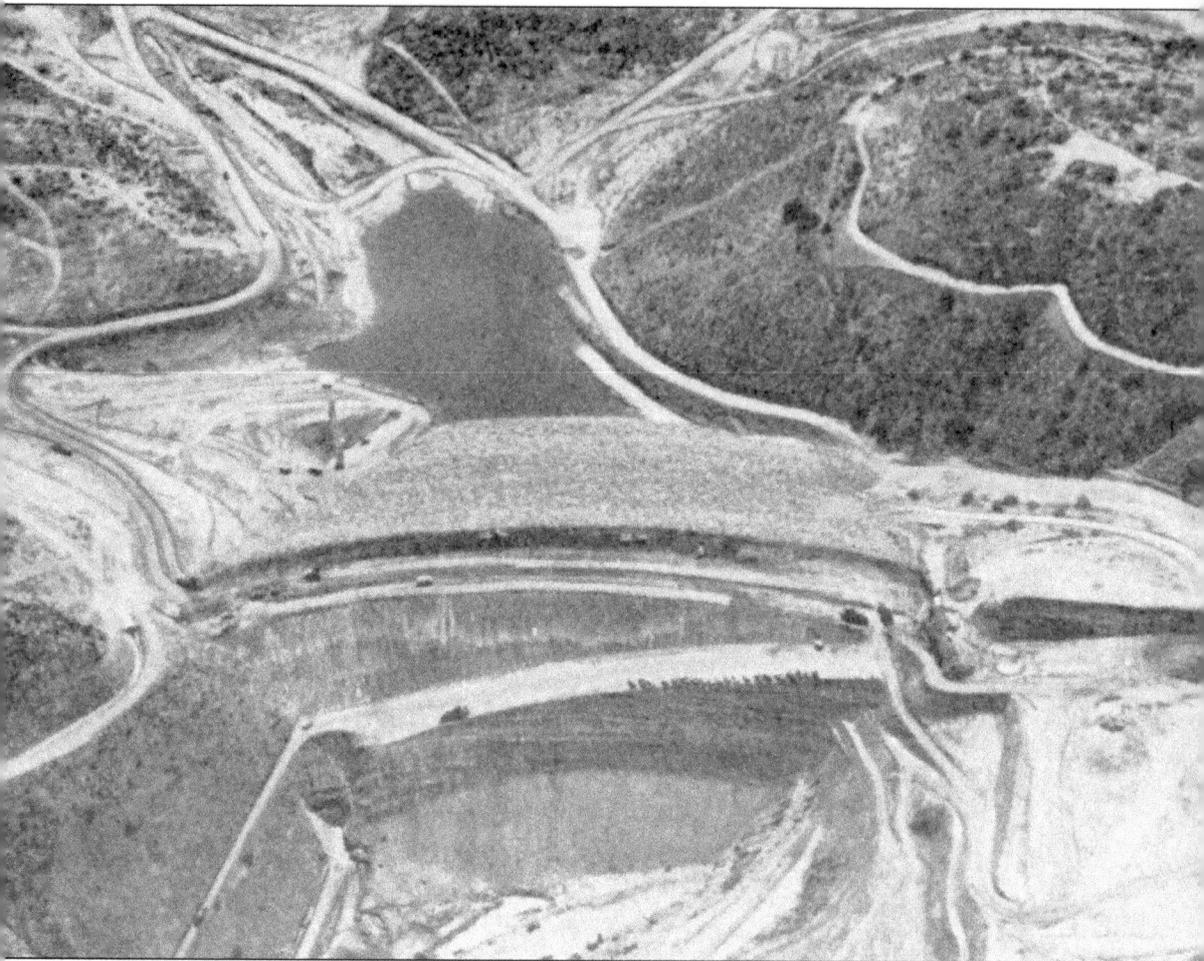

Only one mile from downtown Lakeside is one of San Diego County's most popular fishing areas, Lake Jennings. It was once part of El Cajon Rancho, an original land grant of 48,799 acres. Acquisition of this land in Quail Canyon began in the early 1940s. Dedicated in October of 1962, the earthen-rock-fill dam was named for Chet Harritt, the first general manager of the Helix Irrigation District (1926–1948).

Seven

TOO MUCH WATER

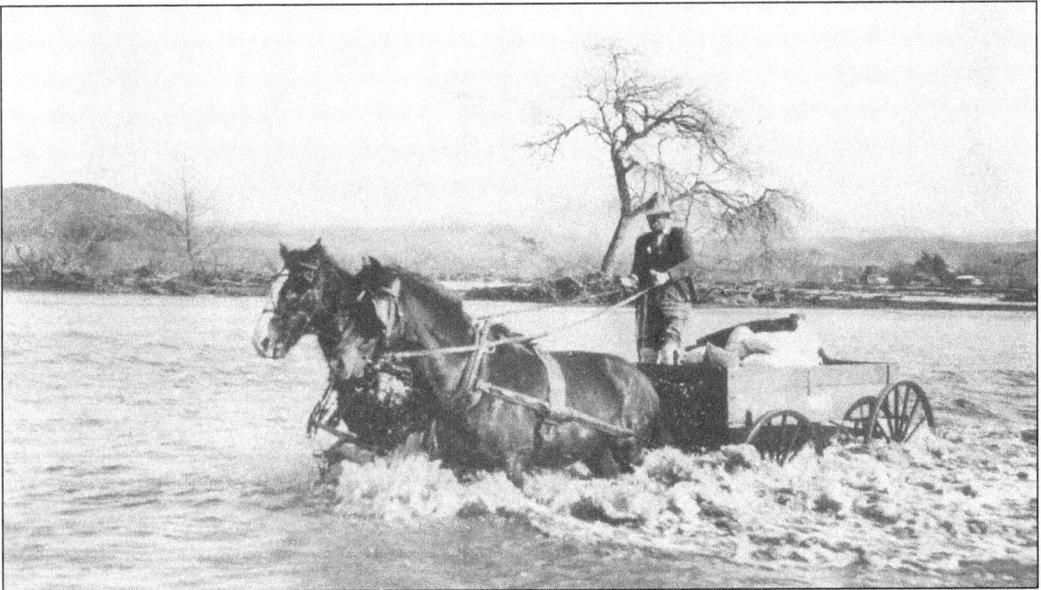

After a long drought, a rainmaker named Hatfield was hired to make rain in January of 1916. To everyone's delight it began to rain, but it didn't stop. By the end of January, Lakeside had lost 21 homes—besides barns, water tanks, and outbuildings. Railroad tracks between Santee and Lakeside were washed out. The railroad and wagon road to Foster Station had disappeared, and the Cuyamaca Flume Company had lost six miles of flume. Here County Supervisor Joe Foster fords the San Diego River with much needed supplies.

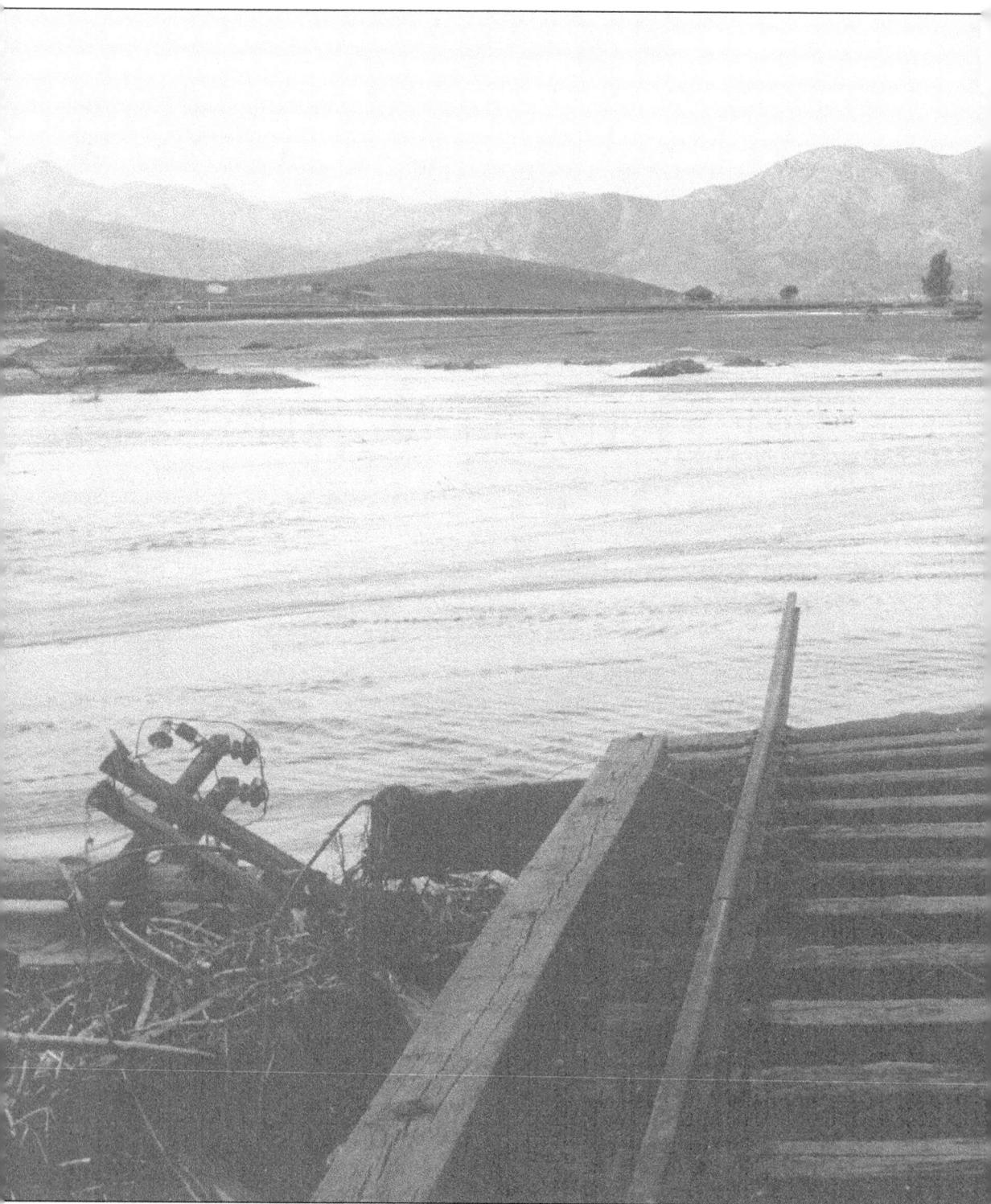

The Lakeside Bridge and railroad bridge on the north side of town were completely washed away. After the Flood of 1916, the railroad tracks to Foster Station were never rebuilt.

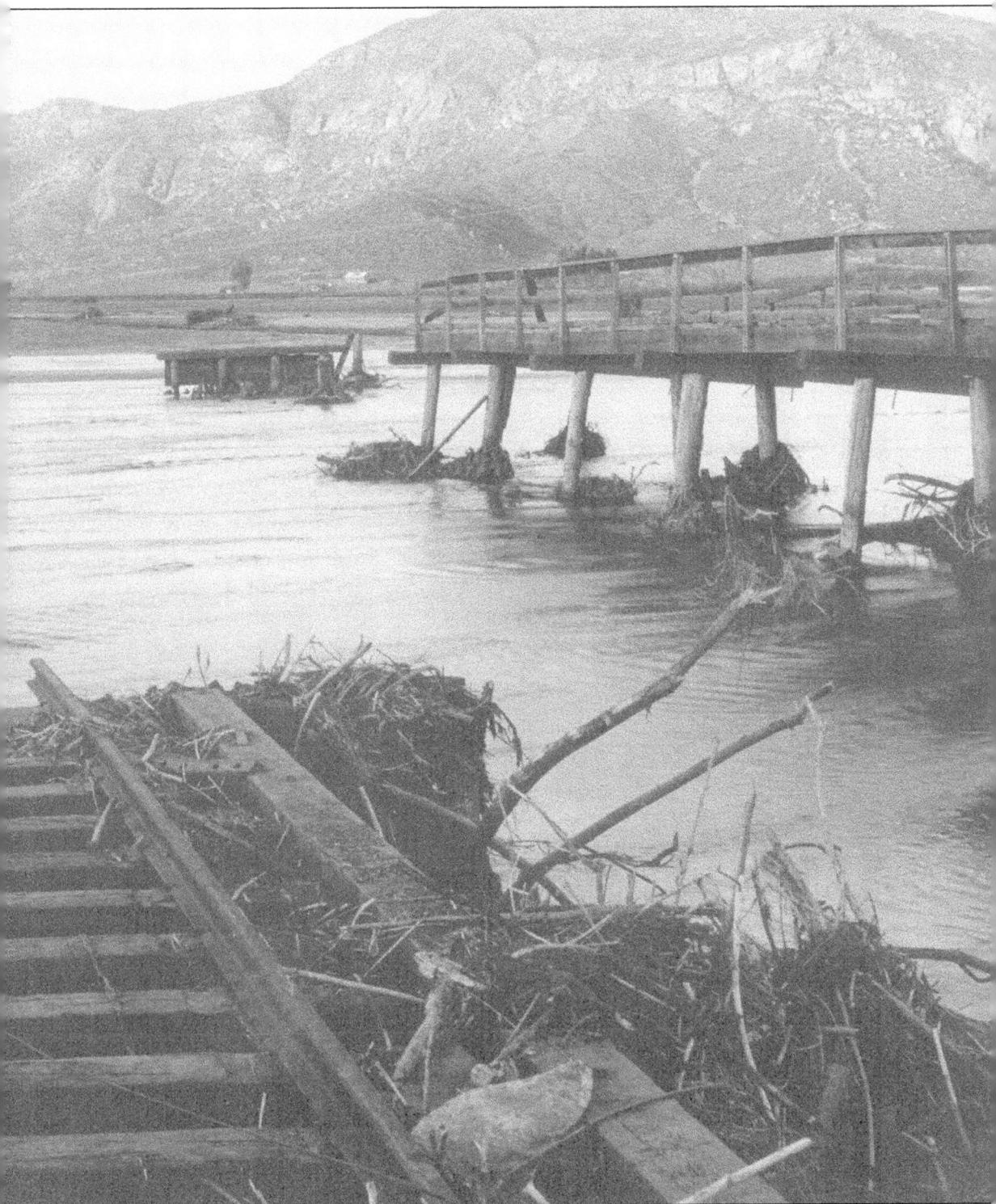

The rainfall total from January 14 through January 27 was 16 inches; the season total for 1915–16 was 21.32 inches.

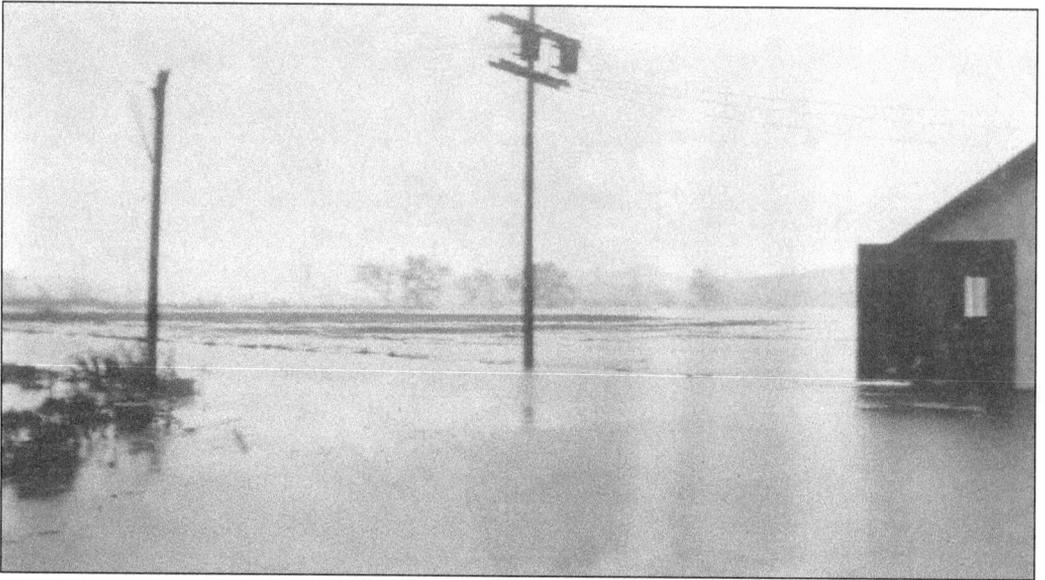

Flooded pastures and roads near the Weston's Westlake Dairy Farm in Dexter Valley are pictured here. Claude L. Weston remembers the Flood of 1916: "We had been to the Presbyterian Church Sunday night, and on going home the river had come up and we couldn't get across. We came back and spent the night at the hotel on River Street. The next day we were able to ford the river with the help of ropes."

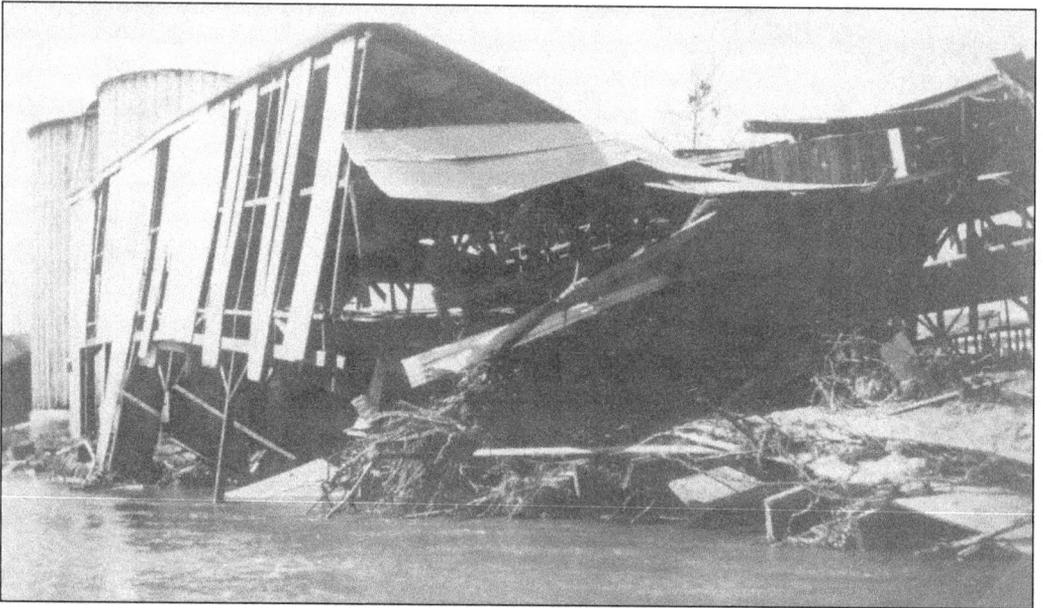

Claude continues: "There were 90 head of cattle in the barn at the same time. We got home but were separated from the dairy barn for three days. We found that the water had wrecked our big barn, caving in one section, and pushed many of the cows' heads under water and drowned them. Others washed away downstream."

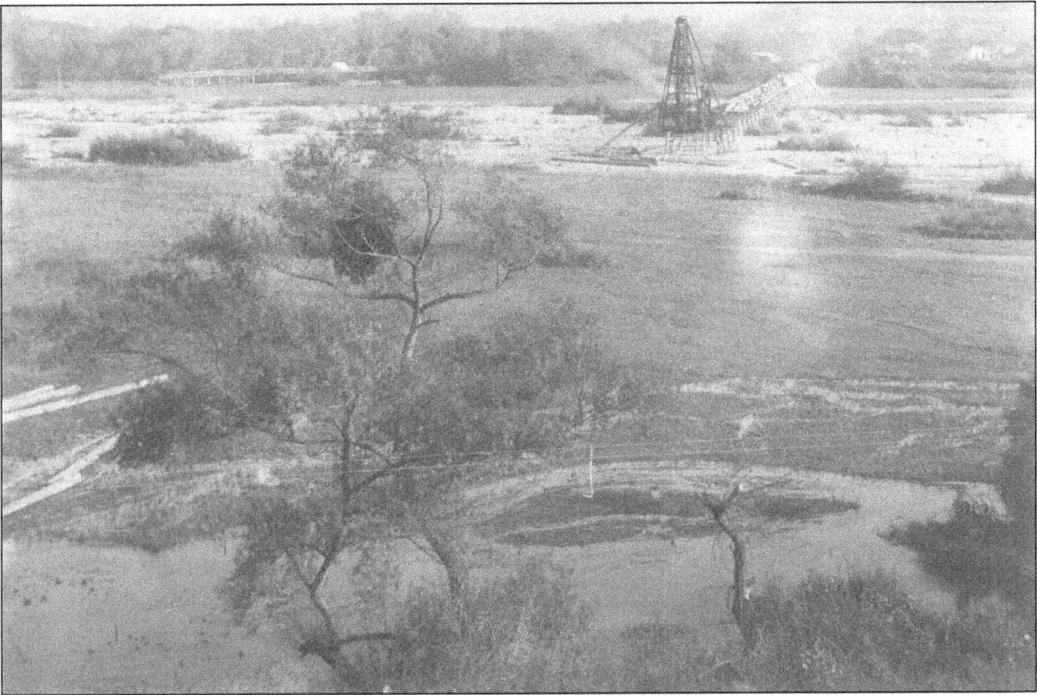

Pictured above is the construction of the new Lakeside Bridge in 1917. The remains of the old bridge can be seen to the left (west).

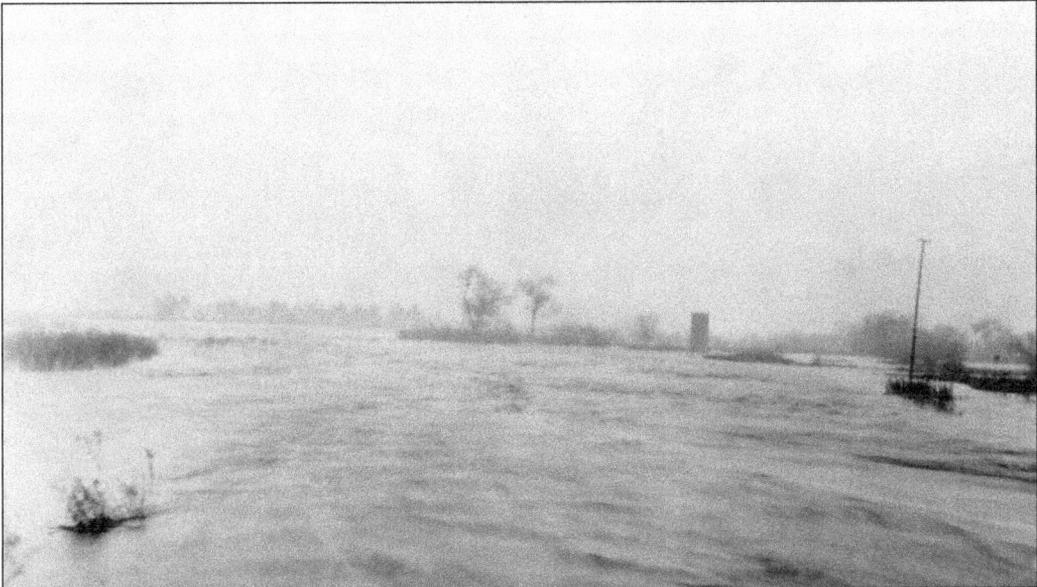

This photo shows the 1921 floodwaters looking west from the new Lakeside Bridge. Rainfall from December 18 through December 27 was 11.42 inches; the season total for 1920–21 was 13.78 inches.

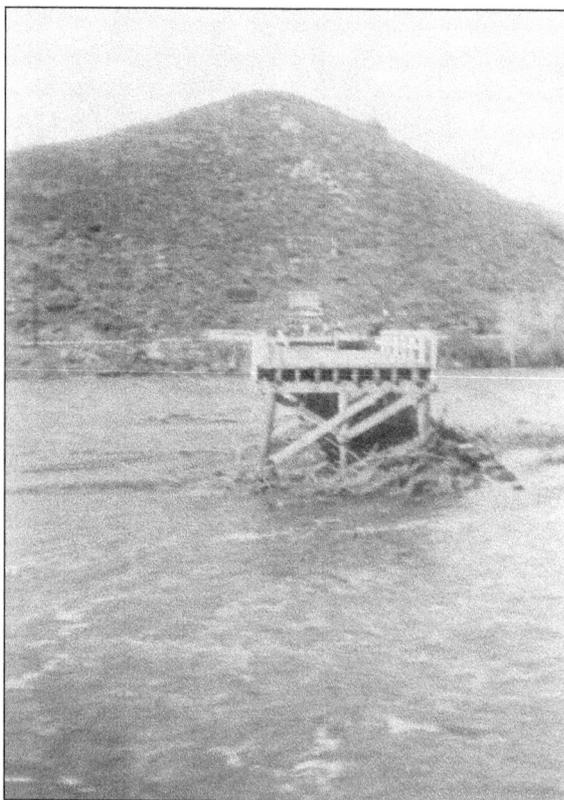

The Flood of 1927 again washes-away the Lakeside Bridge. From February 11–17, in one week, the rainfall was 12 inches; the 1926–27 season totaled 16.39 inches in rainfall.

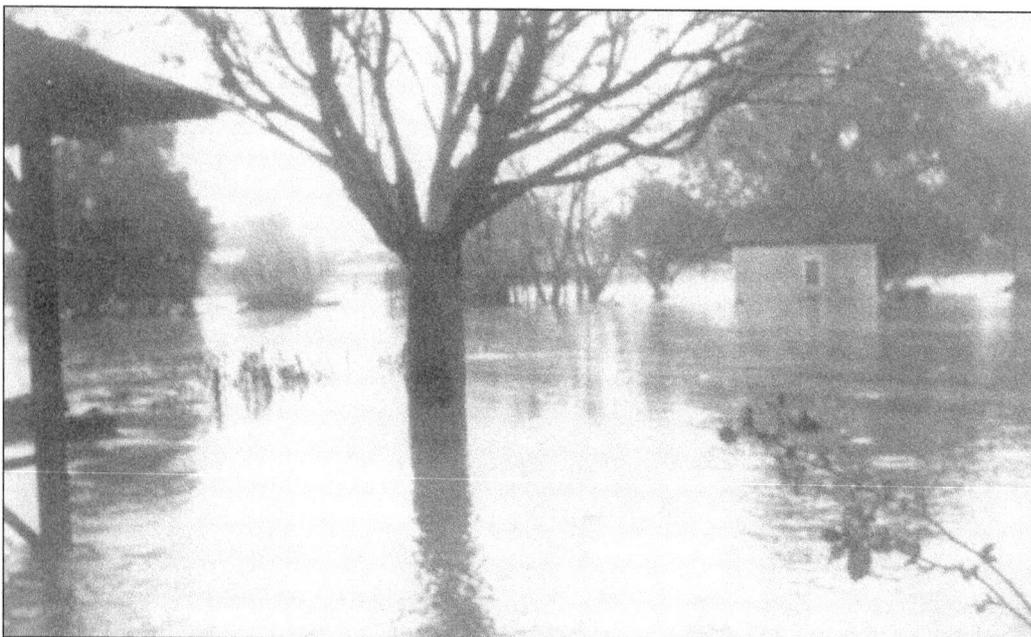

The floodwaters from the San Diego River came all the way in to town and Lakeside was left without water except for local wells. Shown here is the Whitaker's farm on Sycamore Street.

Gandyra's Lakeside Harness and Shoe Shop had lifted off its foundation and floated away. Neely Schillers is seen in this 1927 picture.

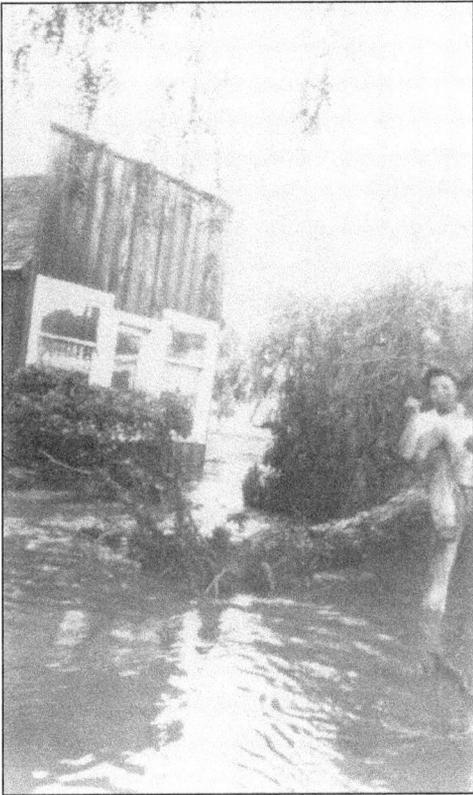

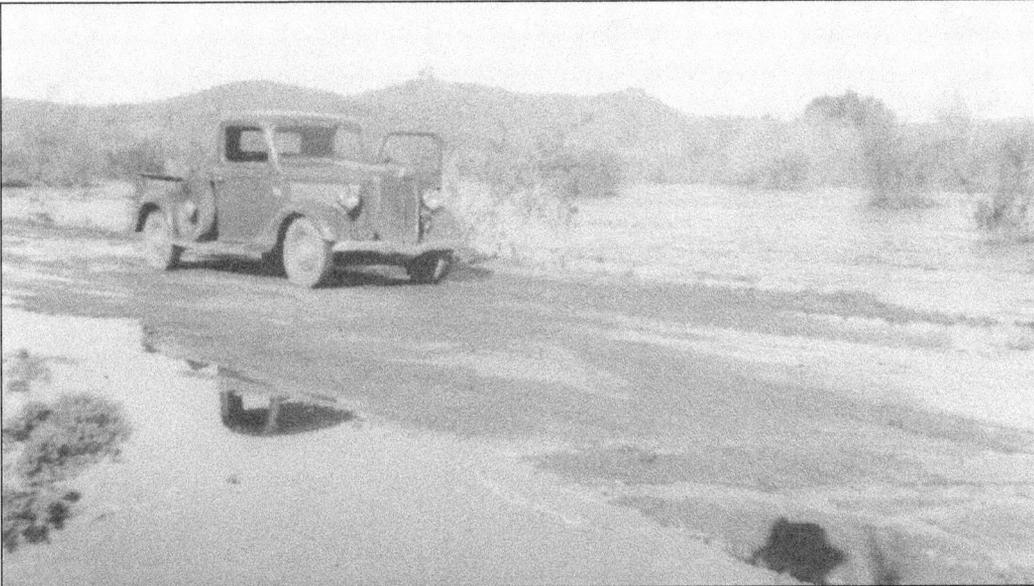

Again in March of 1941, heavy rains caused the San Diego River to run wild.

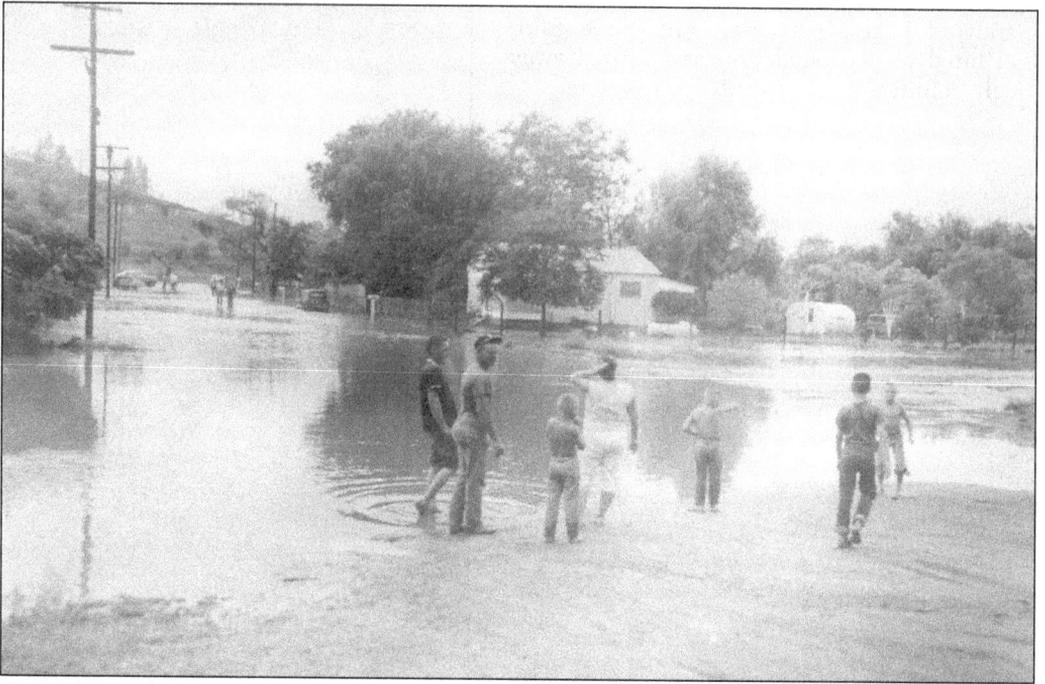

This photo shows the view looking west down Castle Court from Los Coches Road on August 4, 1961. In a few minutes, two inches of rain fell in Flinn Springs and Johnstown, causing a flashflood that tore down Los Coches Creek and raged through downtown Lakeside.

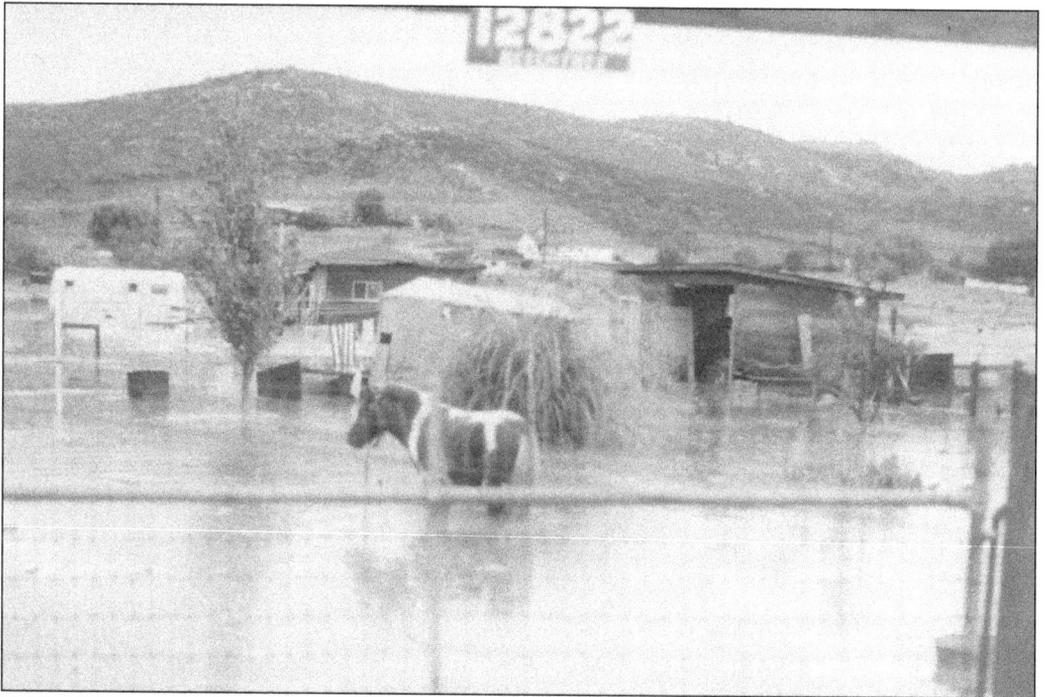

Like this ranch at 12822 Beechtree Street, there was flood damage to more than 50 homes along the Los Coches and Quail Creeks during this freak August cloudburst.

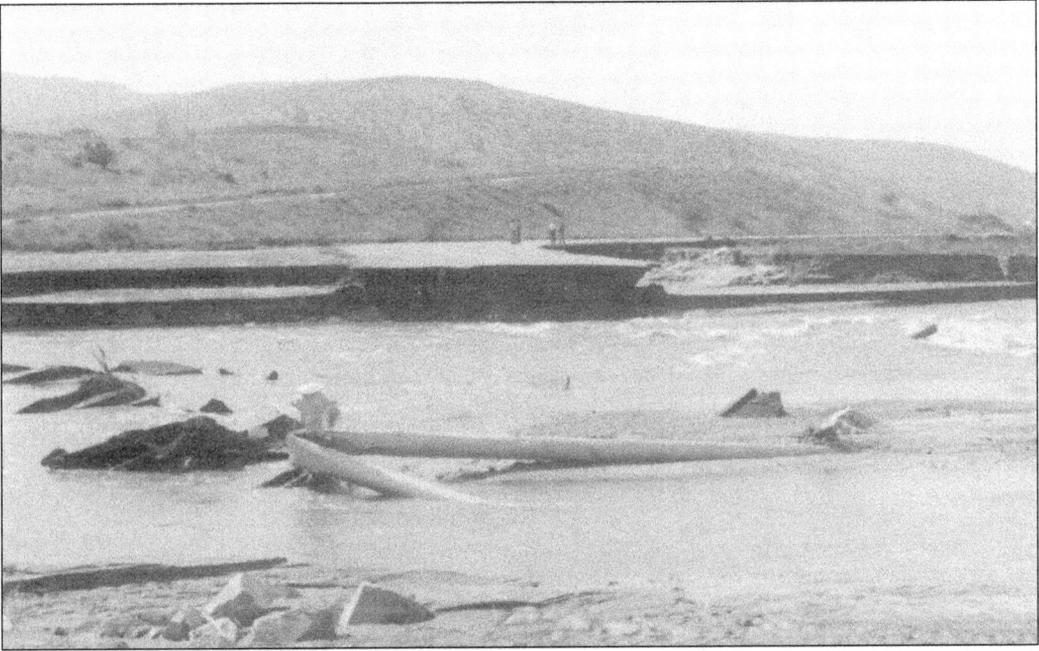

In 1978, the Los Coches Creek jumped its banks and the San Diego River once again took its toll on the Lakeside Bridge. The floodwaters had undermined the bridge's footings, so a new bridge was planned and it was to be completed in 1980. This picture shows the damage downstream at Riverford Road.

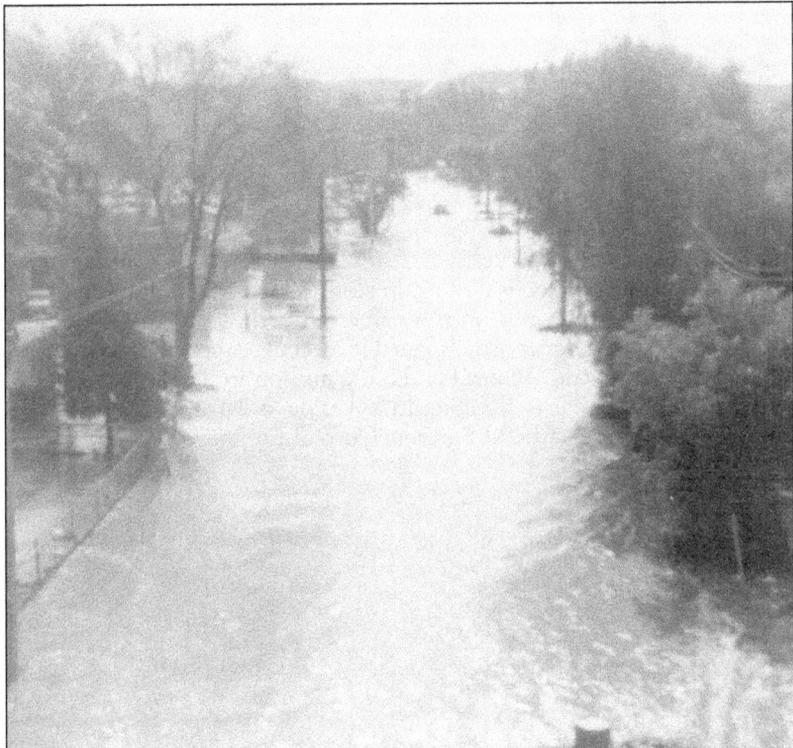

Again in 1979, the Los Coches Creek flowed freely through Lakeside and down Channel Road.

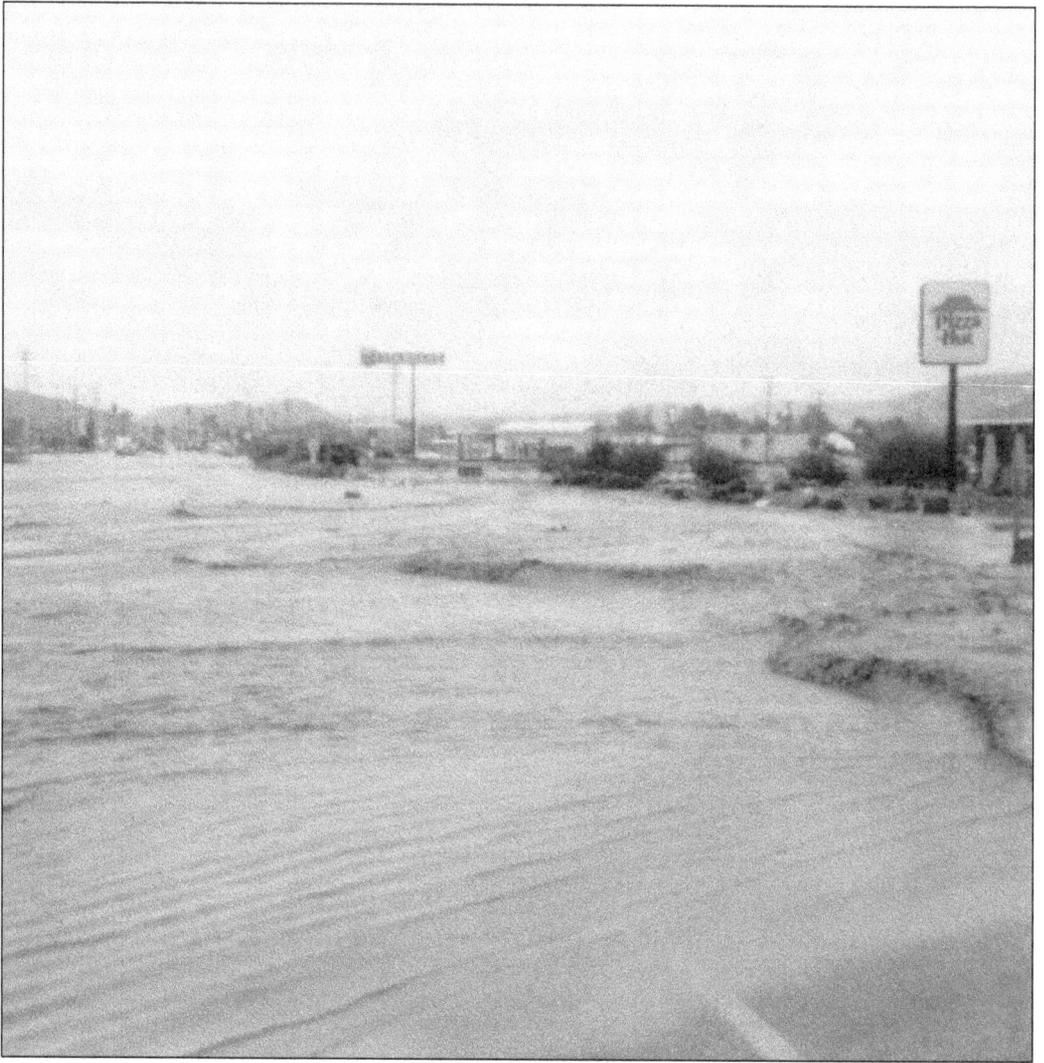

Pictured here, we see floods flow again along Woodside Avenue, Los Coches Road, and Channel Road. The El Capitan was on the verge of overflowing and residents of Moreno Valley were ready to evacuate. Supervisor Roger Hedgecock called it a "state of emergency." Authorities sized up the storm toll: 36 dead and $500 million in damages throughout Southern California. This was the last year of flooding in Lakeside, a 2.1 mile concrete flood control channel was completed in 1987 by the U.S. Army Corp of Engineers.

Eight

TRANSPORTATION

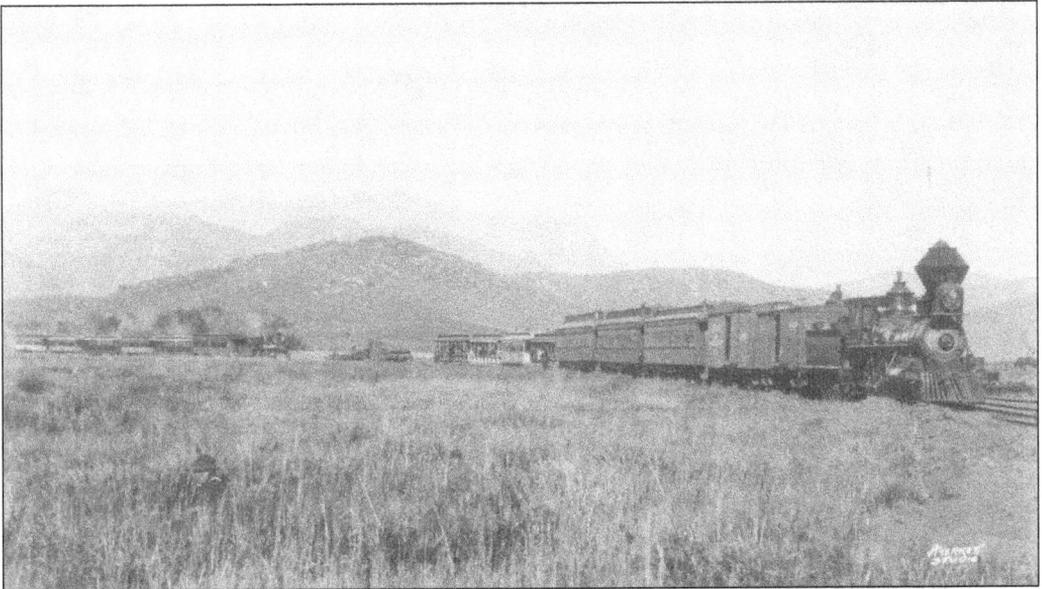

The Cuyamaca Eastern Railroad came to Lakeside in 1889. The route of this rail line from San Diego was up 32nd Street to Chollas Valley, bisecting Mount Hope Cemetery, along Imperial Avenue through Encanto, Lemon Grove, La Mesa, and then up the 741-foot Alta (now Grossmont) Grade. It skirted El Cajon Valley to Santee. It then went along Woodside Avenue through Riverview to Lakeside, across Moreno Valley to Foster (now part of Lakeside). The trains would stop any place along the route if signaled. The fare to Lakeside from San Diego was 85¢ to $1.50 round trip, taking 1.5 hours for the 25 mile trip. That was quite an improvement over the all-day wagon trip.

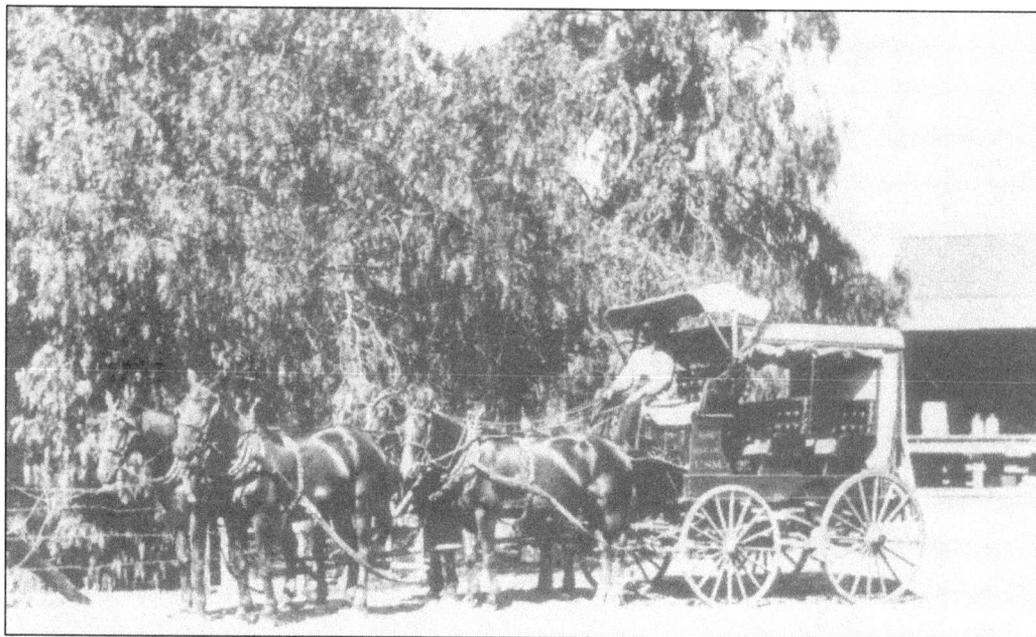

When the railroad came to Lakeside and Foster in 1889, Joseph Foster and Frank P. Frary (one of San Diego's mayors) organized a stage line which took train passengers up to Julian or Banner. There were daily stage runs to the backcountry by 1887. From Foster, they continued to the inland communities of Ramona, Witch Creek, Santa Ysabel, Mesa Grande, Wynola, Julian, and Banner.

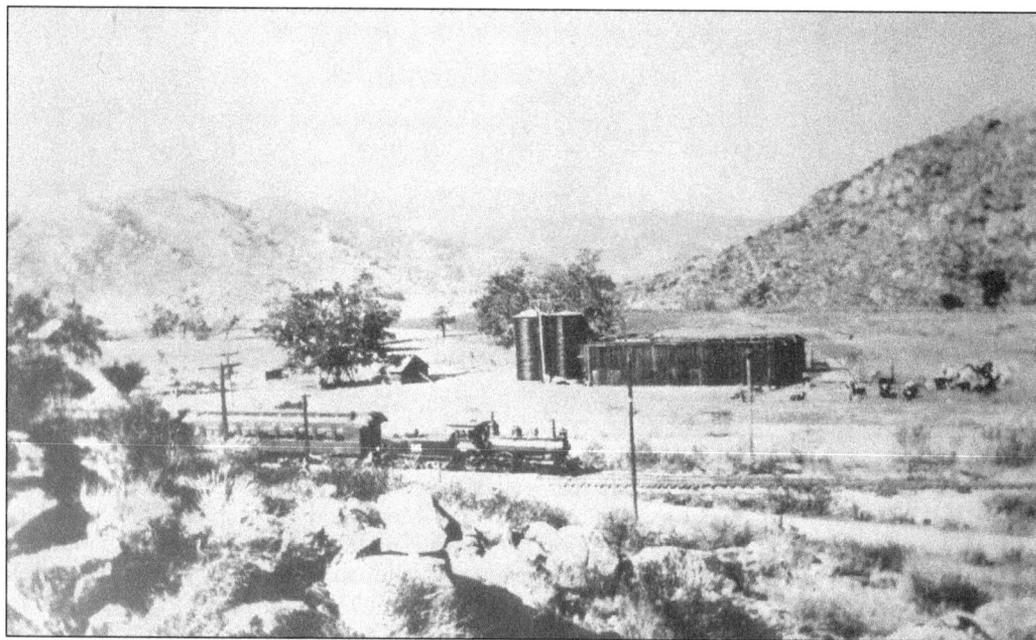

This photo shows the No. 15 approaching Foster Station with the Weston Dairy barns and silos.

112

Posing for this 1890 photograph is Mrs. Martha (Swycaffer) Foster, Joseph Foster, and Beatrice Swycaffer. Joseph married Martha in 1880 and they acquired a ranch three miles north of Lakeside. He became an active and well-known person in San Diego County, being appointed as road overseer of San Vicente district in 1883. In 1906, Governor Parde appointed Mr. Foster to fill a vacancy on the County Board of Supervisors. He was elected and re-elected until his retirement in 1929. During his tenure, he was affectionately known as "Uncle Joe."

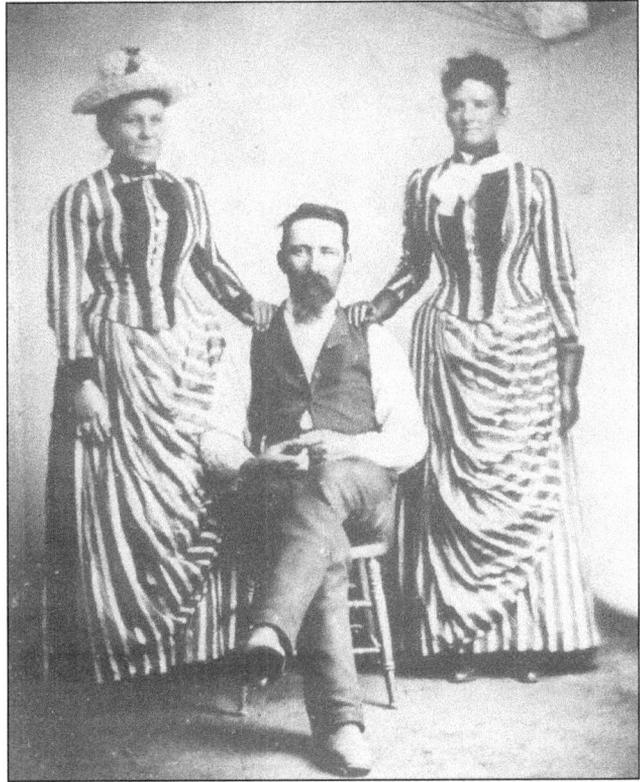

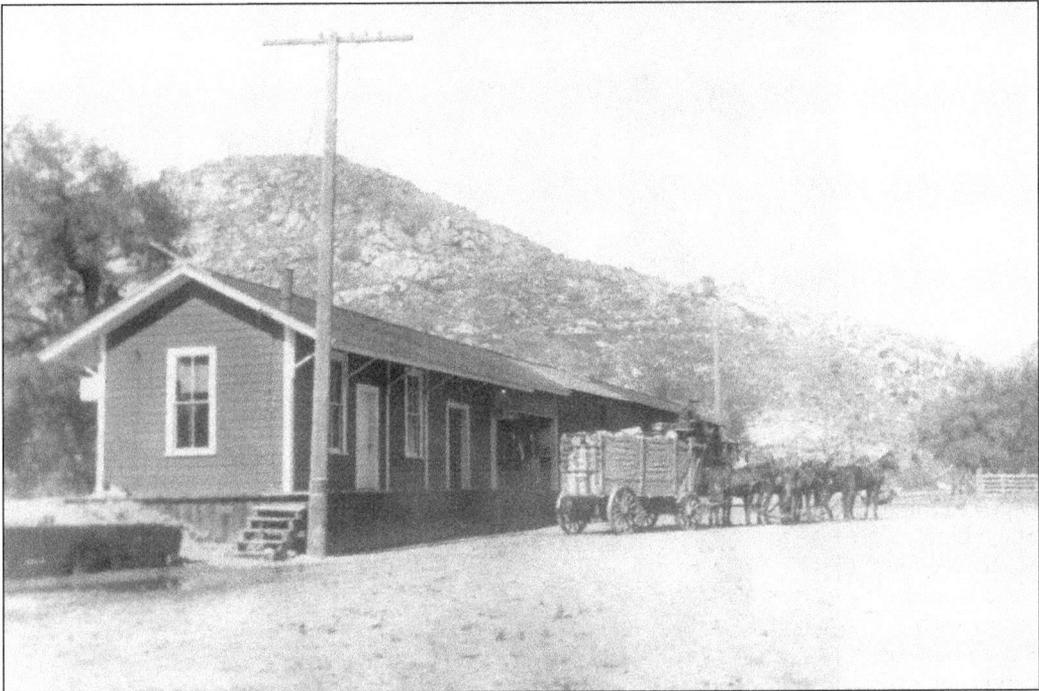

Pictured above, a mountain freighter leaves Foster Station in 1890 for the gold mines in the Julian and Banner areas.

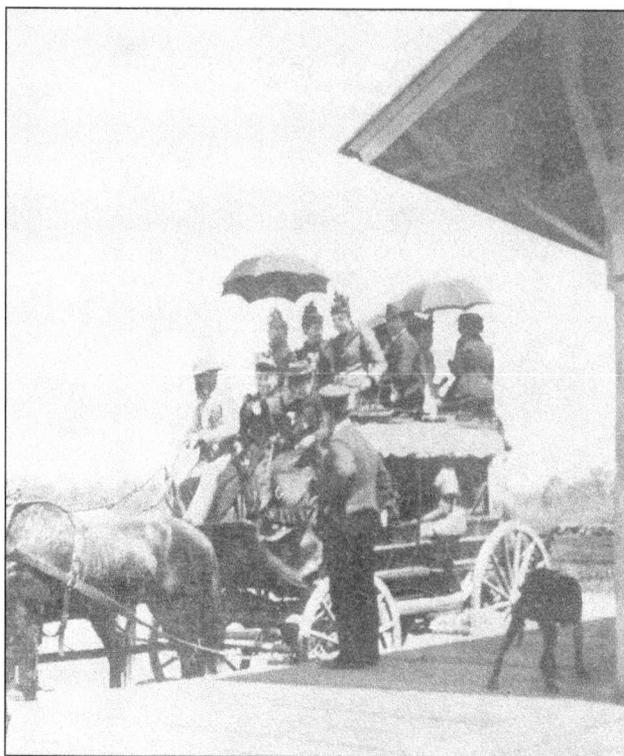

Joe Foster was the driver of this San Diego to Julian Stage Line coach pictured at Foster's Station in 1891. It was cheaper to ride on the top, but you had to bring your own umbrella.

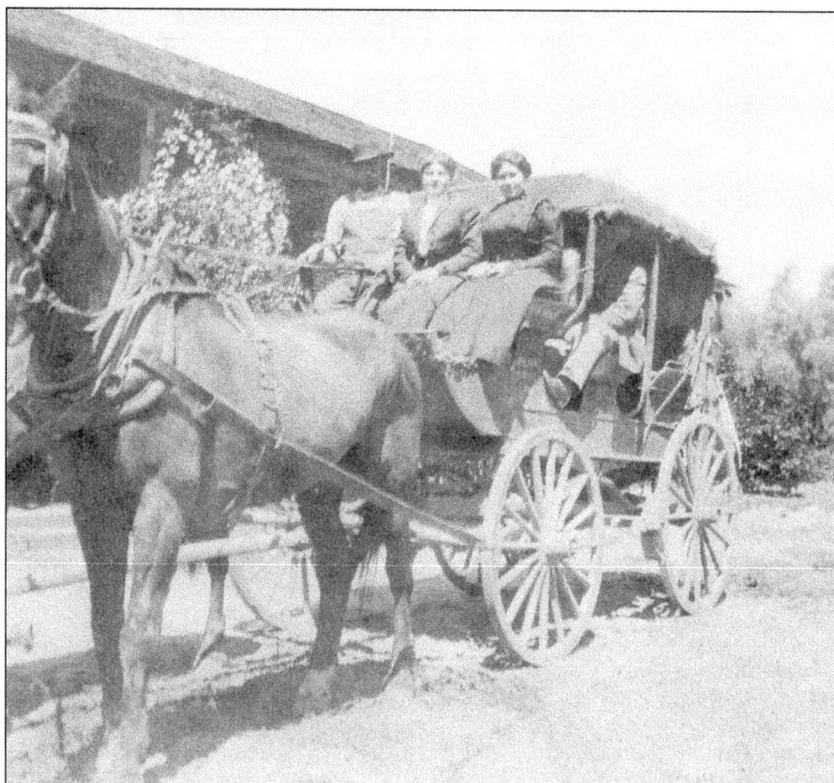

Harry Dye was the driver for this San Diego to Julian Stage Line coach. Maude Heap is in the center with Katie Nicolson Leng (niece of Joe Foster) seated next to her.

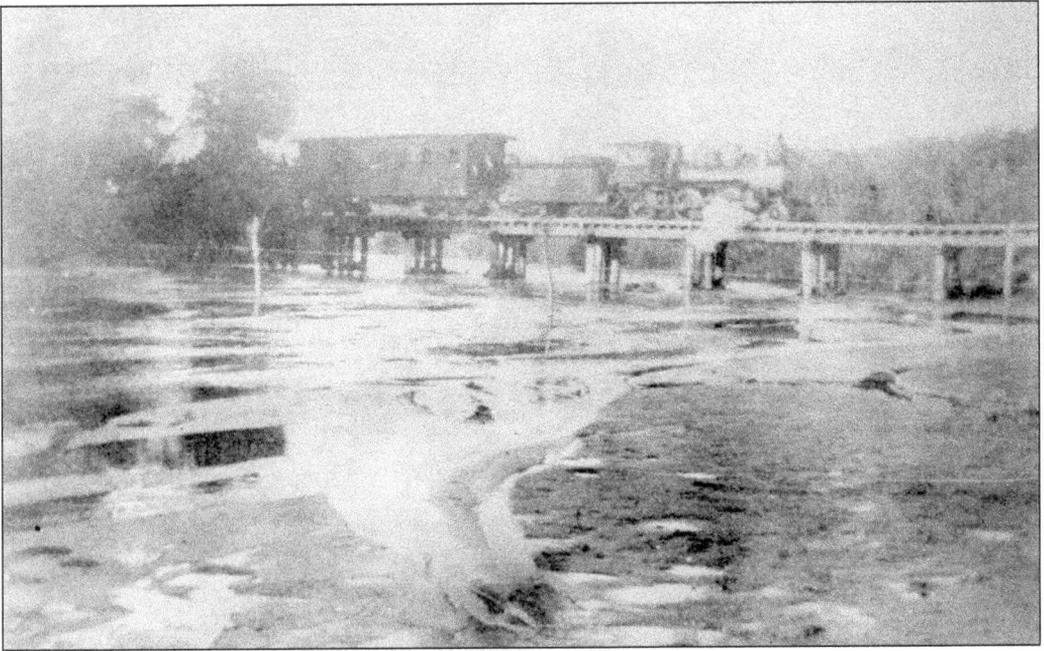

After leaving the depot in Lakeside, the train crossed the San Diego River heading north for Foster Station.

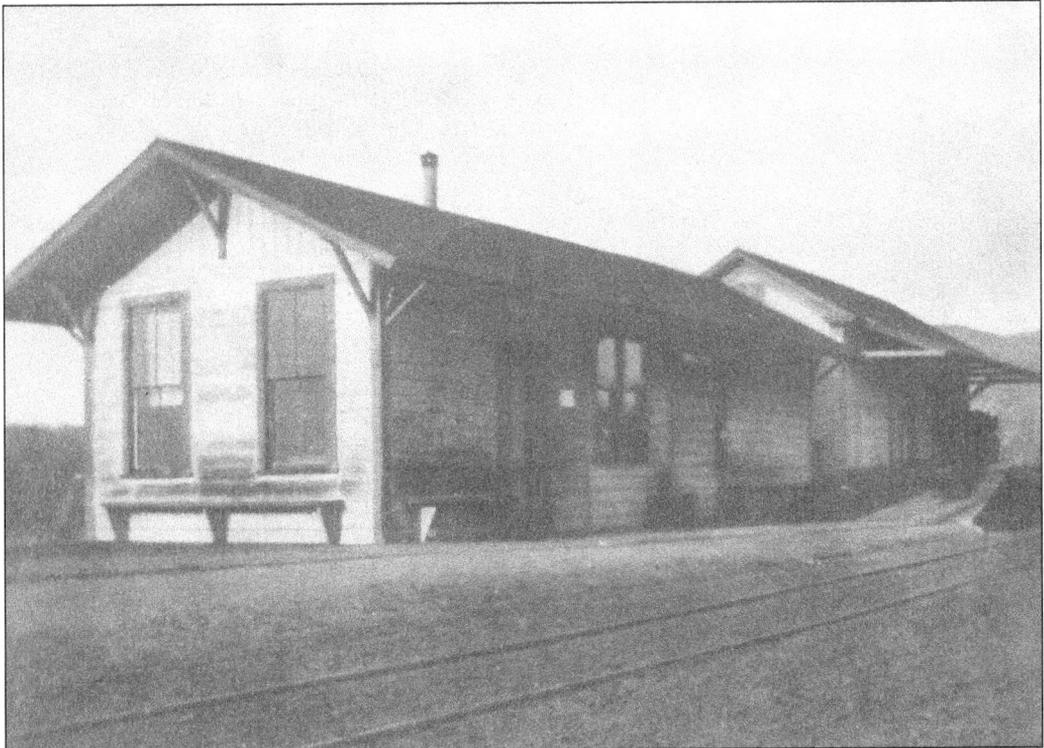

The first Lakeside Railroad Depot was used from 1889 until 1912. At the height of Lakeside's boom era, as many as eight trains a day stopped at this depot on Laurel Street.

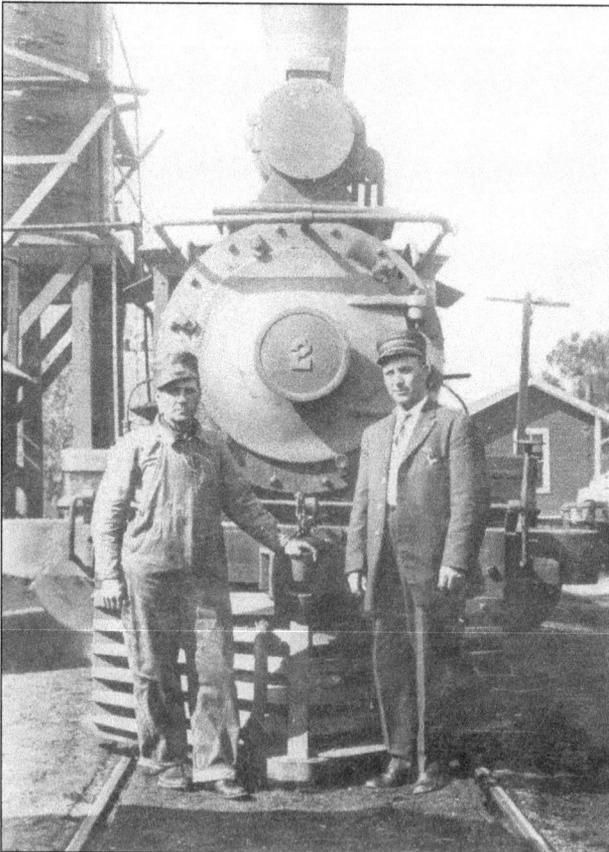

The second, and last, railroad depot was in use from 1912 to 1938. The new Lakeside Depot's stucco building had a mission style appearance. The head carvings were a gift to the city from John Spreckels.

Engine No. 2, built in San Diego by the California Iron Works, is pictured here at Foster Station with fireman Pat Patters and conductor Charles Robinson. At the height of the boom days, there were eight passenger and four freight trains coming to Foster Station each day. After the Lakeside Inn built the racetrack, there were special excursion trains run for special events to lure the crowds.

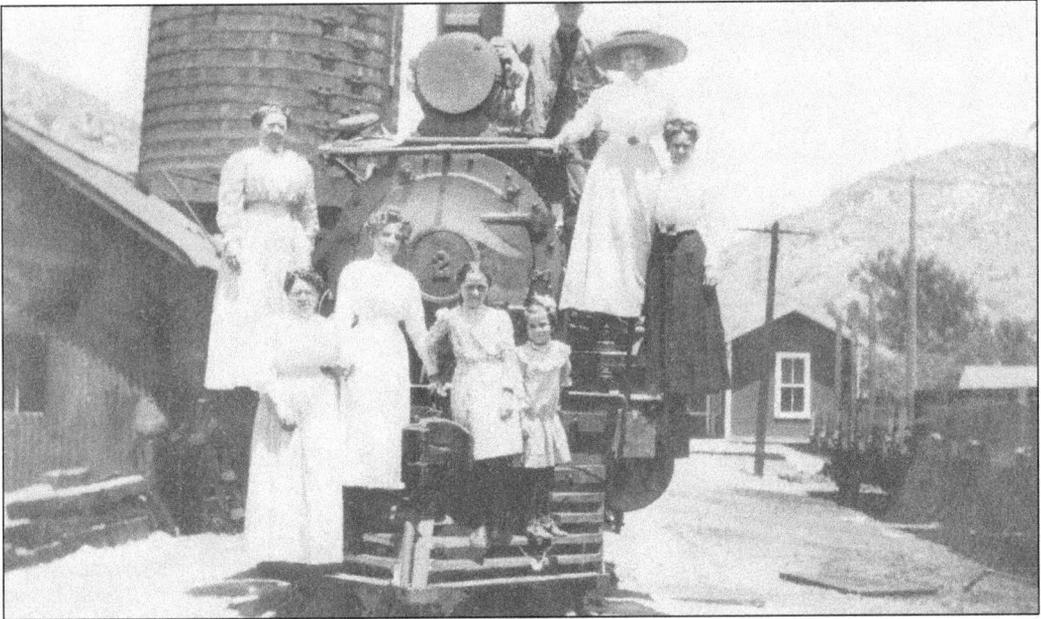

Foster Station is shown here in May of 1910. Pictured, from left to right, are: Mrs. Joe Foster, Mrs. Churchill, Mrs. Pearl Brown, Myrtle Robinson, Iva Churchill, Ray Swanigan (top), Mrs. Katie Nicolson Leng, and Mrs. Carrie Robinson.

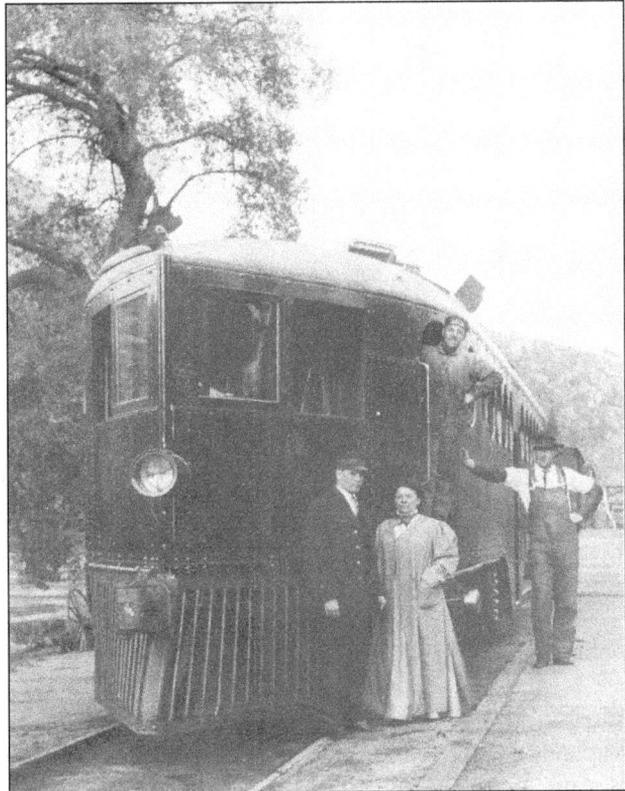

Posing for this 1915 photo of a gasoline engine at Foster Station is Ed Rhinehart, Mrs. Joe Foster, and John Turner.

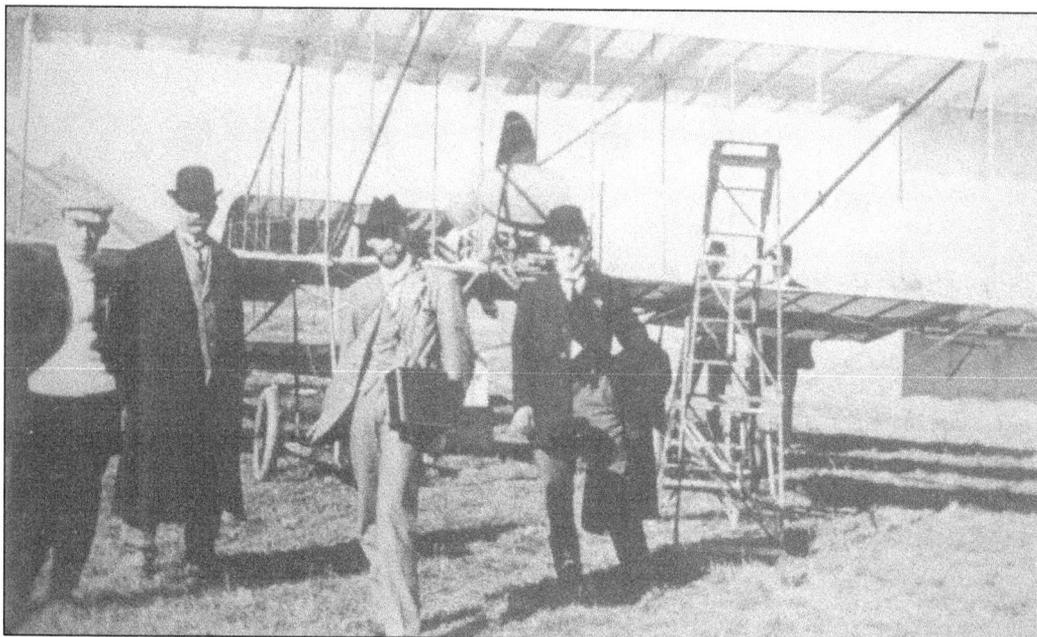

This photo shows a "Fly-in Promotional" in Lakeside during the summer of 1910. Charles Petty is pictured in the center wearing a gray suit.

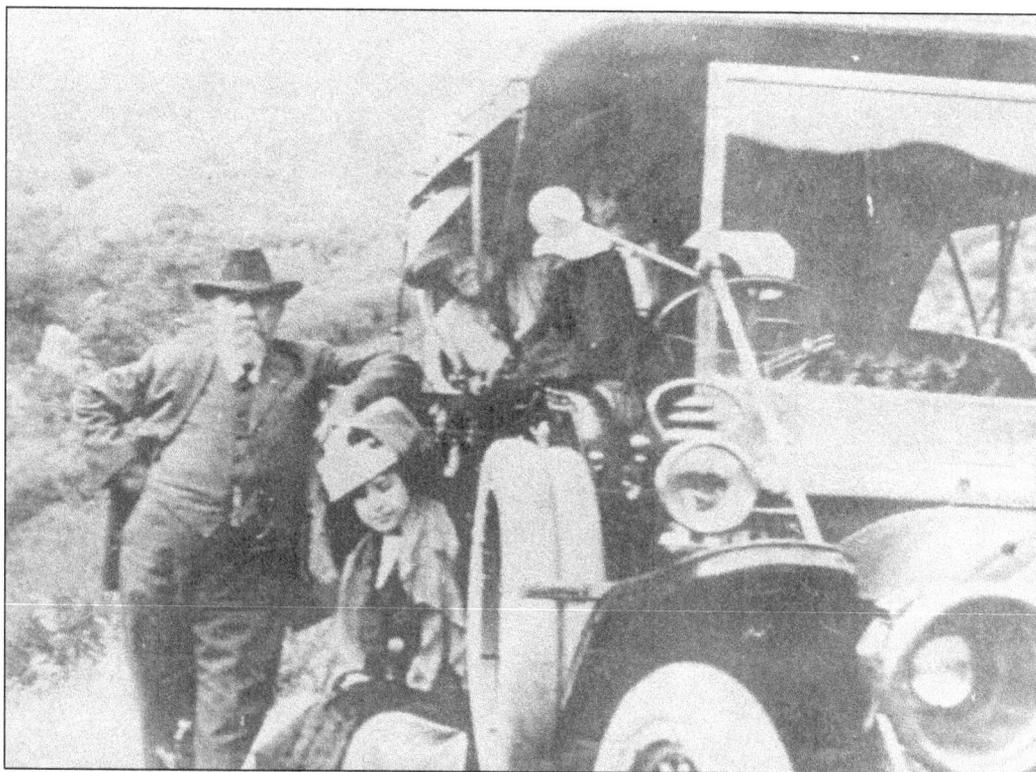

Mr. and Mrs. Joe Foster show-off their 1911 Stoddart Dayton automobile. Katie Nicolson Leng is seated on the running board.

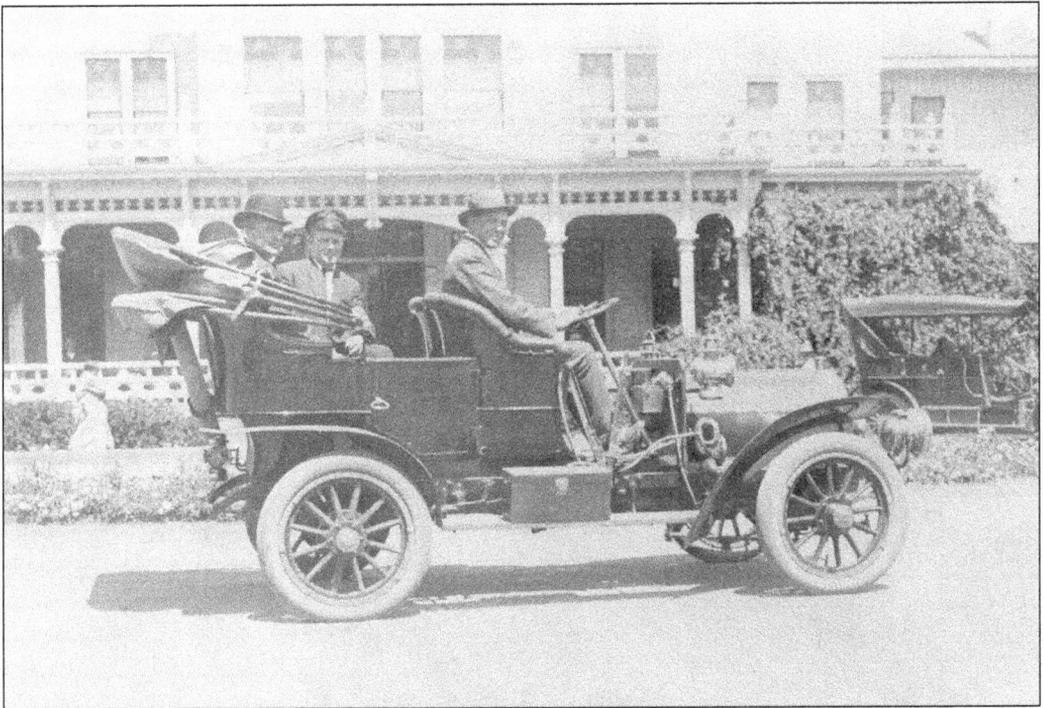
Fred Jackson is pictured at the wheel in front of the Lakeside Inn in 1910.

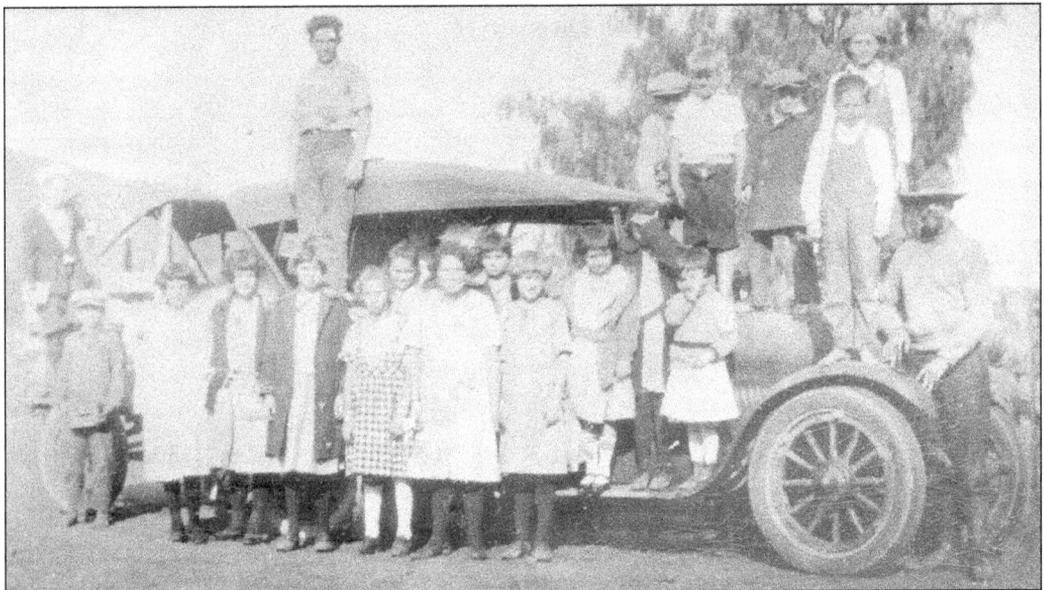
In 1910, Wellington Hoover was the driver of the Lakeside School bus.

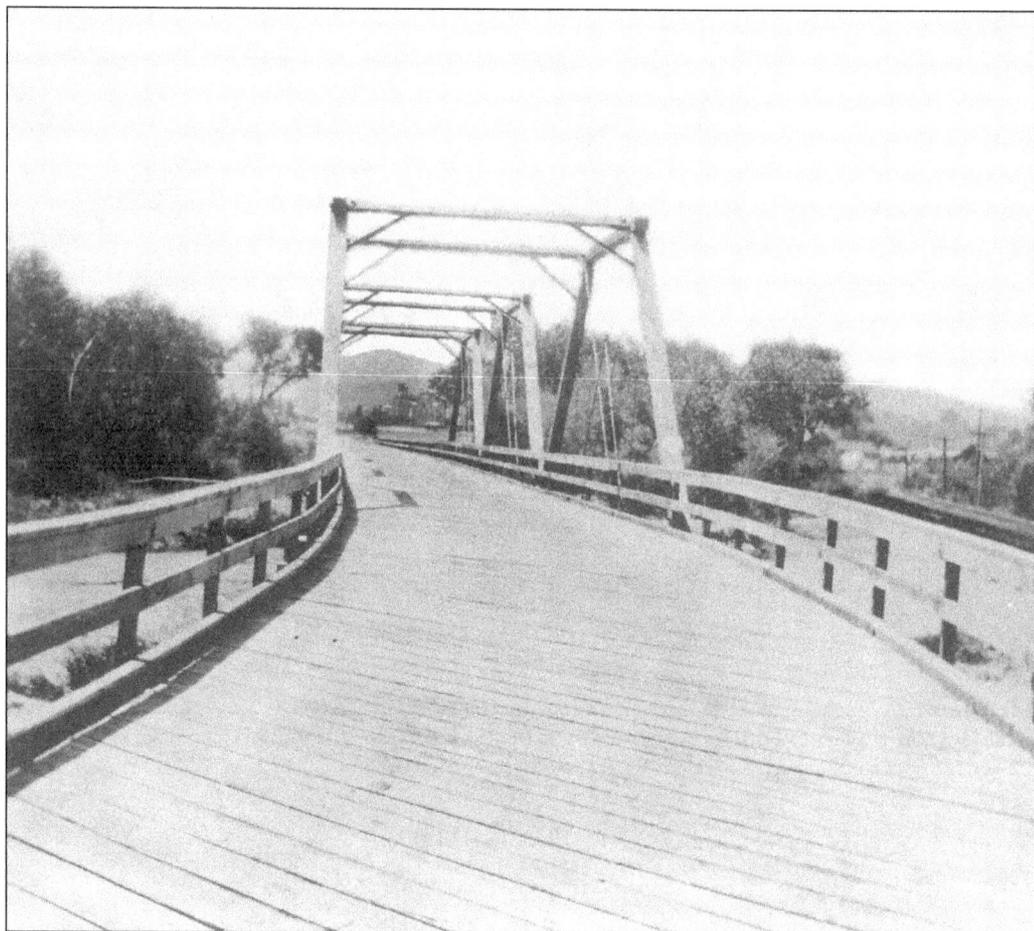

The first Lakeside Bridge across the San Diego River is seen here from the north side looking south. It washed away in the Flood of 1916.

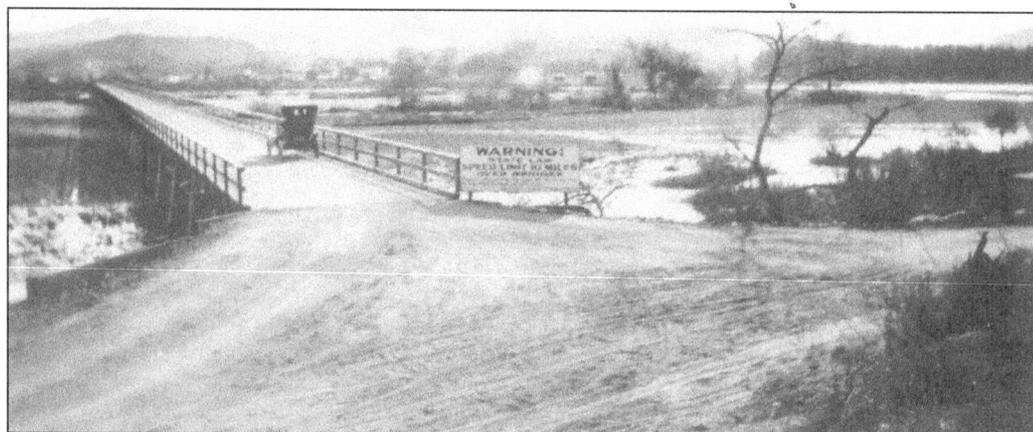

This photo shows the southbound crossing of the San Diego River on the new Lakeside Bridge in 1917. This bridge washed away ten years later in the Flood of 1927.

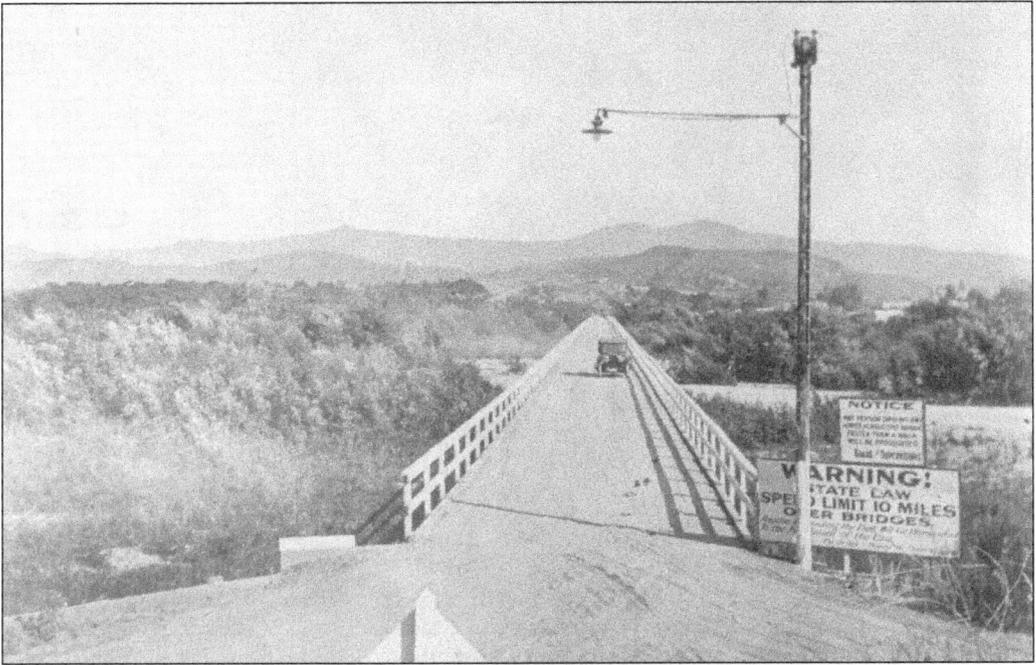

In the 1920s, a streetlight and a new notice from the Board of Supervisors was added to the Lakeside Bridge. The notice reads: "Any person driving any horse across this bridge faster than a walk will be prosecuted." This bridge was replaced in 1940.

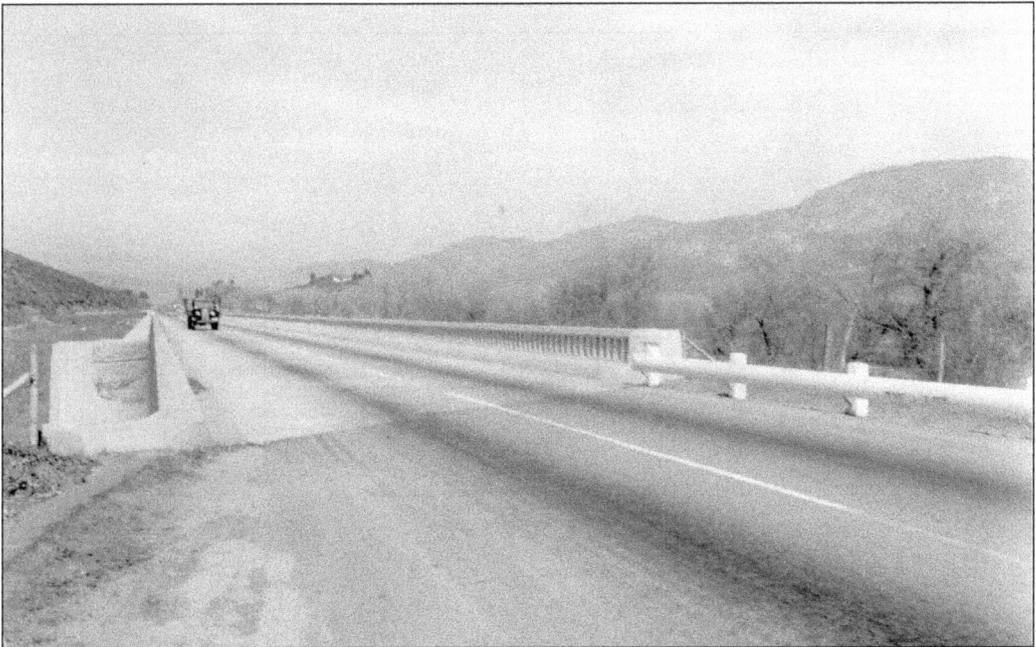

The new modern concrete bridge, built in 1940, allowed cars to cross the San Diego River at 55 mph. In the Flood of 1980, the footings of this bridge were undermined, so it was replaced again in 1981.

Mr. and Mrs. Wormington drive Charles Petty around Lakeside in this May of 1909 photo. (Photo by Charles Petty, "the Tramp Photographer.")

Rev. O.M. Temple of the Lakeside Community Church is seen here driving his 1912 Model T Ford in 1913.

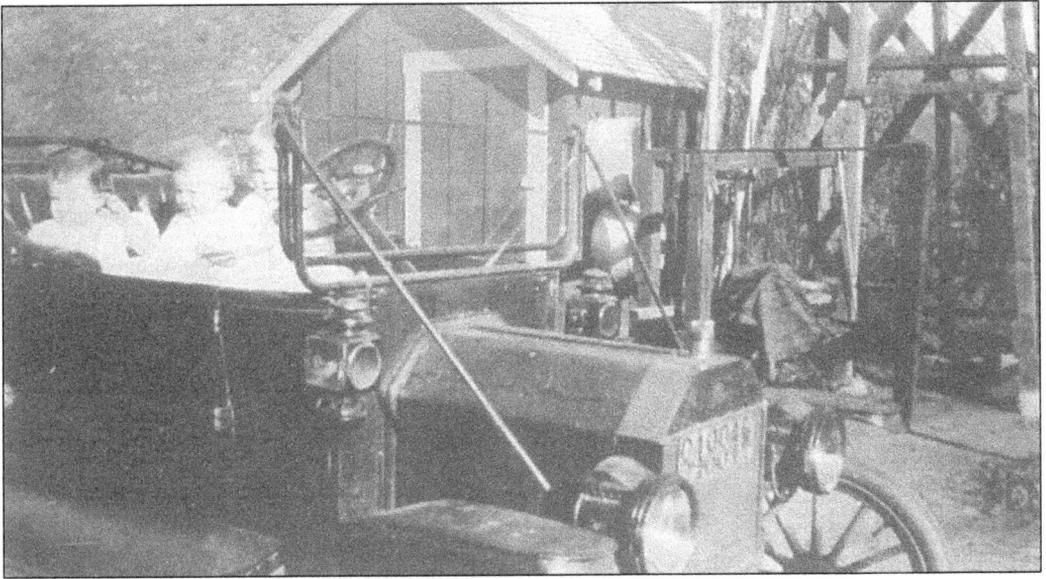

In this 1915 photo, George Philbrook is at the wheel of his father's 1912 Ford Model T at the County Road Station.

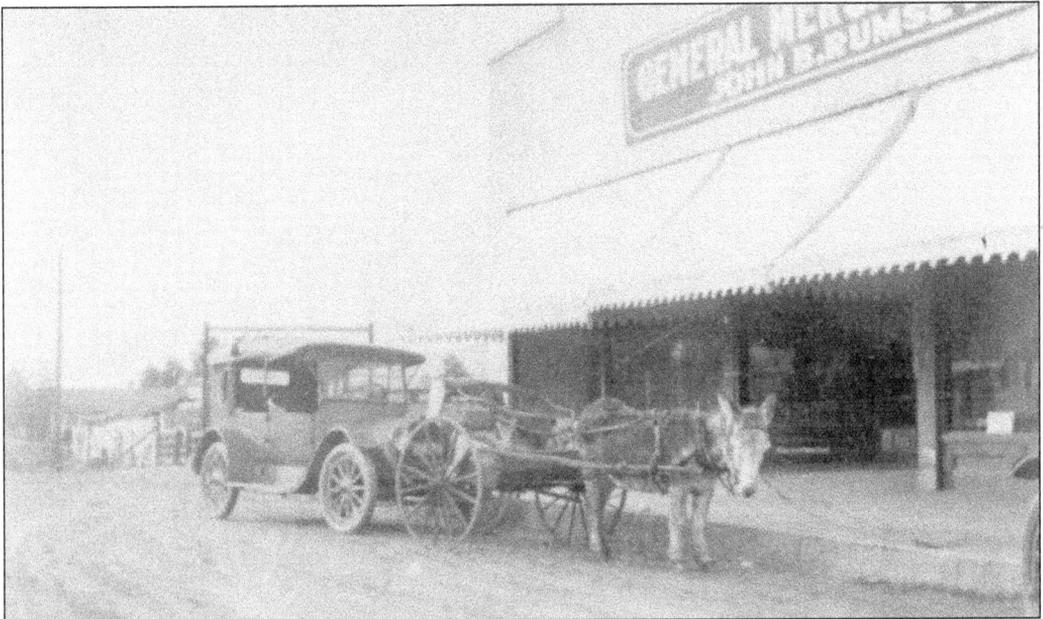

The "old-way" meets the "new" in front of Rumsey's General Merchandise on the corner of Sycamore and River in 1915.

A mock hold-up was held on Mussey grade. This was "the last stage out of Lakeside" in 1916. After the 1916 flood washed out bridges and parts of the road, George Miller went back to driving the stagecoach for a short time. He had the distinction of being the last.

Lakeside's fertile valleys and warm climate made growing alfalfa a profitable money crop.

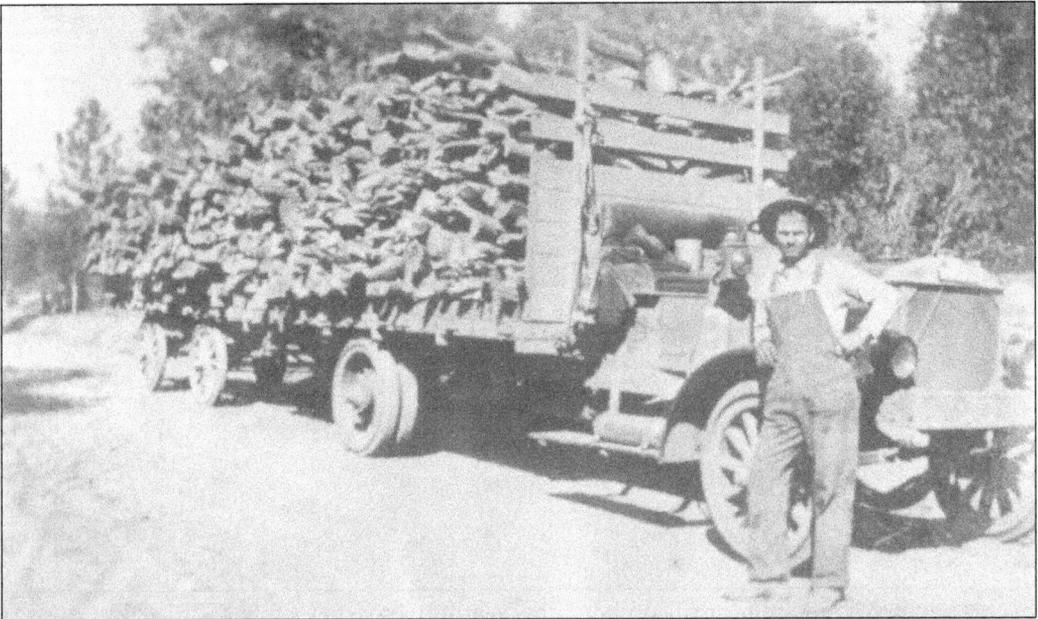

After the stage line closed, George Miller began raising hogs and alfalfa. Here he is seen with a full truckload of firewood in the 1920s.

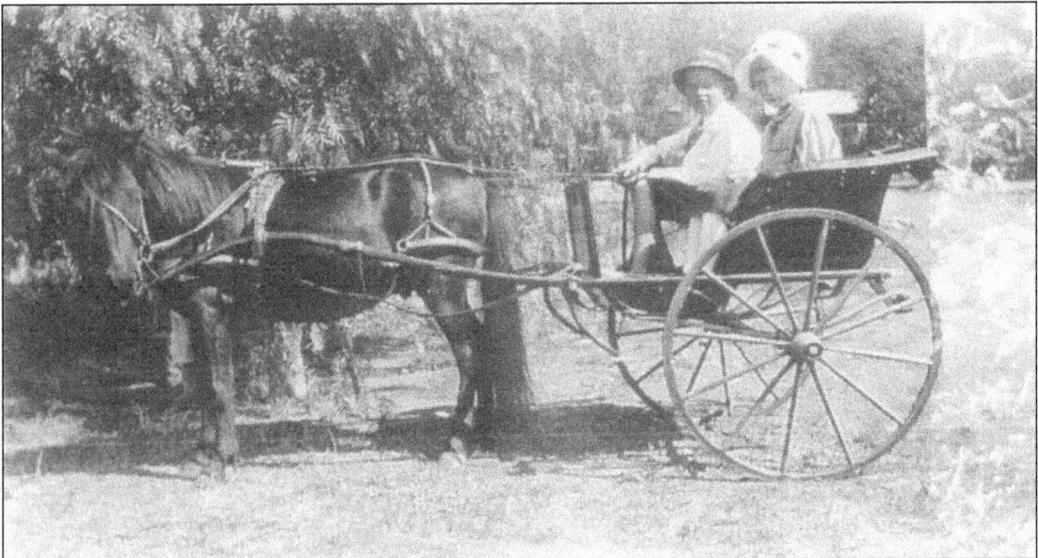

Here, George Philbrook and his sister Kathyrn drive to school in 1922. The horse and buggy stayed at the school during the day.

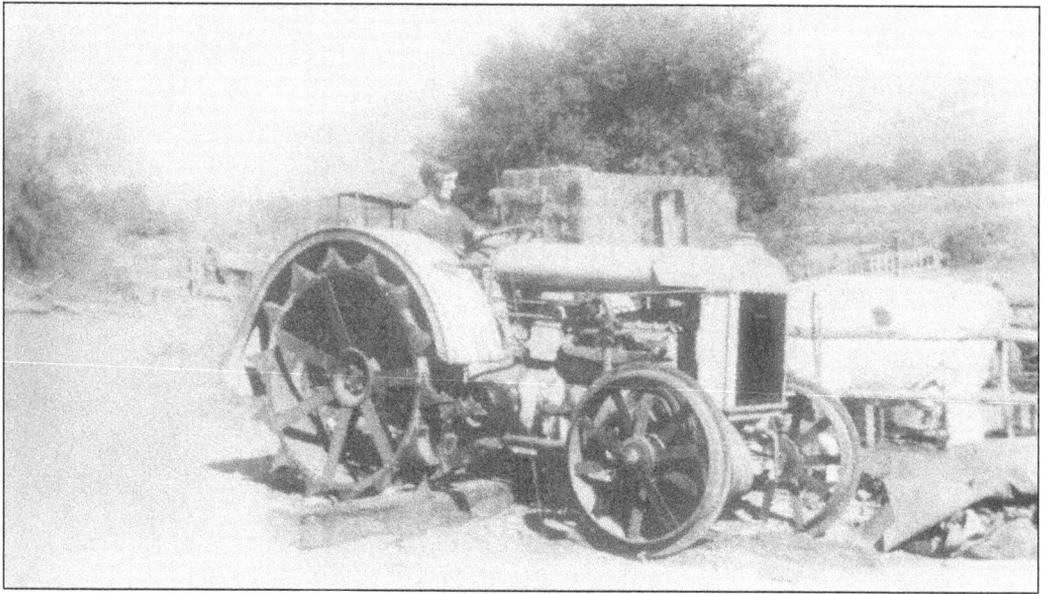

In this photo, Mimi Dinlinger sits on her father's farm tractor on October 22, 1926.

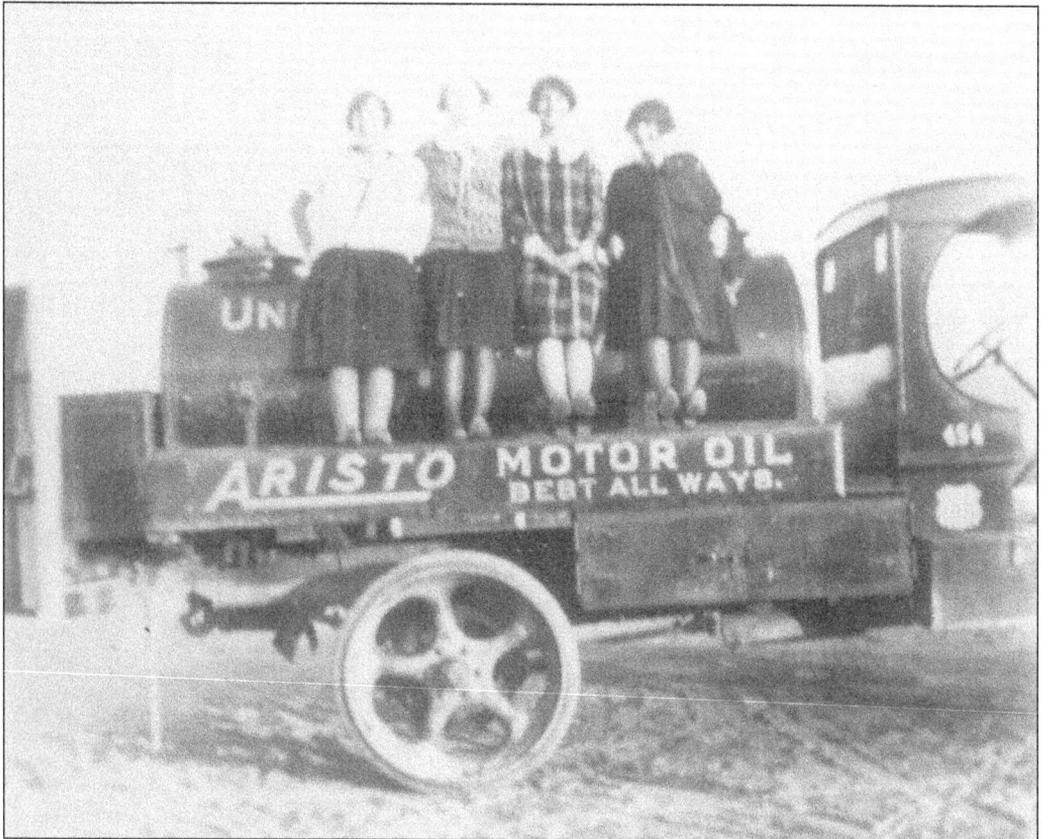

Francis Cameron, Ardith Smith, Joan ?, and Hazel Kouns pose for this picture in the back of a Union Oil Company truck in February of 1926.

126

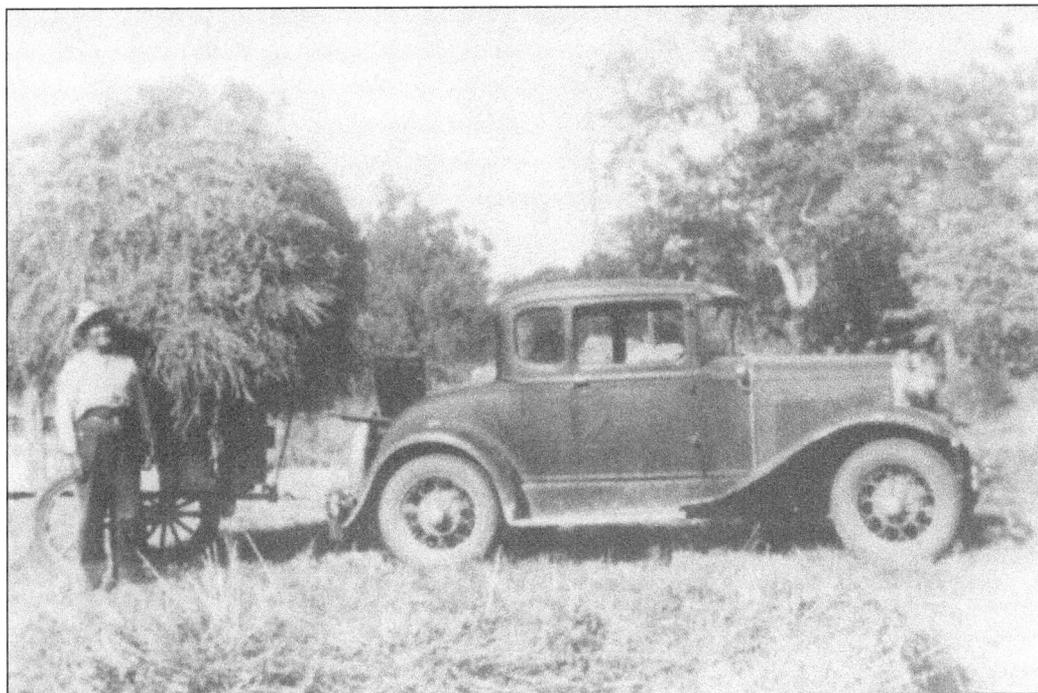

Modernized farming is seen here with Leon "Lee" Farnsworth Jr.'s Model A in 1931. Miguel Fernandez is standing next to the cart.

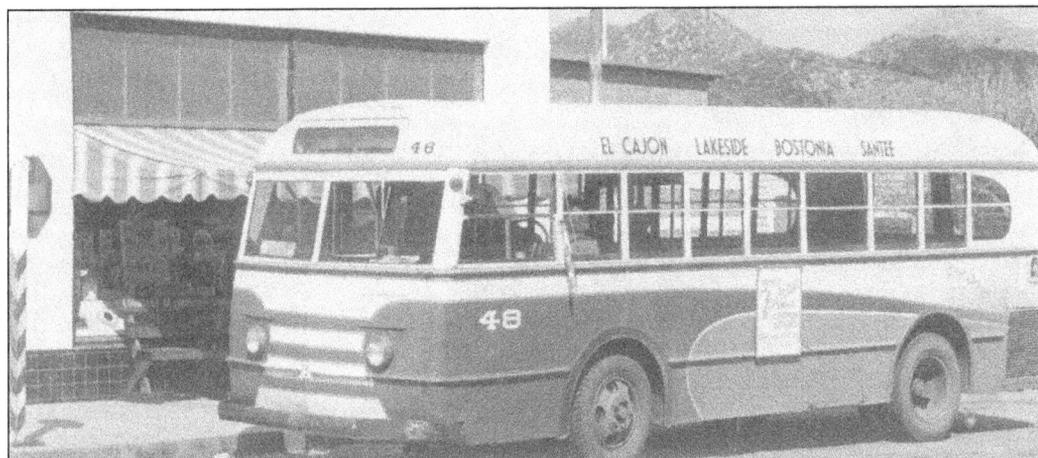

Through the 1950s, the El Cajon Valley Line bus still stopped at the corner of Maine Avenue and Lakeshore Drive.

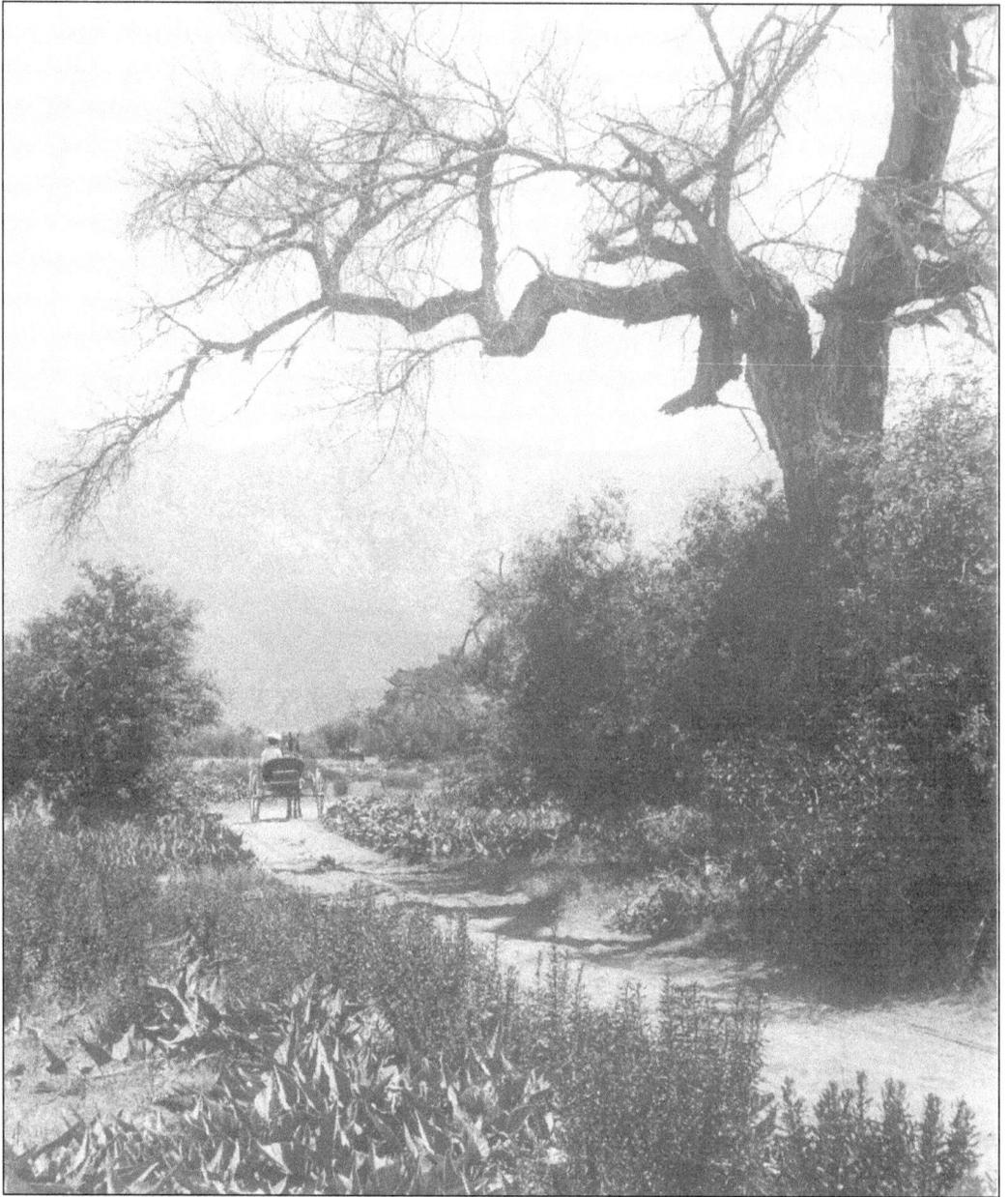

We end our journey through Lakeside's past with this image of a leisurely afternoon buggy ride down the El Monte Valley in 1902. As a backdrop, El Cajon Mountain stands as proud then as it does today. This is a vision from a much simpler time, a time that is too easily forgotten. It is the wish of this author, and the Lakeside Historical Society, that the images presented in this book will renew the memories of the old, and bring the past alive for the young. We need to be reminded that the measure of the meaning of our lives may one day be the things of beauty we treasured and preserved.